humans

brandon stanton

HUMANS

MACMILLAN

First published 2020 by St. Martin's Press

First published in the UK 2020 by Macmillan
an imprint of Pan Macmillan
The Smithson, 6 Briset Street, London EC1M 5NR
Associated companies throughout the world
www.panmacmillan.com

ISBN 978-1-5098-5174-4

5 7 9 8 6 4

A CIP catalogue record for this book is available from the British Library.

Printed in Italy by L.E.G.O. S.p.A.

Visit **www.panmacmillan.com** to read more about all our books
and to buy them. You will also find features, author interviews and
news of any author events, and you can sign up for e-newsletters
so that you're always first to hear about our new releases.

To Savannah

humans

INTRODUCTION

IT'S BEEN ALMOST EXACTLY ten years since the creation of *Humans of New York*. I'm still not sure what exactly to call it. "Photography project" seems a little reductive. "Blog" sounds a little too digital. After a decade of evolution, the work seems to strain against all the labels I've used in the past. Even the title itself seems outdated. Having collected stories from more than forty countries, *Humans of New York* can no longer be taken literally. My hope is that the name now signals a certain type of storytelling.

When I first set out on this journey in 2010, the concept was quite simple: I wanted to photograph ten thousand people on the streets of New York City. I had the added goal of plotting these photos on a map. It seemed like the mission of a madman, especially because I had no training as a photographer. But the impracticality of the goal served a purpose. It got me out on the street. Day after day. Not only learning to photograph, but also to approach strangers, make them feel comfortable, and engage them in conversation. Over time, these peripheral skills would become more central to *Humans of New York* than the photography itself.

As I collected thousands of portraits, I'd naturally have conversations with some of my subjects. I began including short quotes in the captions of the photographs. Some of the quotes were humorous. Others were thoughtful. Still others could be heartbreaking. But all of them provided a brief glimpse into the

inner life of a random person on the street. For a long time these quotes remained quite superficial. I was still uncomfortable in the presence of a stranger: afraid of invading their space, not wanting to offend, unsure of boundaries. I spent very little time with each person. I'd ask a few simple questions, then I would write down the first thing that came out of their mouth.

But as time went on, the conversations grew longer and longer. My questions became less casual. More searching and intimate. I grew bolder in the realization that most people enjoyed the process. They welcomed the opportunity to share about their lives, even with a stranger. Many were honored that someone cared enough to listen. Often I'd spend hours with someone I'd just met, huddled on the edge of a busy sidewalk, examining the events of their lives, trying to understand where they came from. Sometimes people shared secrets about their lives that they'd never told another person. And *Humans of New York* became known for the candor and intimacy of its stories.

As millions of people began to follow *Humans of New York* on social media, it also became clear that the appeal of the work had little to do with the city. It wasn't New York that was commanding so much attention. It was the people. It was the power of the individual story. Building on this realization, I took the process that I'd developed on the streets of New York and began to travel overseas. I photographed in many different countries. With the help of talented interpreters, I interviewed hundreds of people around the world. The conversations felt refreshingly familiar. The work felt the same. And the audience came along

on the journey, which allowed me to keep traveling. This book is the result of these travels.

But before we begin, a quick note on what this book is not:

With a title like *Humans,* it might seem that this book aims to cover the entirety of human experience. And I certainly felt that pressure. I spent a long time away from home. I pushed the book deadline back a full two years so that I could cover as much of the world as possible. But no matter how exhaustive my efforts, *Humans* was never going to be an anthropological study. It was never going to be the perfect balance of every ethnicity, every religion, every voice. It just wasn't possible. In the end, this book is what it was always destined to be: the collected conversations of a single photographer—who traveled to as many places as he could, and met as many people as he could.

Thanks to everyone who's been along for the ride. I get caught up in the work and I don't say it nearly enough: you are the best group of people on the internet. You've created this magic little corner of the Web where people feel safe sharing their stories—without being ridiculed, or bullied, or judged. These stories are only honestly shared because they have a long history of being warmly received. Thank you for the encouragement you've given to everyone I've interviewed. And the encouragement you've given me.

I hope you enjoy reading this book as much as I enjoyed making it.　◆

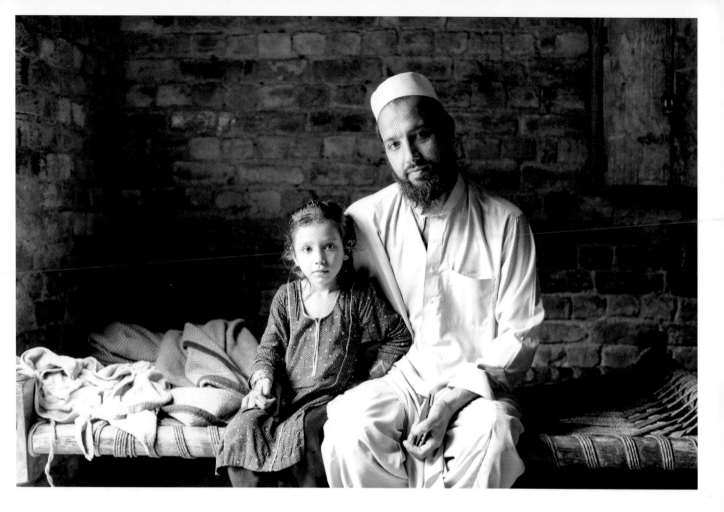

"I spent my childhood working, so I never had the chance to get an education. I was always envious of the boys who got to wear uniforms. This is her first month of school. She comes home and tells me exactly what happened, every day. I love it. If I'm not home for a few days, she'll save up all her stories, then tell them to me all at once."

"I graduated more than one thousand kids from elementary school. I'd still be teaching but my eyes went bad. It's such an important time in a child's life. It's when they learn speech, grammar, and how to pay attention. It's when the tree gets its roots. If you're taught wrong in elementary school, you'll be trying to catch that train for the rest of your life."

ST. PETERSBURG, RUSSIA

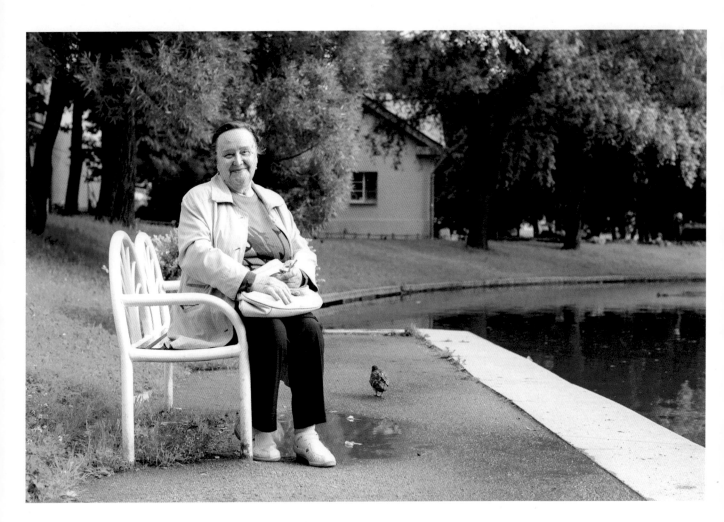

▶ "I'd like them to be ministers or businesspeople. But this one is supposed to start school this year, and I don't have the money to send him."

KASANGULU, DEMOCRATIC REPUBLIC OF CONGO

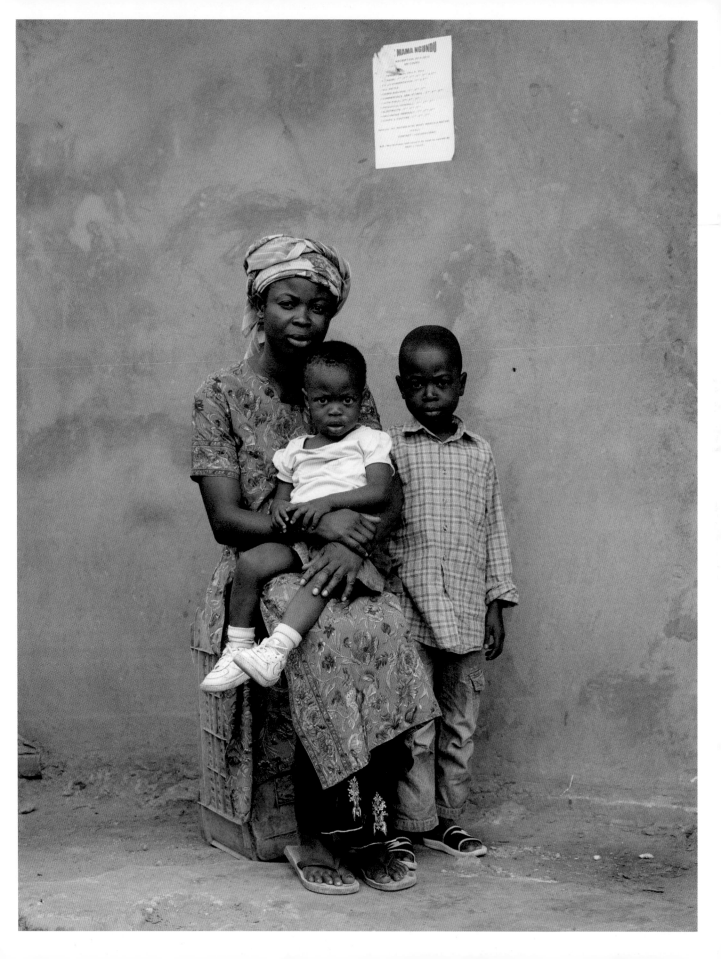

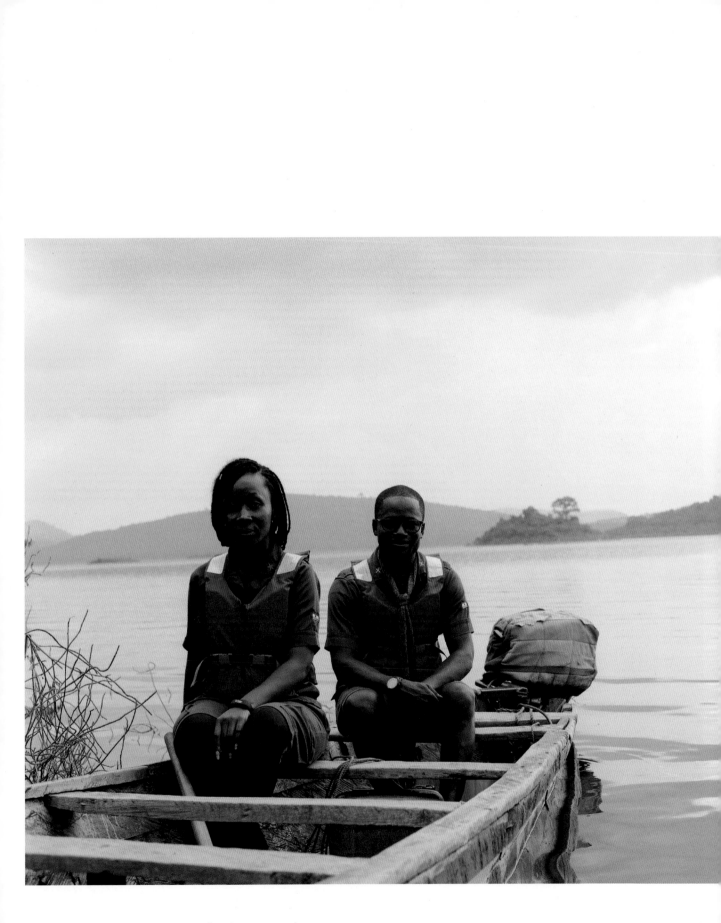

"When I was eighteen, a large group of students visited Ghana from the UK for a youth development program. It was an expensive program. It cost thousands of pounds. But I got to join for free because they needed some Ghanaians for a smattering of cultural diversity. The program was a mixture of community service and adventure. We actually came canoeing on this very lake. The whole time I was thinking about how much money was being made from our natural resources. And how much of that money was leaving Ghana. I became determined to make Ghana money out of the Ghana environment. So after graduating college, I set out to build a world-class adventure company. It's been over five years now. We have twelve full-time employees and twenty-five adventure locations. Best of all, I think we're creating an adventure culture in the country. Our clients were seventy percent foreign when we started. Now they're eighty percent Ghanaian. Behind me is Survival Island. It's my latest project and biggest risk yet. I constructed a full ropes course, and one day I hope to build the world's longest zip line. That would really put Ghana on the adventure map."

ACCRA, GHANA

"I think sixty is a pretty good age for life to terminate. It would certainly clear out some room for younger generations. Everything deteriorates after sixty, anyway. After that we're just old plants being kept alive with extra fertilizer. The pains get worse every day. It's not natural. Think of the millions of people sitting in retirement homes right now. Nothing to do. No future to look forward to. It's no way to live. Everyone needs a pill. That would be great. Enjoy your life as long as you want, but the moment the pain becomes too much, it's in your hands to stop it."

AMSTERDAM, THE NETHERLANDS

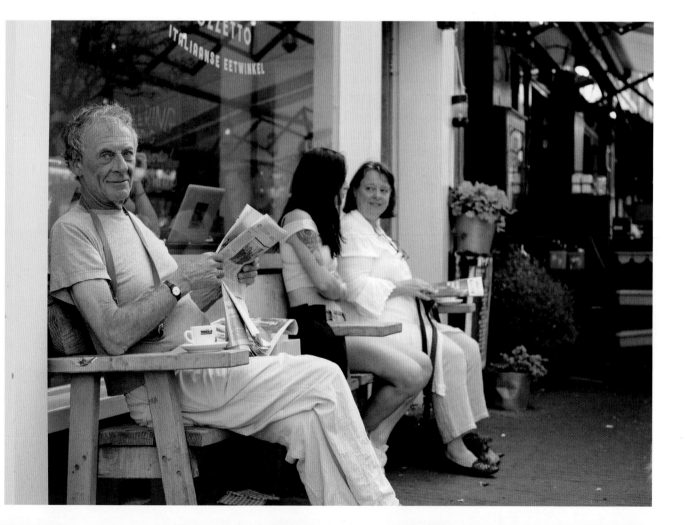

"I told my daughter to wash the dishes, and she called me an alcoholic. It really hurt. I've known I was an alcoholic since I was a teenager, but that was the first time that someone else had called me one."

"I thought it would always be in balance. That I'd always feel compensated. That parenting would always be exhausting, and always be fantastic. But sometimes it's just one or the other. There are moments when it's nothing but anger, frustration, and powerlessness. Maybe we're late for an appointment. Or I need to get to work. And she doesn't want to leave the house. She'll fall on the floor, throw a fit, and not move. You'll try to reason with her but she won't even hear you. And at moments like this you feel so tired. All of the patience, all of the love, cannot be found. You wonder: 'Why did I even start this?' But then in the same day, the same hour, it all turns around. She'll come back from an errand with my wife, and she'll jump out of the car, run up to me, and squeeze me harder than you can possibly imagine. And I can't imagine ever being angry. All I can think is: 'What on earth did I do to deserve this little scoundrel?'"

AMSTERDAM, THE NETHERLANDS

"I've seen a lot of death."

TONGPING INTERNALLY DISPLACED PERSONS SITE, JUBA, SOUTH SUDAN

"There's nothing hard about being four."

NEW YORK, UNITED STATES

"I was allowed to borrow my granddaughter this morning so we are walking through the park. It's our personal pastime. She likes to look at the dogs and birds. Today we saw some blackbirds which was quite exciting."

SANTIAGO, CHILE

▼ "Grandma was supposed to babysit today, but she wasn't feeling well. So I got the nudge at six a.m."

NEW YORK, UNITED STATES

▲ "He's my only grandchild. Every time he does anything, I enjoy it. The other day he pulled down the TV set. I didn't even mind."

KARACHI, PAKISTAN

"We're eating cookies before lunch because Grandpa doesn't have any rules."

PARIS, FRANCE

"I'd always leave the house dressed like a man, but then I'd change my clothes. My mother told me the devil was in me. My father said that I was useless. They even took me to the doctor to find out what was going on. But my grandfather always supported me. He was more open-minded than my parents. I think it's because he worked at a twenty-four-hour restaurant and met all the people who came out at night. Even when I was a child, he'd see the clothes I wore, and he'd tell me: 'If you were a girl, you'd be very beautiful.' When I finally told him everything I was feeling, he said: 'You're a great person, and I'll never be afraid of what's going on with you.'"

BUENOS AIRES, ARGENTINA

"When my grandmother died, there was a feeling that I'm all alone in this world. Her favorite saying was: 'I'm always here for you, whenever you need me.' Without asking questions. Without judging. My parents were different. They wanted things from me. They wanted me to be a good person, and graduate, and get a job, and do well. But I kept failing. I questioned everything. I was bad at school. I didn't follow the rules. I had purple hair. And a nose ring. And to make things worse—I had this perfect, beautiful little sister who did everything right. But every time I messed up, I could go to Oma. And she'd tell me: 'Don't worry so much. These things aren't important.' And 'I love you, darling.' And 'You're not a bad person.' And 'You'll find a way to be happy.' It could be so hard growing up. It felt like the world wanted so much from me. But my grandmother was different. She just loved me."

BERLIN, GERMANY

"I grew up in a very strict household. I had to dress in a modest way. I couldn't drink. Couldn't stay out late. And my family certainly wouldn't want me marrying a non-Muslim. Especially a white guy. It's not even possible to have an Islamic wedding with a non-Muslim. But he's made it clear that he's not willing to convert. And I understand his position. We were just talking about our future yesterday. I know the situation bothers him. He wants me to commit. He wants me to be clear, and say that none of this matters, and that I'm willing to lose everything to be together. But it's not that easy. My uncles would turn away from me. My aunts would turn away from me. I've seen it happen to other members of my extended family. I'd like to think that my mom would never leave my side—but she's a people pleaser, so I can't be sure. My father divorced her. And she's been carrying that shame all her life. So I'm not sure if she can handle any more. Right now I feel like I'm living two lives. I went home for Eid and it felt like I was living a lie. I'm not sure what to do. I know he thinks I'm doubting our relationship. But it's not like that at all. I wouldn't have invested this much time if I didn't want to be together. And I'm willing to do it. I'm willing to tell the whole world, and my family, and have them never speak to me again. But in the back of my mind, I can't help asking myself: 'Why won't he convert? Just for a minute. He doesn't have to follow. But that way I can tell everyone that we're Muslims. Why am I the one that has to make the sacrifice?'"

AMSTERDAM, THE NETHERLANDS

"We have to keep our relationship secret. Our parents would not approve and we're not courageous enough to tell them yet. So we meet in secret three or four times per month. Since the beginning of our relationship, we've shared a diary. We take turns keeping it. Whoever has it will write down our memories. They'll also write down what they want from the other person, and how they feel misunderstood. Then every time we meet—we hand it off."

THE APPROACH

THE CREATION OF *HUMANS OF NEW YORK* has always felt like a mixture of art and door-to-door salesmanship. The interview is the fun part. The conversations are always interesting, and people seem to enjoy the process once it's under way. And since every person has had their share of battles and triumphs, it's usually not hard to learn a good story from a willing participant. What can be difficult is finding someone who is willing to share. The toughest part of my job has always been getting people to stop for a moment. To give me a chance. Because most people hate being stopped on the street—especially in big cities, where being stopped normally means you're being sold something.

No matter how gently I approach someone, and no matter what words I use, a lot of people are going to say no. There can be days when not a single person says yes. So it takes a lot of endurance. And patience. And understanding. Some of it is just timing. A person might turn me down because they're having a horrible day, or they might be in a hurry. But if I discover that same person later, in a moment of relaxation, they might be feeling open to a new experience. Many of my portraits are taken in parks, which has nothing to do with my love of nature. It's because people are much more approachable when they're sitting under a tree than when they're rushing down a sidewalk.

In big cities especially, people will develop a bit of a shield to avoid unwanted interactions. They avoid eye contact. They re-

fuse to stop walking. They seem to be permanently "late for a meeting." A lot of people will turn me down before they even know what I'm asking. This can come across as rudeness, but it's not. It's just a natural defense mechanism honed by years of urban living. And it's almost always driven by fear. It's quite rare to find a person who enjoys being rude. Rudeness is almost always a reaction to stress. It's a means of protection. It's a shield. And getting past that shield has always been my biggest challenge.

In the early days of *Humans of New York*, it was hard to not feel like I was doing something weird. It was hard to maintain faith in the meaning and value of the work. After hearing several *no*'s in a row, I'd want to go home and quit. But every time I broke through a shield, and found a person on the other side, it was energizing. The moment a person agrees to be interviewed, everything changes. It's amazing how people transform when they realize you're not a threat. They become much more relatable. More familiar. More recognizable. Big cities can feel so isolating because we rarely get past this point with people. Everyone is hiding behind their shield. They're on guard at all times. At least until the end of the day, when they get back home, around people they love and trust, and suddenly become themselves again.

For all these reasons, the approach is perhaps the most important part of my job. It's the process of getting through to the real

person. Finding what's behind the shield, and presenting it to others. If our shields are what separate us, it's what's behind them that brings us together: the struggles, the worries, the pain, the weakness. All the soft spots. The places we protect. These are the things that make us most relatable to others. These are the things that connect us—if only we allow them to be seen. ◆

"I've been sitting here for four hours thinking about what I should do. I don't want to go home. I fucked up again. I've been a drug addict my whole life. But I was clean for three months. I got a job at a call center. I was doing well. Then as soon as I got my paycheck, I went out drinking with some coworkers. It was supposed to be a normal thing, but then I tried a little coke. Same story as always. I ended up going on a binge and lost my job. And now I don't want to go home. I live with my mother. She's never lost faith in me. My brother was killed in the army so I'm her only son. She doesn't deserve this. She was so happy that I had a job. She'd convinced herself that things were finally going to be OK. And I've got to go home and tell her what happened. And I don't want to do it. She's not even going to be mad. She'll just be so hurt. Then she'll ask me if I've eaten."

BOGOTÁ, COLOMBIA

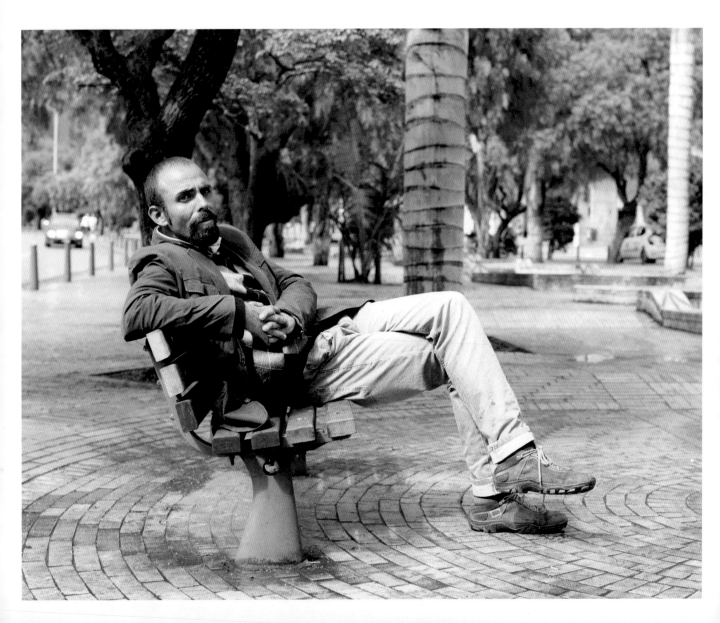

"My mom works in restaurants and cleans houses. All her money goes to my tuition. She always tells me just to focus on school. We were short on money last semester, but she told me: 'Don't worry about it. I'll find it. You just continue.' She's always been like that. She never wants me to be stressed. My dad passed away when I was a young child. So we've always struggled. Sometimes when I was growing up, there would only be enough for one meal. And my mom always said that she wasn't hungry. I didn't realize until I was older that she had only been pretending."

LIMA, PERU

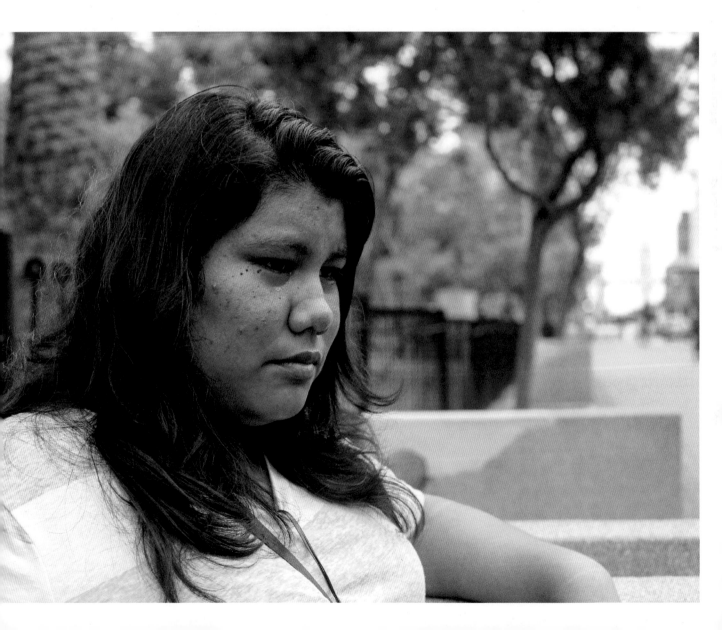

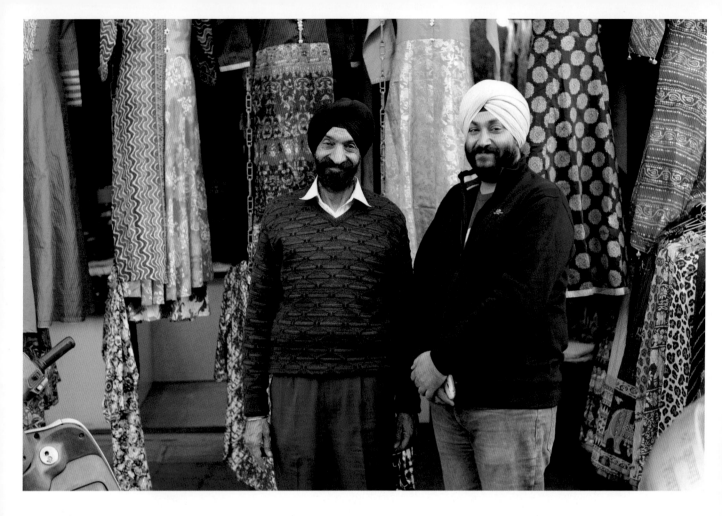

"When I was twelve years old, I really wanted a bicycle. So he bought one for me. Shortly after that, I noticed that he wasn't wearing his favorite ring. He told me that it was being repaired. When I became an adult, I asked him again: 'Dad, where is that ring? I want to make one just like it.' Finally he told me: 'I sold that ring to get your bicycle.'"

JAIPUR, INDIA

"One night, I was walking up the hill with my soccer ball and the police and drug dealers started to shoot at each other. I jumped over the wall and ran all the way home. I told my mom what happened, and she got so mad at me. I told her that I was just playing soccer and I didn't do anything wrong. Then she started to cry. And I started to cry. And then we went to the church and prayed for a very long time."

RIO DE JANEIRO, BRAZIL

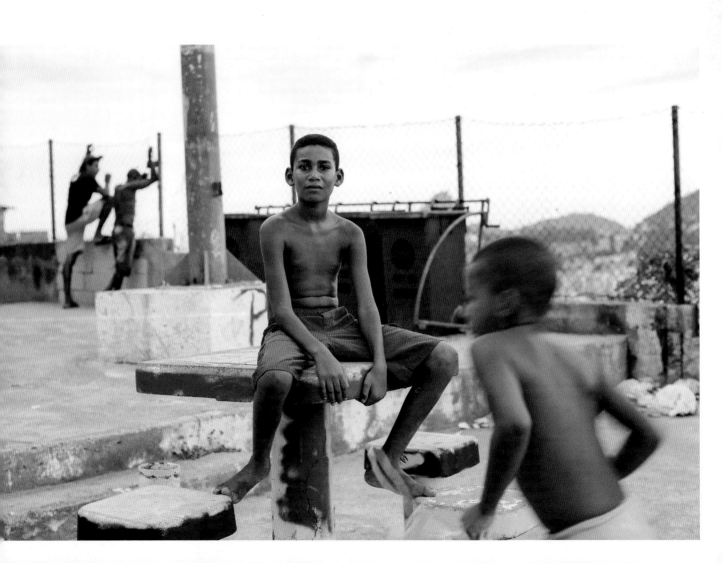

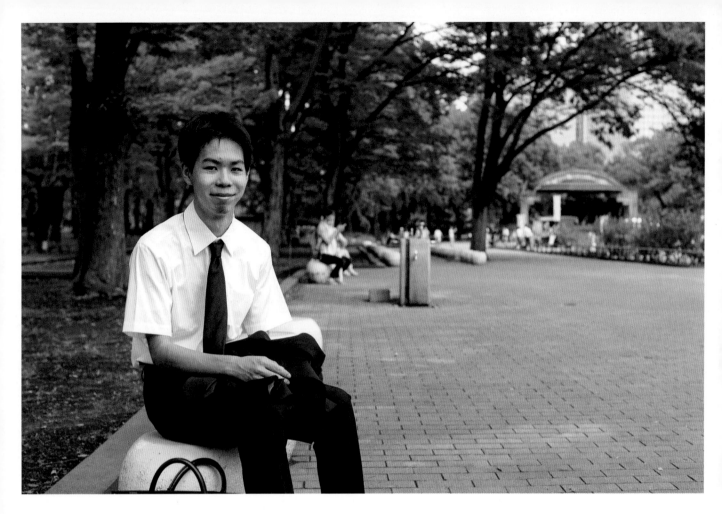

"Two years ago we took our entrance exams for university. The school announced our results in an auditorium. One by one, they called the number of everyone who passed. When I didn't hear my number—I couldn't breathe. I wanted it to be a dream or a lie or a prank. For my entire life I'd wanted to be an engineer, but I wasn't even smart enough to attend university. I have a habit of walking when I feel hopeless. And that night I walked twenty kilometers I felt lost. Like I had no path. I stayed in bed for the entire next week. But you can't stay in your room forever, so I finally mustered the courage to consult the people around me. My favorite teacher suggested that I apply to be a civil servant. She reminded me that I have a strong sense of justice. So I spent an entire year studying for the exam. The results arrived yesterday, and I locked myself in my room to open the envelope. It said: 'Accepted.' I've been looking backwards for so long. I've been feeling ashamed of myself. But that's finally over. Right now I'm in Tokyo for a career fair. All of the ministries will be presenting. Whatever position is chosen for me, I will give it my all. I'll be happy with anything. I'm just excited for the opportunity to spend my life helping others."

TOKYO, JAPAN

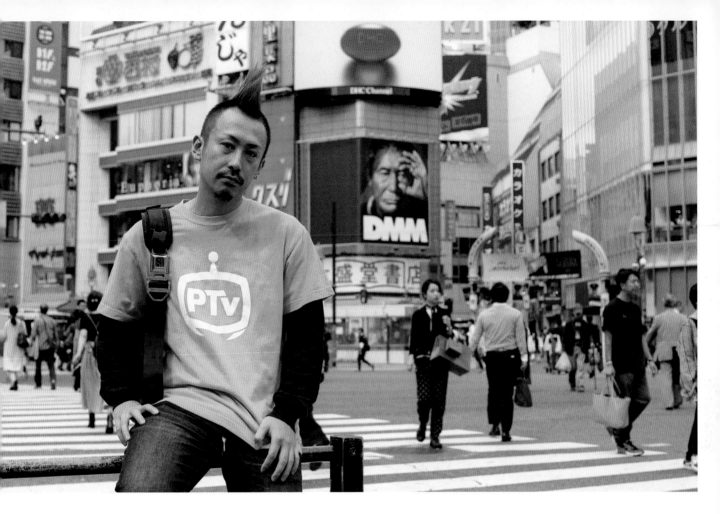

"I've got to find a way to get more views
for my YouTube channel."

TOKYO, JAPAN

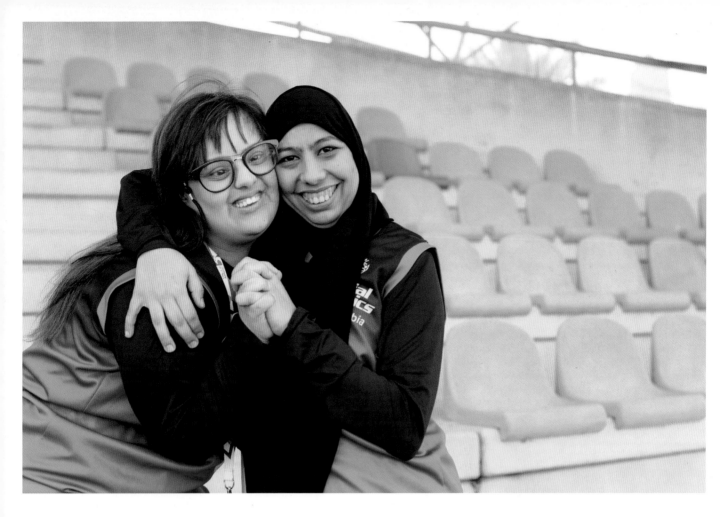

"We are the first female athletes from Saudi Arabia. It makes us feel wow. It's one of the nicest moments in our life. I have to be happy and positive because I am the basketball team captain. Whenever we make a shot, I clap. I also clap if we miss it. And I clap if the other team makes it. If somebody is sad, I tell them, 'Don't be upset, my sweetheart.' And then I rub their shoulder. This is my teammate Dahwi—I am her friend and she is my friend. I love her so much. She loves food and we dance together. We blow each other kisses during the game. Yesterday we won. But it doesn't matter if we lose because at the end we always dance."

SPECIAL OLYMPICS WORLD GAMES, ABU DHABI, UNITED ARAB EMIRATES

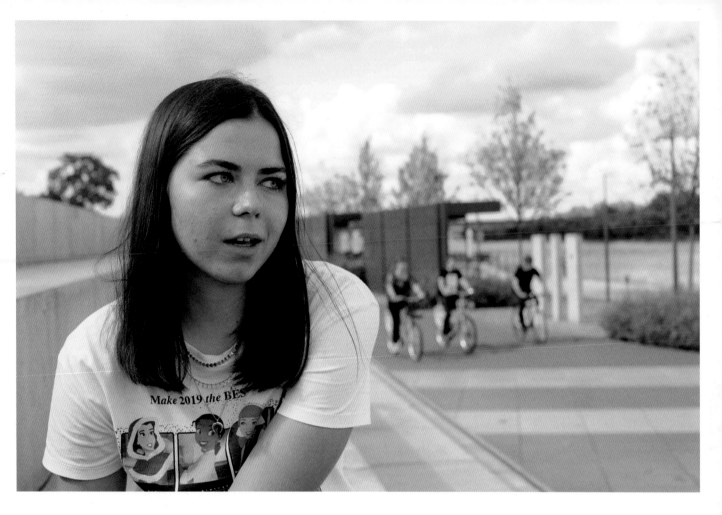

"I've always wondered if I'm a mean person. A lot of people think that I'm cold. I don't feel cold when I'm alone. Or when I'm with my close friends. But it's not easy for me to get to know people. I guess I'm just guarded. I don't really talk about my feelings. The more I talk about them, the more I feel misunderstood. I don't like to sit close. I'm not a hugger. I don't even like to be touched by people I don't know. It's taken me so long to know myself, I don't want people feeling like they know me immediately."

WARSAW, POLAND

"We don't have any hobbies. But we do try to get together a few times a month to judge people and complain about things."

NEW YORK, UNITED STATES

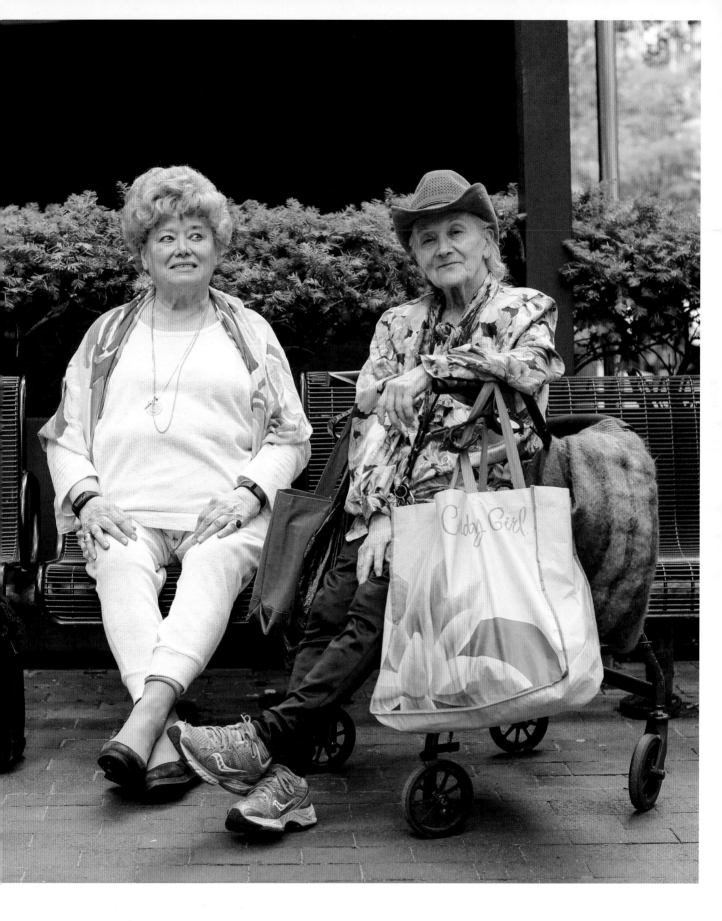

"My wife wanted to wash her hair and cook dinner, but the baby started crying. So I brought him outside to see if it would help. We've gone about thirty minutes without screaming. We're from Mozambique. I originally came here to find work as a ceiling installer, but I brought my wife along when we found out she was pregnant. The healthcare is much better in this country. It's too early for them to go back home because the child was born premature, but I'll feel safer when they're gone. It's too dangerous for them here. South Africa is a good place to work, but they don't like us being here so much. The abuse mainly comes from other black people. They call us names. They tell us to go home. They attack us because they think we're stealing their jobs. But I'm just doing what I know. They don't understand what it's like in my country. You can't survive with kids. I'm just making the only choice I have."

JOHANNESBURG, SOUTH AFRICA

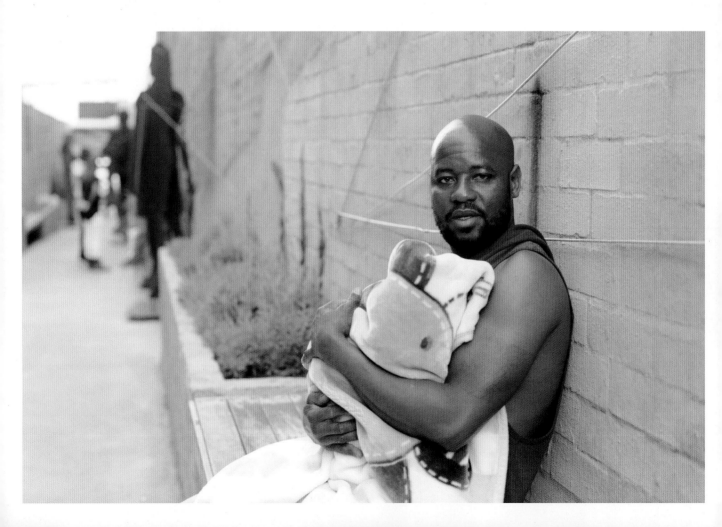

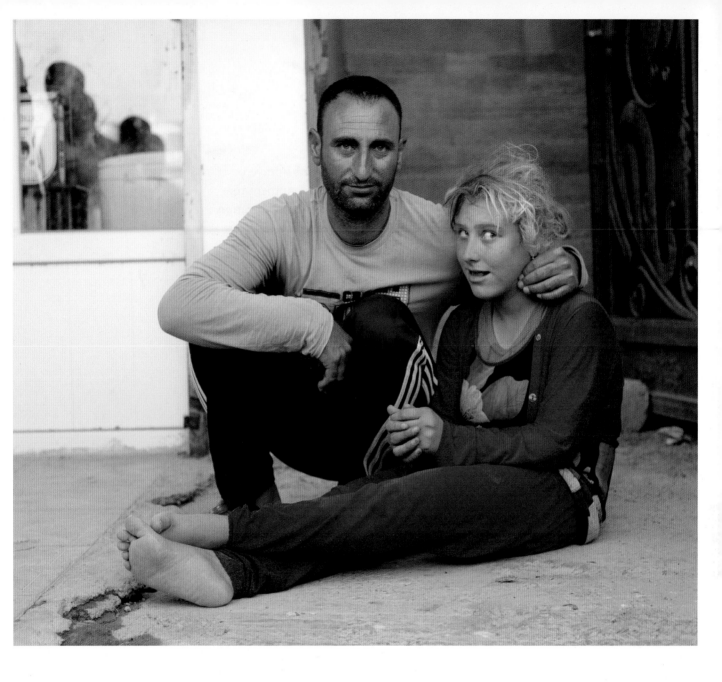

"I would give my soul if I could fix her brain."

DOHUK, IRAQ

"My daughter had a hole in her heart. I prayed constantly because I never knew the moment that God would be listening. We were given medication from the doctor, and then God healed her."

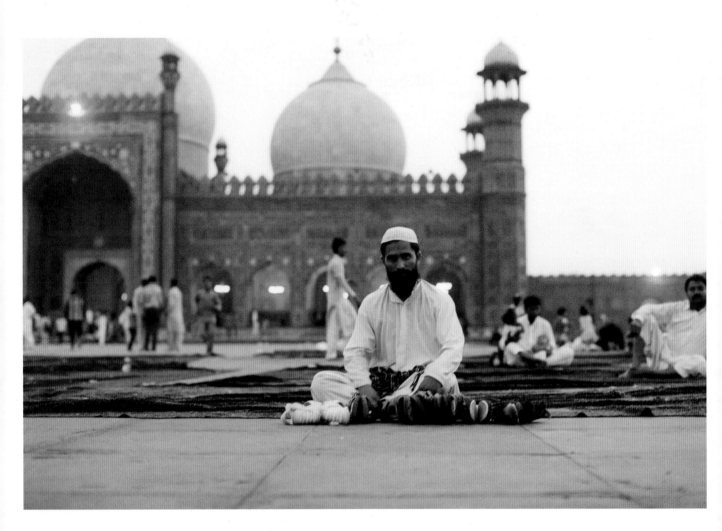

"I sell grain for people to feed the pigeons and cows. It's a way to get good karma. This has been our family's business for eighty years. It began with my grandfather, then my father, and now it's mine. I have about 250 or 300 clients that I see every day. Things were going very well. We had two houses. A car. Lots of gold. But a few years ago my brother-in-law got kidney disease. Our family spent everything to save him. We traveled all over India. People said: 'go here, go there,' and we always went. And we always paid whatever they asked. My mother even donated her kidney. But nothing worked. He died seven months ago. My parents passed away soon after because of the stress. Now I'm all alone. I own nothing but a scooter. I still believe in karma. Without it I have nothing left. But only God knows what I did to deserve this. If I knew, I wouldn't have done it."

JAIPUR, INDIA

"I took him to see *Brokeback Mountain* when it came out. I thought I was challenging him with the choice. But at the end of the film, he turned to me and said: 'That's me.' We'd been married for thirty years. Our kids were still young. I didn't know what to do. Do I leave? Do I stay? We were expats in another country at the time, so we were all alone. I had nobody to talk to. We went to a therapist to see if it was possible to stay together, and she told us: 'I've seen it work. But only if one person is very discreet and the other is very tolerant.' So I agreed to try. It's been ten years. It's been exhausting in a lot of ways. I asked too many questions at first. I made myself miserable. Now I give him a lot of space. And I get a lot of space in return. I've been traveling alone for about two months now. I know what's going on back home but I don't ask about it. My friends ask me why I don't move on with my life. I don't know the answer. Maybe I'm just too afraid to be alone at this age. But I still feel like he's my soul mate. We have the same view of the world. We both love children. We love traveling and good food. He really is a good man. He's just gay. And we've had such a good life together, I'm just not ready to stop sharing it."

NEW YORK, UNITED STATES

"When I first told my mom, I was crying my eyes out. It took me ten minutes to even begin speaking. When I was finally able to say it, she told me to think more about it. And that maybe I was uncertain. After that it was like it never happened. She never mentioned it. I tried bringing it up a few weeks later, and she said something painful. I don't know if she meant it or not—but she told me that staying single is OK. She gave me examples of people in our family who had never married. It made me feel like she'd rather me be alone than gay. I've decided not to push it. I don't want to cause a fight in my family. I don't want them to get our church involved. So I've begun to create stories in my head about how a relationship would be impossible anyway. I try to magnify my flaws: I'm too insecure, too jealous, too possessive. Nobody would be attracted to me. It makes it less painful to think about. Like I'm not missing anything. Because even if I could be with someone, they'd never want to be with me."

HONG KONG

"I love my mum because she's the nicest mum and is so kind to me. And I love my dad even though he has a new girlfriend and he doesn't live with us anymore. But Mummy says he loves me very much and he cares for me so much, even if he's very busy and doesn't have time to talk to us, and he works far away so he can't come see us. But Mummy says he loves me so much."

LONDON, ENGLAND

"I don't even know why they have Father's Day. Fuck Father's Day. Dad's vagina didn't rip open and his nipples never bled once."

"I can do all the same things as my wife except for the milk part. And I try to make up for that by reading a lot of stories and showing her my vinyl collection."

BUENOS AIRES, ARGENTINA

"I'm not sure why Dad loves touching his phone so much."

SEOUL, SOUTH KOREA

"I've been a single father ever since my son was two. He saved my life in a lot of ways. His mother and I used to consume a lot of drugs, but I did a full stop when he was born. But his mother never got her life together. She'll show up sporadically but then disappear for months at a time. I try to fill in the holes with as much love as possible, but I know it bothers him. He's just not at an age where he can fully express his feelings. I try to protect him from all the volatility of my own life. I broke up with my girlfriend yesterday. And I'm sitting here wondering how I'm going to explain it to him. I actually waited a long time before introducing them because I didn't want her to be another absence in his life. But now it didn't work out. And I've got to figure out how to break that down for him."

BOGOTÁ, COLOMBIA

"We promised Mom that we were going to let
all the grasshoppers go."

"My wife is on maternity leave right now. Our son is four months old. And we have a daughter who is five. In addition to not sleeping well, I desperately need to find some work. Right now I'm working freelance. I had a couple big projects recently, but those have already ended. Maybe I should go work for a corporation. I've always tried to avoid it, but maybe that's the responsible thing to do since I have kids. There's always more pressure when it comes to people who wouldn't be here if it wasn't for you. You understand from day one how it works. An infant can't even eat by himself. It's all on you. When you first see the baby, it's like a little stranger. You don't know this person. You need to learn what it needs and who it is. But as they grow, and start to communicate, you begin to see a real person, someone similar to you, with their own needs, and their own world, and it's becoming more and more complex over time, and you're becoming more and more important in that world. And that can be a lot of pressure."

WARSAW, POLAND

"I was a bit of a loner before I had her. I wasn't a social person. I stayed away from people because I thought that everybody had a plot or a scheme. But she's taught me how innocent people are when they start out. I mean, sometimes she'll butter me up because she wants candy or a cookie. But then other times she'll just hug me for no reason."

NEW YORK, UNITED STATES

"Over the past few years I've been having a lot of negative thoughts. Toward the world. Toward myself. Toward other people. I've been struggling with chronic depression, and I think the most obvious symptom is negativity. My perception changed so slowly that I didn't even notice. It didn't feel abnormal. I just thought I was seeing the world clearly. I thought people were basically mean. I couldn't find the energy to sit down with them, talk to them, and learn they aren't bad. But watching her grow has been a revelation. She's positive toward all humans. And everyone is positive toward her. I never know who starts it. I don't see who begins the interaction. But so many times I'll be on the bus or metro, and I'll look up, and she'll be smiling at a stranger. And they're smiling back. And it makes me so happy. Sometimes my face hurts from smiling so much. I'd somehow forgotten that if you smile, people smile back."

BERLIN, GERMANY

"I love walking around the city. I catch the Metro-North train at eleven forty every morning. I go to the same gym that I've been going to for forty years. Then I just start walking. If you take big strides, it really stretches you out. And there are millions of other people walking around. You never feel alone. People smile at you. On weekends I'll bring my granddaughters with me and we'll tour different neighborhoods. We've seen ten or twelve so far. Sometimes I get to borrow them for the whole afternoon. But they're at sleepaway camp right now so I'm missing them a lot. And that's about it. I do a little shopping at the thrift store. I stop and read the paper. I eat at outdoor restaurants. It's simple but I found what makes me happy and I'm doing it. And when I'm heading home at night, sometimes I think: 'I just had the best day of my life.'"

NEW YORK, UNITED STATES

"We don't like pictures like this. It is not good to reduce an entire country to the image of a person reaching out for food. It is not good for people to see us like this, and it is not good for us to see ourselves like this. This gives us no dignity. We don't want to be shown as a country of people waiting for someone to bring us food. Congo has an incredible amount of farmland. An incredible amount of resources. Yes, we have a lot of problems. But food is not what we are reaching for. We need investment. We need the means to develop ourselves."

KINSHASA, DEMOCRATIC REPUBLIC OF CONGO

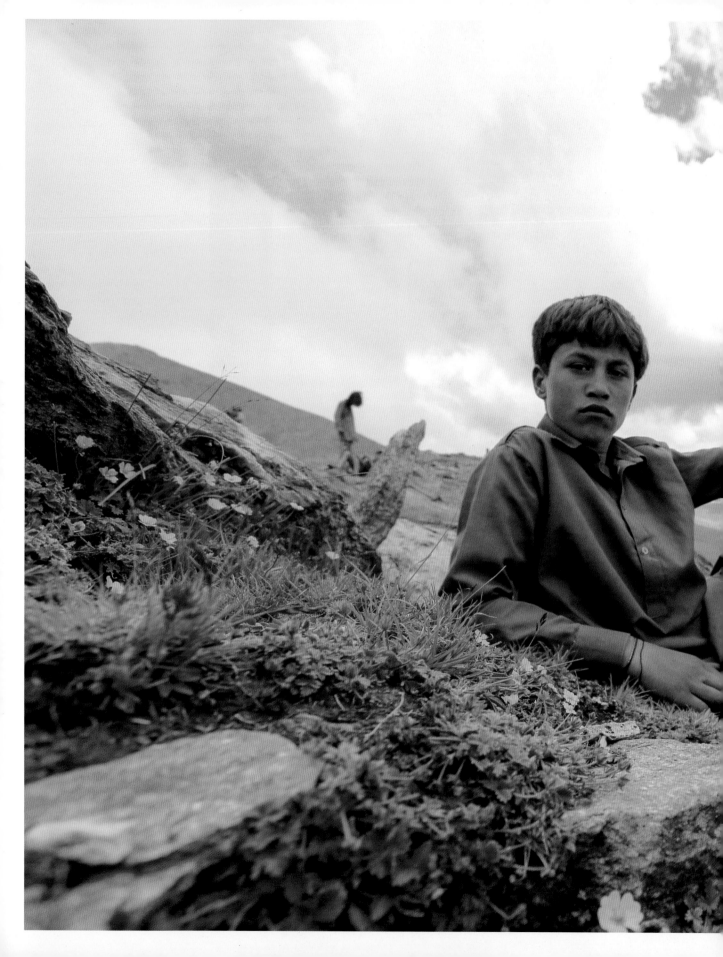

"I want to be a
police officer.
For the power."

BABUSAR TOP, PAKISTAN

"I want to be a mailman so I can let people know when it's their birthday."

NEW YORK, UNITED STATES

"I don't know how old I am."

"My first addiction was gambling. I pushed it so far that I lost our family home. I couldn't handle the stress so I needed an escape. I used to be a bodybuilder back then. My arms were this thick. I was healthier than you are. But now this is my only breakfast. It makes me numb and I sleep until the evening. It's been about ten years. And the longer I do it, the more pain that's waiting for me if I stop."

LAHORE, PAKISTAN

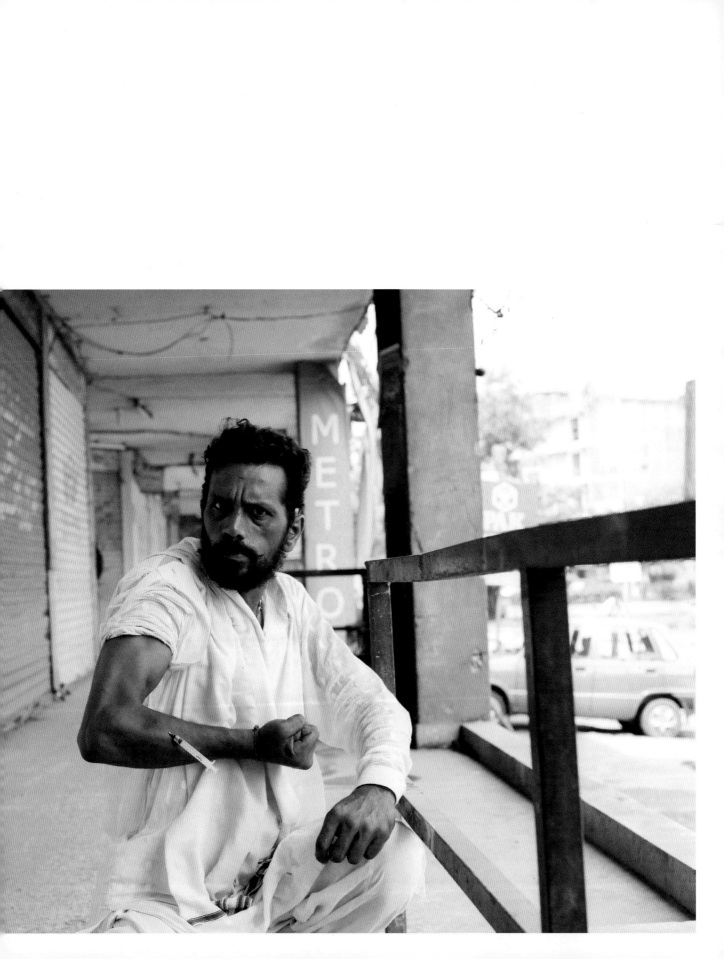

"It was a social thing at first. I'd just play cards with my friends. But I had good luck in the beginning. I started to win. And I started to love it. I couldn't wait for the weekend. Soon I started going to the casino during the week. I'd work the early shift and I'd have all afternoon to play. I abandoned all my responsibilities. Once you start playing—you forget that you're hungry, you forget that you're thirsty, you even forget that you have a family. I lost the grocery money, the rent money, everything. Winning felt great. And losing made me need to win. I'd make up excuses every time I came home empty-handed. I'd say that I was mugged, or that my work hadn't paid us that week. Eventually I had to sell my car. I lost our house. I lost my wife. We'd been together for twenty years. I just took for granted that she'd always be around."

MEDELLÍN, COLOMBIA

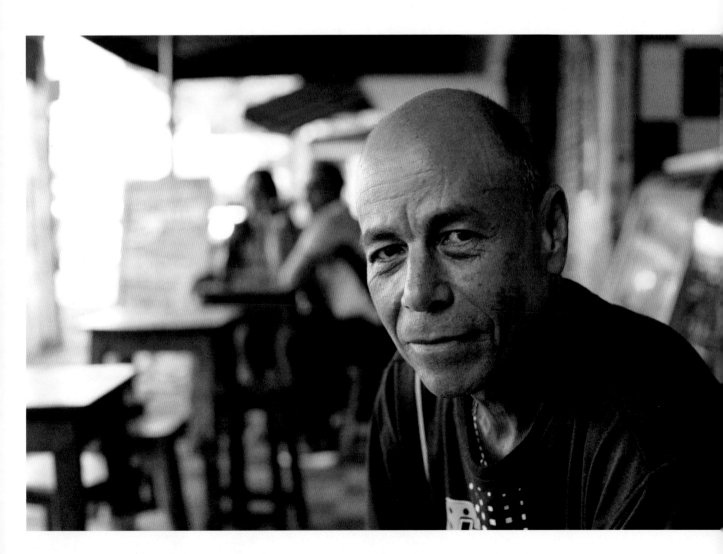

"It's like a little moment: two days, maybe three. When you can forget about life and all the pressure. The clubs are really, really beautiful. The music is so good. There are people from every age and background. And everyone takes drugs. Nobody cares what you do. You can have hairy armpits. You can have a girlfriend. Nobody cares. Everyone is just so happy to be there. We all dance together and everyone is so kind. It's such a beautiful thing for an eighteen-year-old girl to see. It's the feeling I was looking for. So I held onto it. These people became my family. But it was all an illusion. They turned out to be lost like me. They were just as vulnerable as me—but some of them were twice my age. My friends have lost jobs from partying. One of them lost his kid. And deep down I know they're sad because they didn't do shit for themselves. They missed something in their life and they know it's too late. So they just wait for the weekend. Wait for that moment to come again. And it always comes again, for two or three more days. But it never lasts. Because Mondays exist. You wake up and you're like: 'Oh shit, it's over.' But that's OK, because in five days it starts again. Then one morning you wake up, and seven years have passed. And you're twenty-five. And you still haven't gone back to school."

BERLIN, GERMANY

"He had a heart attack at the office. He was only forty years old. We'd left the house together that morning, but he never came home. I was in shock. They told me to cry but I couldn't. I lost so much weight. My children were still so young and I knew I'd have to fight alone. I'd let my husband pamper me for my entire life. We were always together. There were so many things I didn't understand because he'd taken care of everything. He'd always driven us everywhere. I'd fall asleep in the car the moment we got on the highway. So I had to learn to read maps, and figure out directions, and how to wait for the bus. It made me so nervous when the crowd started pushing, but I learned to push too. I learned to go to the pharmacy and wait in line. It seems so simple, but my husband had always been the one who went to the pharmacy. I had to teach myself all these things. But God made it easy for me. The time has passed so fast. I supported us by working as a teacher and I've educated both my children. Now they're teachers themselves. And my daughter is getting married this Saturday. My son is going to walk her down the aisle."

JAKARTA, INDONESIA

"One thing I love about New York is that it's constantly reminding you that it doesn't need you. It's like riding a wild horse. I wanted to be an artist, but the only work this city was willing to accept from me was to sit at a table and read tarot cards. So I did it for twenty years. I have no ability to predict the future. I told everyone that beforehand. There's no invisible hand moving the cards. There's no spirit whispering secrets in my ear. But I do believe in the cards. I believe in them like you'd believe in a poem. I believe in their aesthetics. I worked with French cards. Very old cards. Each card was beautiful, but when you arranged them on the table, they would speak to each other. They'd relate to each other. They became metaphors. I'd merely ask each person to look at the cards and describe what they're seeing. Everyone brought their own lives to the table. Their own memories. Some people left thinking they'd gotten a prediction. Some left thinking they'd gotten advice. Some left with specific ideas: the title of a song, the conclusion of a novel, I never knew. Because everyone brought their own needs to the cards. Just as we bring them to every encounter. Just as we'd bring them to a poem."

NEW YORK, UNITED STATES

"It was an easy job. You could do it drunk if you were clever. But I just got tired of the routine. I'd spend all day drinking, smoking, and practicing with my band—then I'd freshen up and go wait tables in the evening. I felt like a zombie. Like I was going nowhere. Then one day I asked the boss for two weeks off, and he said no. So I quit right there. I left everything behind. I took my motorcycle and drove to a new town. It felt like I was finally getting somewhere. Like I'd broken out of my prison. Like I was progressing. But I couldn't escape myself. I had no opportunities. No skills other than music. I tried telemarketing for a while, but I'm not that kind of person. So my life fell apart. I got evicted. I ended up in a tiny apartment. I isolated myself. I'd broken away from all of my chains, and I thought that would make me happy. But I realized that some of those chains I liked. It's nice to make money. It's nice to be trusted by other people. It's nice to be responsible for my own life. Those chains were the proof that I could take care of myself. And when I lost them, I got scared. I fell apart. It took a long time to pull myself back together, but things are better now. I've got a therapist. I'm working as a bartender. I have a great girlfriend, a nice apartment, and my own parking spot. I'm almost back to the place I ran away from."

MONTREAL, CANADA

"I quit my job earlier this year. I'm taking a little time to focus on myself. I worked from nine to six every day. I often brought my work home with me. I was getting sick, and anxious, and I wasn't sleeping well. But I could never accept my weaknesses. I'd see other people working harder than me, and I'd think: 'If they can do it, why should I feel tired?' Eventually I pushed myself so hard that I became depressed. One reason I couldn't slow down is because my entire family is hardworking. Both my parents are architects. My grandfather is an engineer. The importance of hard work has been passed down through the generations. I think our country is afraid to stop working. There have been so many hard times. There's been so much hunger. For so long we had to work all the time just to survive. Even though things are better now, that's a difficult psychology to escape. I'm starting to interview for new jobs. But I'm asking different questions. Money is the last thing I worry about. I'm much more interested in the schedule."

ST. PETERSBURG, RUSSIA

"It's looking like my dad isn't going to make it. So I'm sitting here trying to figure out what life is going to be like without him. He was my North Star. He was the chief aide to Newark's first black mayor, and president of the Board of Education. I remember being sixteen or seventeen, and attending a speech that he was giving, and the whole crowd went silent the moment he stepped up to the podium. And I remember thinking: 'How does somebody do that?' That's how big of a person he was. And seeing him get so frail really flipped me out. Two days ago I walked into his hospital room and he was unresponsive. They had him hooked up to IVs and they were draining blood from his stomach into a jar. I had to leave the room, and I couldn't go back for several hours."

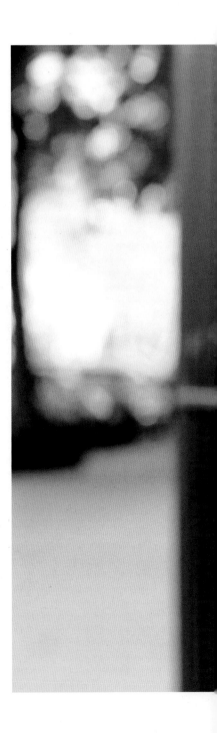

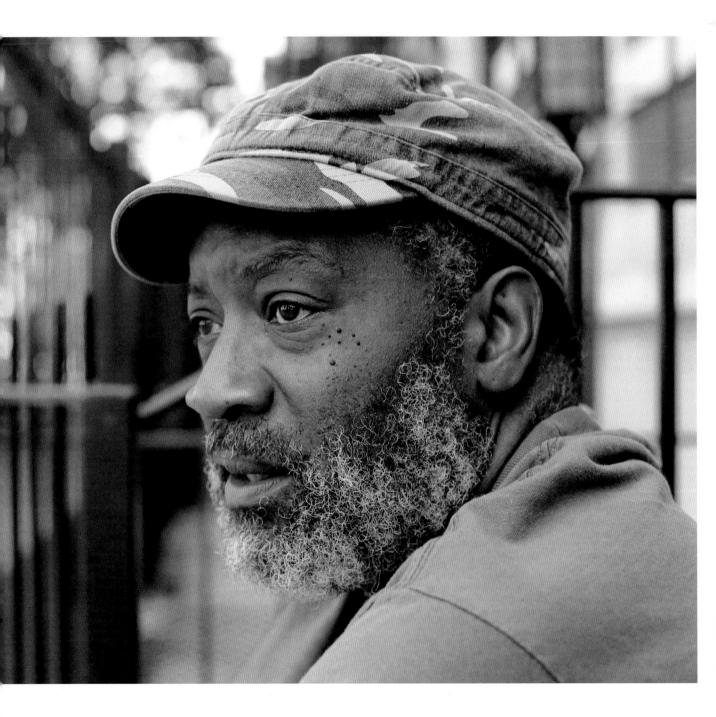

"It was so hard to get out from under his shadow. He was so known in the community that I couldn't do anything without people saying: 'That's Sharif's son.' I couldn't try and fail and be a fuckup, because it was always his name that I was representing. He lived life on his terms. That's who he was. The allure of being a public figure was always greater than the allure of being a present father. I remember him leaving the house at six a.m. and coming back at three a.m. There were a lot of times when I looked into the stands at a track meet or a football game, and there was nobody there. Only when I was old enough to join his fight did I finally start spending time with him. If he was organizing a protest against the Board of Education, my brothers and I were the ones setting up the tent cities. He once told me: 'I'd love for you to love me. But as long as you grow into a man who provides for his family and cares about his community, I don't need you to love me.' It took me a long time to stop resenting him for not providing the things that I wanted. But eventually I had to accept I couldn't choose who he was. But I could choose to love him."

NEW YORK, UNITED STATES

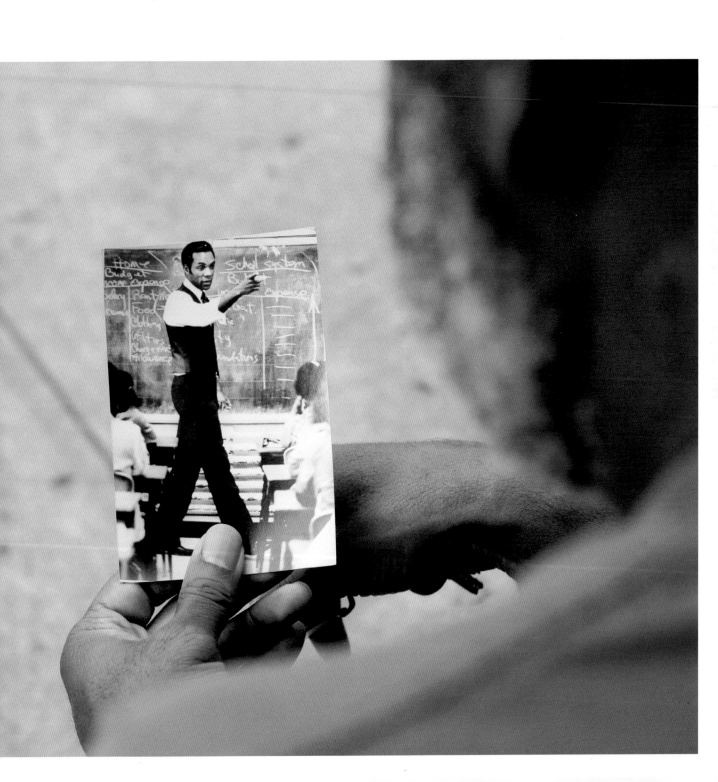

"People take you to fun places when you're five, but unfortunately you also have to study difficult topics. Today I had to write 'toothbrush' in all capital letters."

MADRID, SPAIN

"I thought it was a blessing at first. All my insecurities suddenly disappeared. I was writing Facebook posts in the middle of the night. I had always been so shy, but now I could talk to strangers about God. I felt like a prophet or something. I began acting strangely at school. I told my students to pretend like we were the crew of a spaceship. I took them on strange field trips, and gave them strange assignments. Eventually there was an embarrassing incident that I don't even want to talk about. But I had a delusion, and I ended up damaging the property of a student. That's when a fellow teacher came up to me, and told me that I should call a doctor. I was diagnosed as bipolar in November. They gave me medicine and I started to come down. December was a depression. I spent several months in daily care, and I'm just now beginning to get back to my life. I cut my hair. It was my way of cutting the past away. And recently I went back to school again. On the first day, I spoke at a teachers' meeting and apologized to everyone. All of my colleagues were very kind to me. I was especially afraid to meet with my students again, but it wasn't bad. They said they understood. Some of them even came up and hugged me. Yesterday I was talking to my colleague—the same one who had the intervention. And I told her how surprised I was that everyone had been so kind and forgiving. She said that everyone had known me for a long time. And they knew I wasn't myself. And that it was my right to be ill. And it wasn't my fault. And that whenever you're honest about your struggles—people will understand. And they will accept you."

WARSAW, POLAND

"It seemed like my personal failings were on display for everyone to see. I'm not all that attractive. I have a speech impediment. I'm not good socially. I saw other guys having romantic success and I felt a lot of envy. I concluded that women owed me something. They owed me a chance. And I was angry they weren't giving it to me. I'm ashamed of it now, but during that time I formed a lot of bad and hateful opinions. I joined 'incel' communities on 4chan and Reddit. I found a lot of men there who felt just like me. The community provided this pseudoscientific justification for hating women. It let us feel like it wasn't our fault. We stoked each other's anger. And it felt good. Honestly, anger is just very addictive. You want to feel angry when you're suffering. It gives you adrenaline. It gets your endorphins going. It's a release. It's a substitute for what you're missing."

NEW YORK, UNITED STATES

"I was like an 'incel' kid. I'd never had a girlfriend. I'd only had sex with prostitutes. I was very suicidal. Then one day I was standing next to a cute girl at a bus stop, and I googled: 'How to approach women.' That's when I came across a forum for pickup artists. It's exactly what I'd been looking for. It seemed like a cure for my autism. I watched all the videos I could find. I started working out at a gym. I'd spend all day approaching women. Soon I was only hanging out with other pickup artists. They respected me. They wanted to learn from me. Finally there was something I was good at. Right now I have over one thousand numbers in my phone. It's a bit like gambling. Sometimes it goes well. Sometimes it doesn't. But you always have the chance for sex. There are so many tricks to learn. Women have emotional brains. They get addicted to feelings. You can use that to your advantage. The first time you meet her—tell her she looks amazing. But never give her a full compliment again. She'll always chase that validation. It's like a drug. Tell her 'she looks beautiful for her age.' Tell her 'she looks good in this lighting.' Keep her insecure with half compliments. Keep her feeling like there's something wrong with her. Like she's not good enough for you. Like she needs sex for validation. Of course it's manipulation, but why should I care? I've been manipulated so many times in my life."

AMSTERDAM, THE NETHERLANDS

"It was the summer between eighth and ninth grade. We were make-out buddies. Sometimes he'd talk to me during the day. Other times he wouldn't. We were in his basement late one night, getting drunk, and he kept asking me if I wanted to do it. My heart was racing and I was terrified. I kept saying: 'Maybe,' 'Maybe,' 'Maybe.' Then he said: 'No more maybes. Let's flip a coin.' My stomach sank. After we finished, he said: 'I think I heard my dad upstairs. You need to leave.' I went home and filled up a whole page in my journal. I wrote in purple Sharpie, over and over: 'It didn't happen.' For the longest time I felt like it was my fault for feeling hurt. Like I was being overly sensitive. It took five years for me to realize that consent is not a coin flip."

NEW YORK, UNITED STATES

"I met her on Christmas Eve, 1984. I had a band in Kingston, and we were playing at a big, fancy hotel called Golden Seas. The hotel had given us little cottages to live in at the back of the property. And that's where I first saw her. She was doing her chores. And right away my eyes got busy. Her name was Hyacinth, which means beautiful flower. She was poor like myself. But I told her that I'd make it big one day. From day one I was promising her that she'd have the big life. A real big life. A nice, beautiful house. And a whole ton of money that she couldn't finish. And whenever I said it, she'd always just smile. In a humble way. A soft way. I know she was looking forward to it—just like me. But in thirty-five years of marriage, she never pushed me. If I couldn't find a job, or things didn't work out, she never took issue with it. She was never demanding. And that made me want to succeed even more. But it never happened. We found out she had cancer in April, and by then it was too late. I'm all alone now. I've lost my friend. And I've lost my motivations—the success that I was hoping to enjoy with her. It never materialized. I helped her with the chores, and the cooking, and raising the children. But I couldn't give her the easy life. Before she passed, I told her: 'Hya, I always wanted to give you all the good things. So much more than what we had. I'm sorry I haven't been able to achieve that yet.' And she replied in a humble way. In a soft way. Something we always say in Jamaica: 'Ah suh it guh.' And so it goes."

MONTEGO BAY, JAMAICA

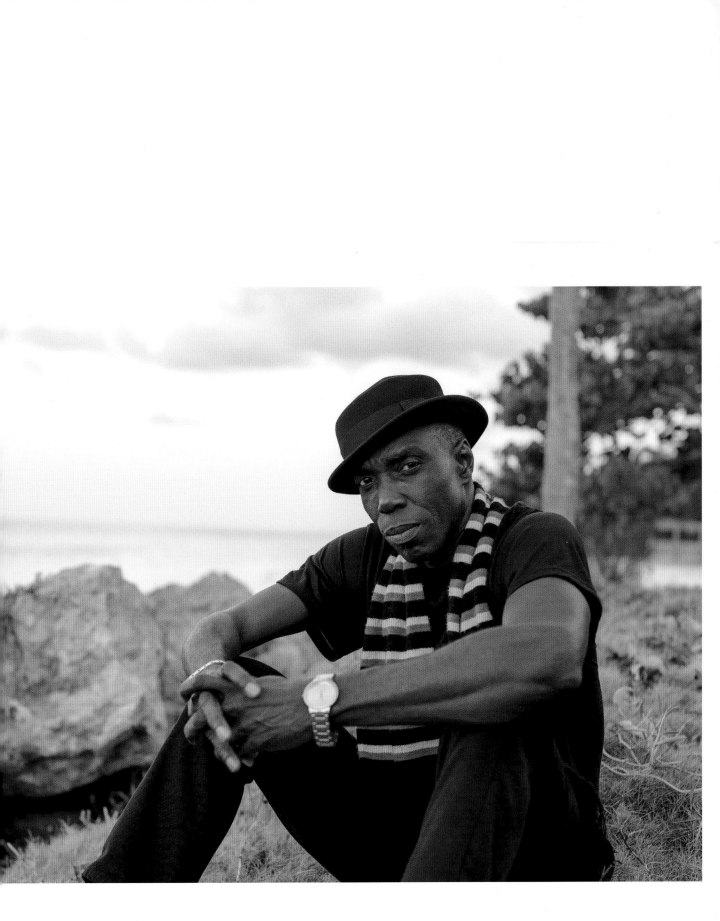

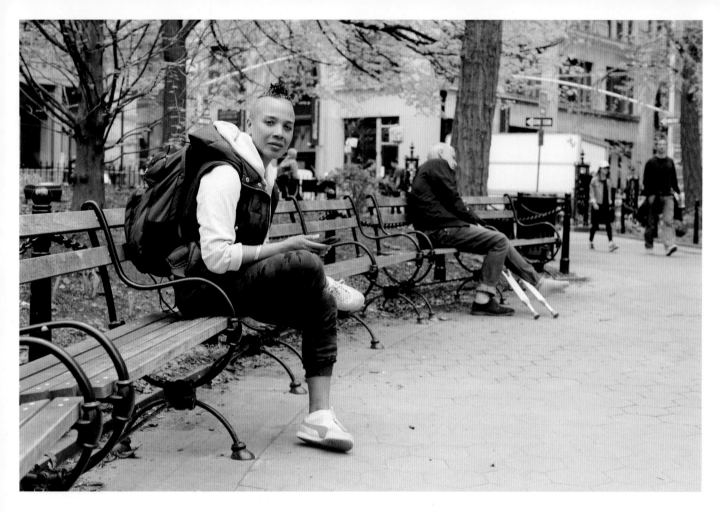

"I've always believed in heaven. But it was so hard to lean on that understanding after my father passed away. I was a daddy's girl. His death was an emotional clusterfuck. I could close my eyes and imagine he was somewhere else. But for the first time in my life, I couldn't pinpoint his location on a map. And even though I'd taken an astronomy class in college, I couldn't find him with a telescope. His absence was so much more real than I thought it would be. And it really shook my beliefs. I had to form a deeper understanding of what exactly 'heaven' means. And I'm still working on that."

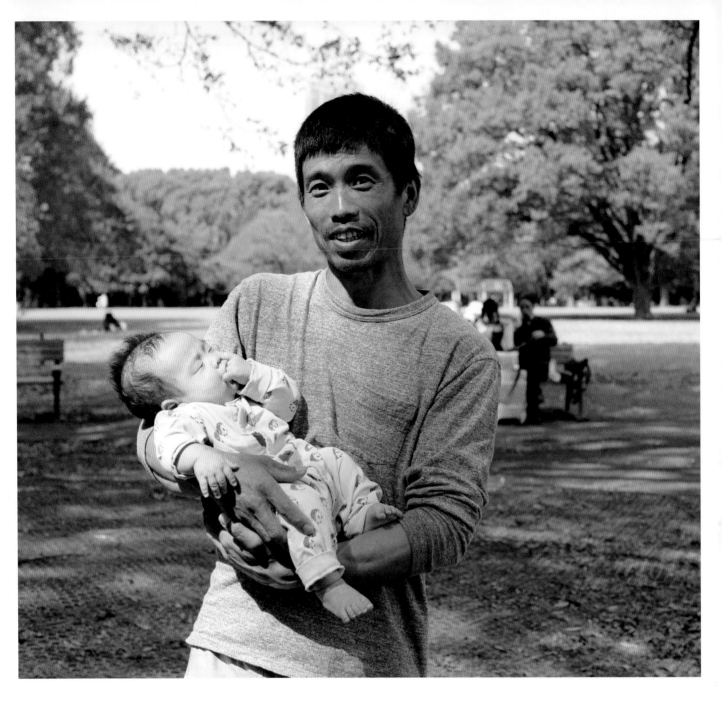

"In a lot of ways he's just like an animal. He doesn't seem to have many thoughts. Only whether he feels good, or doesn't feel good. He seems so simple. But there was a time when he was only a month old, and it was just me and him, and I looked over, and he was making an expression that I couldn't quite place. It seemed reflective. Almost melancholic. Like an old person makes when they're thinking back on their life. And I wondered: 'Could he be remembering something the rest of us have forgotten?'"

"I'm ninety-six years old. I'd rather just take a pill and get it over with. Whenever I tell that to my wife, she pretends to slap me in the face. But I'm ready to go. And I'd like it to be sudden. I've had a good run. I was lucky enough to share my life with someone. She's ninety now. We've had a lot of time together. We have seven grandchildren. Eight great-grandchildren. But there are just so many things I can't do anymore. I have the money. I have the time. Just not the ability. Whenever I walk, everything hurts. I enjoy sitting here in the park. I think about all the friends that I've lost. People come talk to me. Time passes by. But I'm ready. I'm not scared of it. I'd like my soul to go to wherever the souls go."

BARCELONA, SPAIN

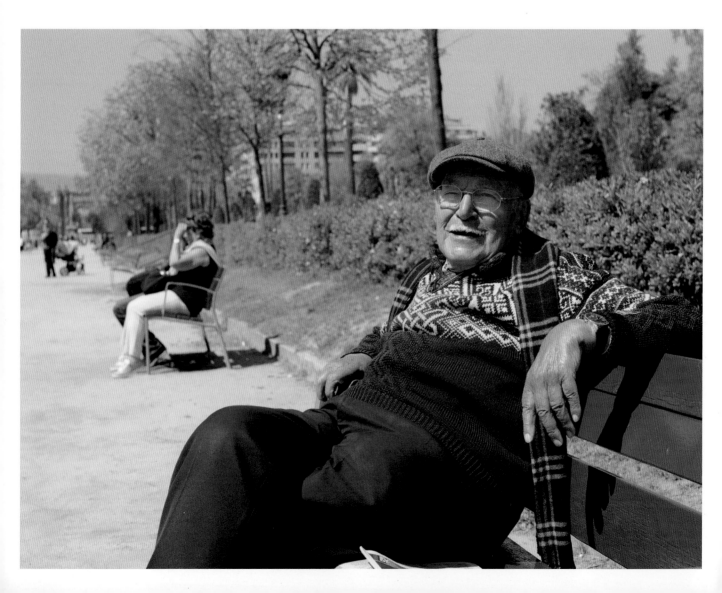

"We're praying for the souls of our ancestors."

JAMMU, INDIA

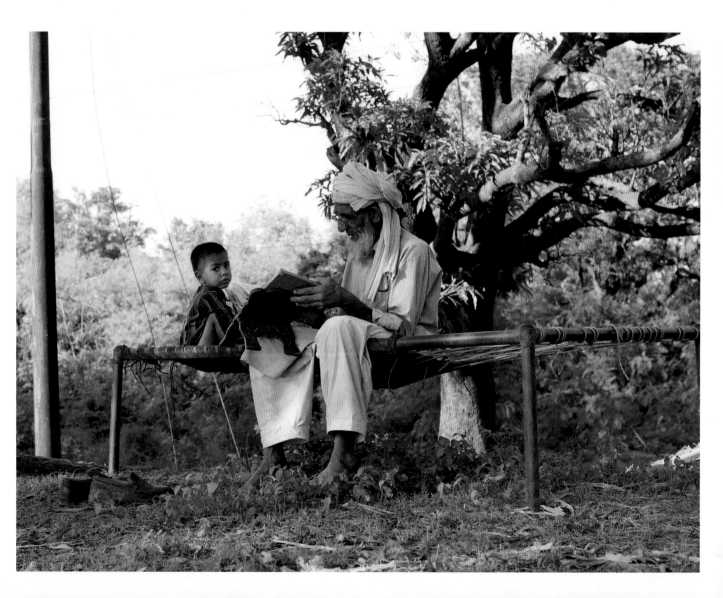

*She initially said no when I asked for a photo,
but another old woman walked by, and began
speaking passionately in Ukrainian. Apparently
convinced by the words of the passerby, the
woman shrugged, and posed for the picture. After
everything was finished, I asked my interpreter:
"What did that other woman say?"*

She said: "You must not refuse a photo,
because you must represent the women of
your land. Now go to eternity!'"

ODESSA, UKRAINE

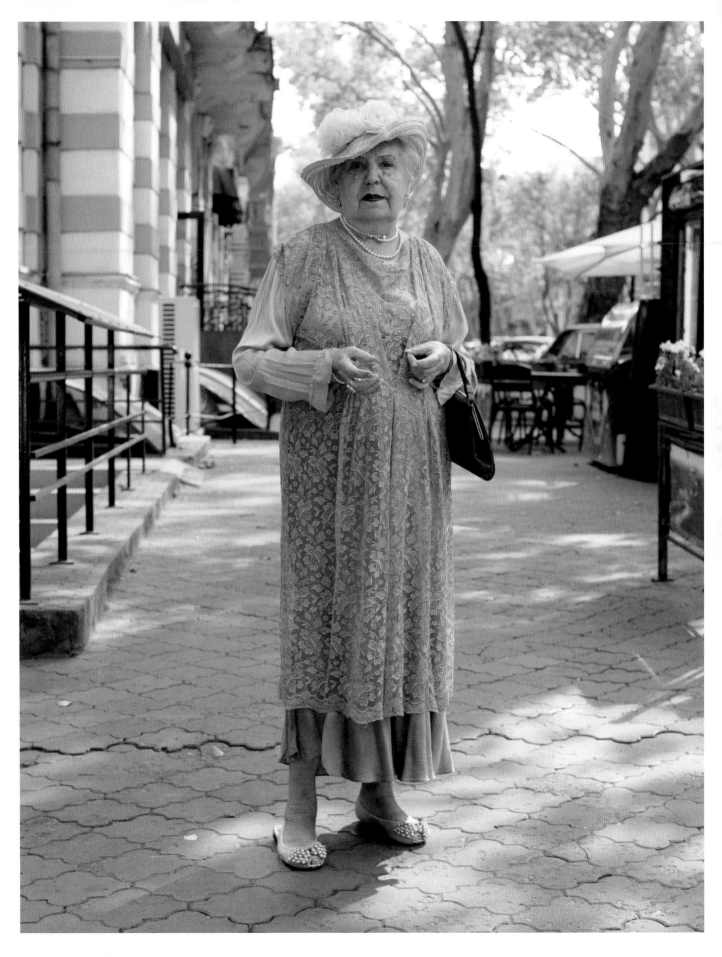

"I want to live a happy life. I'm tired of living a poor life. I'm trying to save money for school but nothing is working. I've left home three different times looking for work. The first time I found a job as a housekeeper. But every morning when I got dressed the man would try to touch me. I was only seventeen. He wouldn't even stop when I threatened to tell on him. His wife blamed me for his attention. She beat me severely. There were bruises all over my body. She didn't even allow me to eat. But I tried to stay because I wanted to go to school so badly. Then one morning he tried to rape me in the bath, and I finally ran away. When I found a new housekeeping job, the same thing happened. This time it was a pastor. I don't know why this always happens to me. It makes me so angry. I get mad at my parents for being poor. I get mad at my friends for going to school. When I see their graduation pictures on Facebook, I just start crying. I'm already twenty years old. I should be finishing school, but I haven't even started yet."

LAGOS, NIGERIA

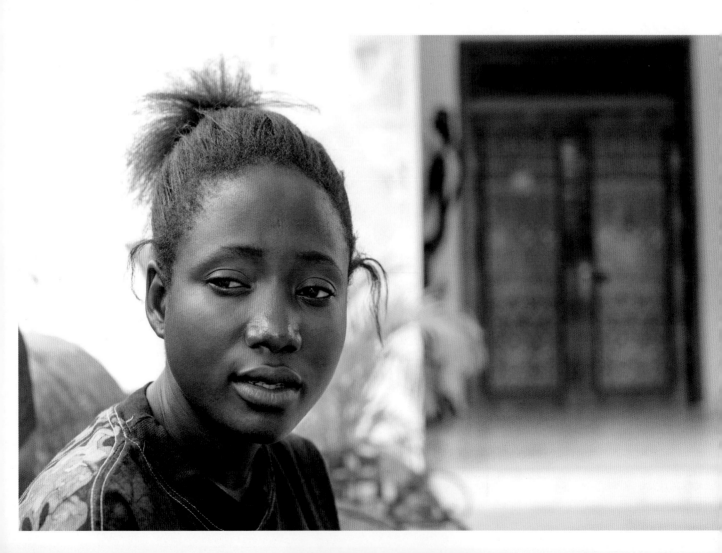

"It was early in the morning when the military came. I woke up to a big sound that sounded like a bomb blast. Then the shooting started and everyone was screaming. We ran for our lives. It was dark and there were people running all around us. It only took us thirty minutes to get to safety because our village is close to the border. But then some of us decided to go back. There were five of us. We were curious. We wanted to see what happened to the others. We crawled on our stomachs to the top of a hill, and looked down at our village. There were so many dead bodies. Some of them were my cousins. I saw a girl from school with three soldiers kneeling on top of her. They were covering her mouth so she wouldn't scream. I felt so dizzy. I couldn't stand up. I used to have a dream that I was going to grow up and help my family. I was studying hard. Now I don't even know why I'd want to live in this world."

ROHINGYA REFUGEE CAMP, BANGLADESH

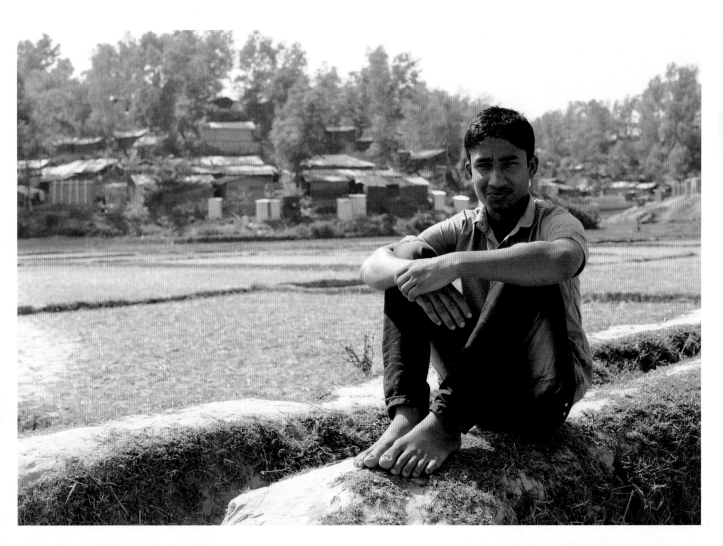

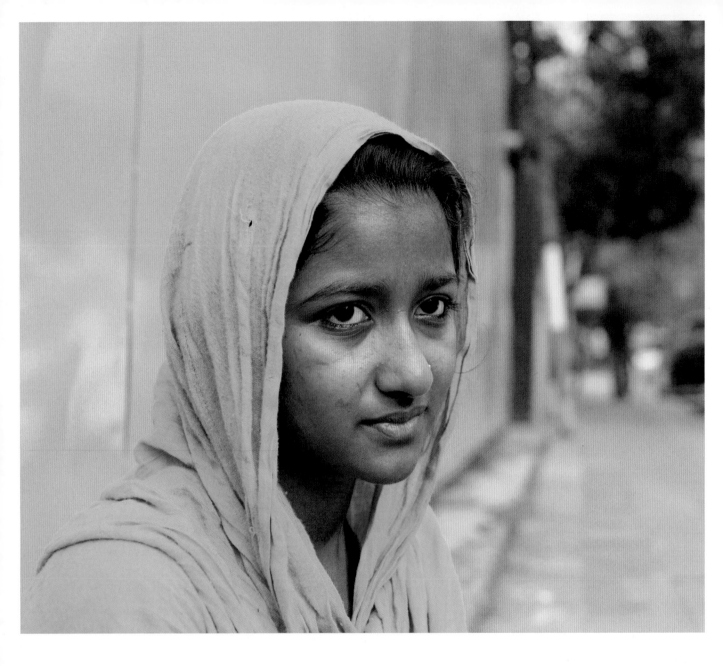

"I always sat in the first row. I always had the highest rank in class. I wanted to be a teacher, just like my teachers. But when it was time to enroll in grade seven, my mother told me we couldn't afford it. I cried and begged but she just stayed silent. My teachers were so sad that they offered to pay half of the tuition. But it wasn't enough because we'd still have to pay for the books and exams. So my mother made me understand that school was not in my luck. I'm still seventeen, but now I'm married and I work as a maid for a family. I wash their clothes, wash their dishes, clean their bathroom. Their house is near a school. So every morning I have to watch the children walk by in their uniforms."

DHAKA, BANGLADESH

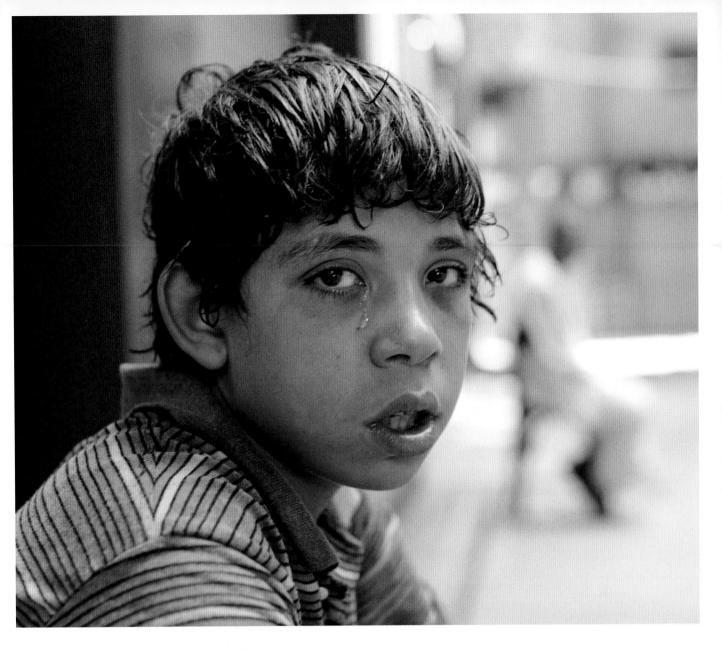

"My mom is in prison. I see her every fifteen days. My siblings take me to visit her, but then they leave me when it's over. My grandmother doesn't want me. My uncle beats me up. I have nowhere to live. The only person I have in my life is my mom. Every time I visit, she asks me if I'm staying with relatives, and I tell her: 'Mom, nobody wants me. I have no one.' I sleep on the street. I can't go to school. I just hang out with the older kids. Sometimes we wash cars together for money. Last week I was washing a man's car and he bought me clothes and food. He told me I could sleep at his house. So maybe I'll start going there."

CAIRO, EGYPT

"My parents divorced in the eighties, and my father assumed all the children would come running to him. He was a prominent person. He was an honorary chief in two places. He had his own radio show. There were books in our house with his name on the cover. So he assumed all of us would take his side. But it never happened. I was the only one who tried to maintain a relationship. Now he's in his seventies. And he's fallen into this space where he doesn't have the clout or visibility that he did before. For his entire life people have listened to him. We always had important visitors in the house. But now he's lonely and he's not handling it well. He's got like four different Facebook accounts. It's bad. He's posting a lot. He's openly complaining about my siblings. He's sharing memes. He's even 'liking' his own stuff. And leaving comments. In all caps. I don't know if he can't see what he's become, or he just doesn't care."

LAGOS, NIGERIA

"They've been together since they were my age. But ever since they decided to separate, I've noticed that a light seemed to dim in my dad. And a light seemed to grow in my mom. I just don't think that Mom felt she could grow with him anymore. Mom was always the practical one. Dad was always the dreamer. He was the one who played games with me, while Mom was the one who helped me with my homework. Mom recently went back to school and got a new job. Dad is still hoping that his art will get noticed. She thinks he needs to be realistic. He thinks she lost hope too early."

NEW YORK, UNITED STATES

"Before education, my family only knew how to work. It was always very quiet in our home. My grandfather was a laborer, but he paid to send my father to a tutor so that he could learn to read. He said that, if nothing else, my father should learn how to read and write his name. After I was born, my father used this knowledge to teach me how to read. I started with local newspapers. I learned that our village was part of a country. Then I moved on to books. And I learned that there was an entire world around this mountain. I learned about human rights. And now I'm studying political science at the local university. I hope to be a teacher one day."

HUNZA VALLEY, PAKISTAN

"I grew up in Russia. My mother was a severe alcoholic, so I spent my entire childhood in a home for troubled children. Some of the kids were violent. A lot of times there wasn't enough food. On the weekends my grandfather would pick me up and bring me to see my mom. But she was always so drunk that we'd never speak. I had plenty of opportunities to be adopted over the years. Families would visit the orphanage from all over the world. But I always said no. Because my father was still alive. He was in prison but he was still alive, so I always imagined that eventually he'd come for me. Then one morning when I was nine years old, I woke up and my father was there to bring me home. It was the happiest moment of my life. I finally thought we'd be a family again. But my joy only lasted for a few days. Because he went back to doing criminal activity. He began to drink heavily. And soon he was beating my mother. After a few months he abandoned us and I went back to the orphanage. On Christmas Day they told me he was dead. After that I had nobody. My teacher became like a mother to me. Her name was Anna Mihailovna. I'd be a criminal without her. She brought me little gifts to comfort me. She encouraged me to read and paint. She showed me the right path. But she made me promise: 'The next time you have a chance to be adopted, you must accept.'"

"I remember it perfectly. An Italian couple walked into our classroom while taking a tour of the school. They weren't even looking to adopt. Their friends had come to adopt one of my classmates, and they were merely tagging along. I was scared of them at first. But Anna nudged me to the front of the class. She encouraged me to give them one of my paintings. And the next day the orphanage director called me to her office. She said the Italian couple wanted to speak with me. They talked to me for an hour, and at the end they gave me a bag of oranges. I handed them out to all the other kids at the orphanage. I think the couple was touched by this, because that's when they invited me to visit Italy. Anna prepared all my documents. I ended up staying with the couple for several weeks. They brought me all around Italy. I could tell they were friendly, but I was still frightened. They lived in such a big house. They were giving me so many things. And I couldn't understand a word they were saying. I had no idea why they cared about me so much. They told me they wanted me to stay and join their family. Anna begged me to do it. She told me that this was my chance to change my life. But I was so scared. All my friends were at the orphanage. So I told the couple no. When I went back to Russia, I lost the backpack with their contact information."

"My behavior grew worse over the years. I became a troublemaker. I got in fights. And when I turned seventeen, the director kicked me out of the orphanage. Anna cried. She didn't want me to leave. But thankfully she'd prepared me well for life. She'd taught me to do little jobs like washing dishes and cleaning. She'd taught me right from wrong. She showed me affection. She knows what she did for me. She knows it was her. Every Christmas, every birthday, every women's day—I reach out and tell her that it was her. I joined the military after leaving the orphanage. After serving for a few years, I began working the night shift in a bread factory. Things were going OK. It was a decent salary. I bought a car. But I wasn't moving forward in life. My first girlfriend dumped me. I fell into a dark place. Then one night I opened a very old book from my childhood, and a phone number fell out. It was the number of a young boy that I'd met during my trip to Italy."

"I called the number immediately. I didn't speak any Italian. But I kept repeating the names of the Italian couple, and I gave him my phone number. The couple called me back the next day with an interpreter. They told me they missed me. They said they'd been worried about me. I told them I was finally ready to change my life, and they said: 'Enough with Russia. Come live with us.' So I came to Florence. And when I arrived, they introduced me to everyone as their son. It was a whole new world. A whole new life. That first night my father sat me down, and he said: 'I understand you're afraid. But you're part of our family now.' I have a mom and dad now. I have a brother and sister. I have aunts. I have uncles. We celebrate things together. I'd never celebrated Christmas before. I was twenty-three and I'd never even had a birthday cake. But now we celebrate all of these things. And we share sad things too. We go through things together. These last few years something deep down inside me has changed. I'm more open. I'm more caring. I don't really believe in God but there's got to be something. I don't know how any of this was possible. There is no one in the world like my mother and father. Now I want to enlarge our family. I want to have children of my own. And I want to tell them everything that happened to me."

FLORENCE, ITALY

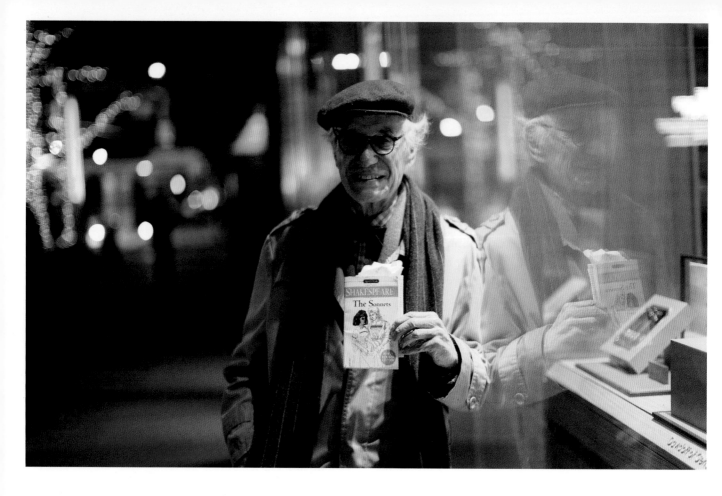

"I'm reading Shakespeare's sonnets, so you've caught me at a time when I've been thinking a lot about love. Its definition is elusive, which is why we write about it endlessly. Even Shakespeare couldn't touch it. All the greatest love stories just seem to be about physical attraction. Romeo and Juliet didn't know if they liked the same books or movies. It was just physical. But after sixty-two years together, it becomes something different entirely. My wife passed away in January. And she used to say, 'We are one.' And believe me, she was not the type of person to overstate something. Now that she's gone, I realize how right she was. So much of our lives were linked. We were very physical and affectionate. But we also shared every ritual of our life. I miss her every time I leave a movie and can't ask for her opinion. Or every time I go to a restaurant and can't give her a taste of my chicken. I miss her most at night. Because we got in bed together at the same time every night."

NEW YORK, UNITED STATES

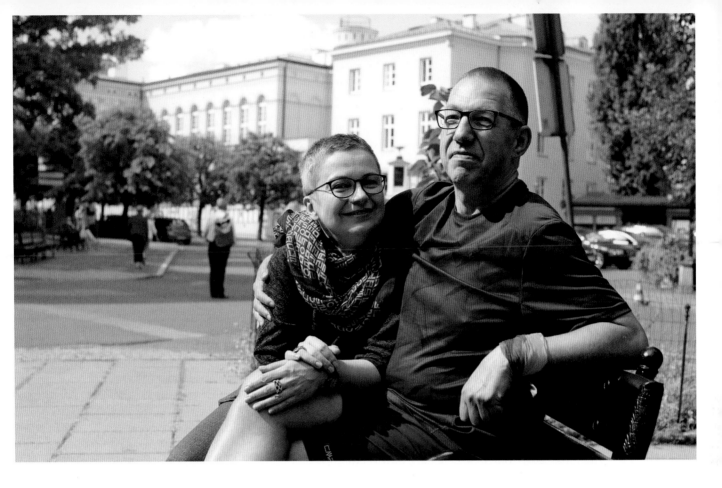

"Her name is Dobrochna, which means 'The Good One.' And few names in Polish are so literal. She trusts everyone the moment she meets them. She wants to believe the best about the world. She's wise, she's funny, she's sexy. And we think alike: I finish her thoughts, she finishes mine. Sometimes it seems like we're a whole being. Whenever she's not at home—if she's presenting a paper at a conference or something, my life changes to functioning. I get up, I cook breakfast, if I'm bored I might go to a gallery or a concert. But to be honest, I don't really enjoy these things. My only pleasure is that I'll tell her later what I saw. I feel like nothing else could exist in the world, and the two of us could be fine. We move here, we move there, we visit new places, we meet new friends, and all of them are wonderful and wise and clever, but with all respect and love—they are temporary. I could survive without them. But I couldn't survive without her."

"Her tumor had a very complicated name. Many words. At first they told us three to five years, and that it wouldn't be painful. We tried to keep living. We tried not to think about what could happen, and just function as normally as possible. It wasn't so bad when we were together. But the alone moments were wrenching. When we were falling asleep. Or waking up. On the one hand it's dark and silent and you feel calm. But there's always this gaping hole of fear in front of you—that the most important thing in your life might end. During the day you can cover it up. You can get busy, and focus on work, and think about other things, but the moment the distraction passes, and it's night, and quiet again, the gaping hole returns. It's always there, waiting for you."

WARSAW, POLAND

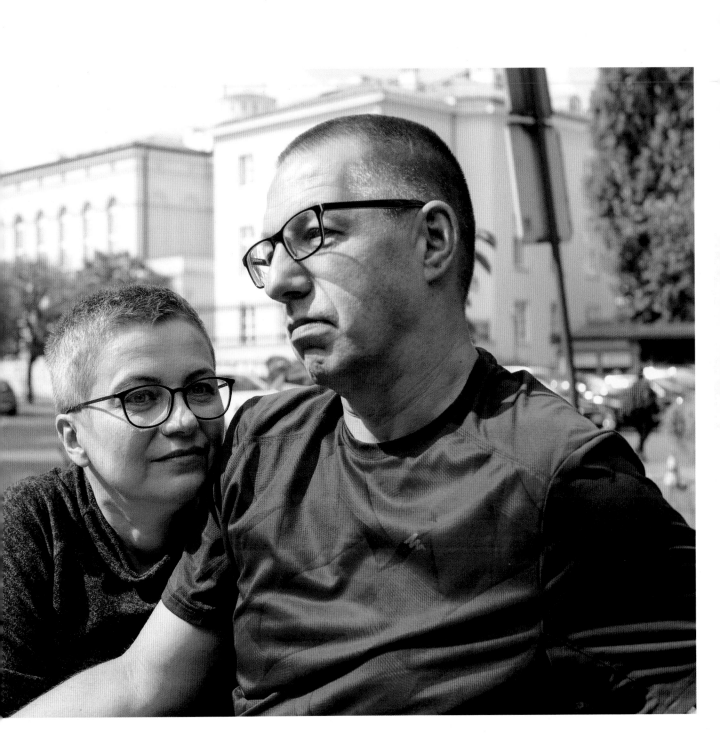

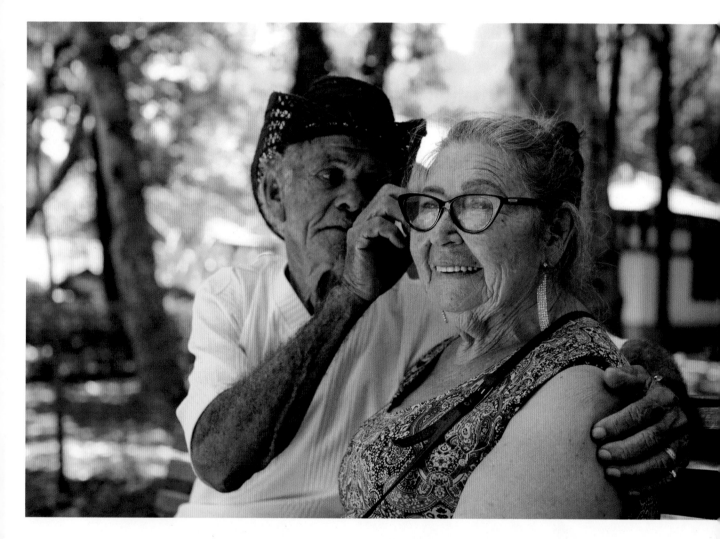

"Both of us are widowers. We met last year at a dance for seniors. He treats me so much better than my husband ever did. My husband treated me like a stray dog. He used to beat me. He'd get angry, and yell, and break things. He'd always say that I'd never meet someone else. But this man is different. He always tells me that he loves me. He always wants to be with me. He makes me feel like a princess."

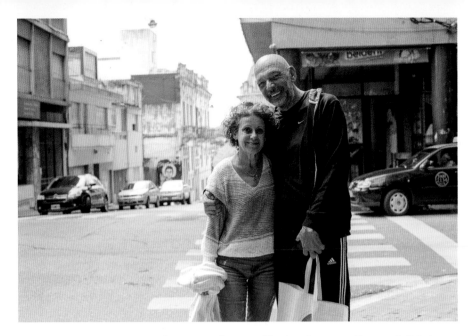

"We met on the internet four months ago. Both of us are divorced. It's been forty years since I felt this way. I'm so happy, but I'm nervous too. It's hard for me to get rid of this feeling that it won't work out well. But I chose him because he wrote on his profile: 'I'm an honest man. And I will do what I say.' I've been disappointed a lot. Every past relationship has left a scar. Hopefully this time there will be no scar."

ROSARIO, ARGENTINA

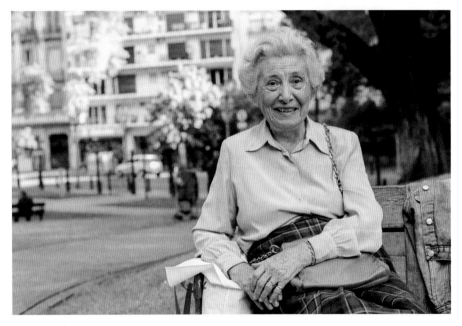

"I'm looking for a tall man. Eighty-five to ninety years old. Preferably a professional. Needs to have a good mood. But other than that I'm pretty open."

BUENOS AIRES, ARGENTINA

"My husband is ninety-two and he keeps trying to make love to me. I have to swat him away. I had seventeen kids already. That's all in the past. Whenever he gets out of the shower, he starts singing this song about a woman with long hair that he wants to kiss. He says the song is about me. I tell him: 'Nope! Not me.'"

LENÇÓIS, BRAZIL

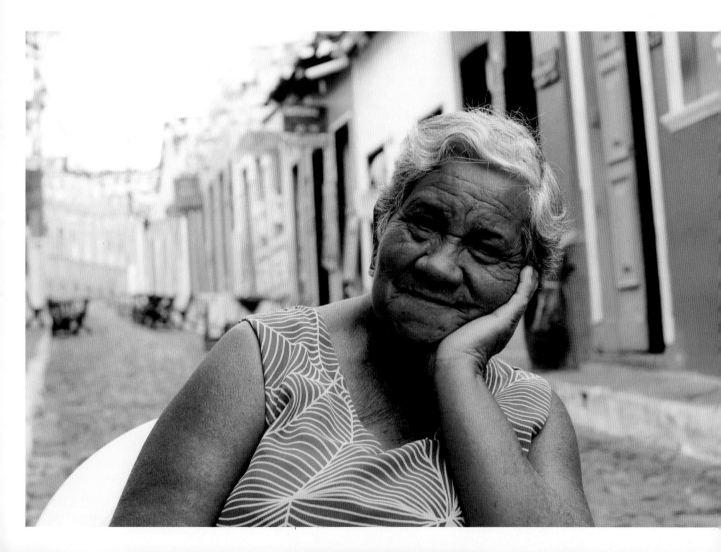

"This is my first girlfriend so I don't even know what to do. I don't know what to talk about. I don't even know how to sit."

"Shortly after we were married, I got tuberculosis and rashes broke out all over my body. They smelled so bad that I had to be cleaned three times a day. She always made me fresh food and made sure I had clean clothes every time I bathed. One morning, during this time, she asked me: 'Would you do the same if I got sick?' I promised her: 'I'll do even more.' She died a few years ago from a brain tumor. She was in bed for the last three years of her life. Toward the end, she couldn't identify people. Water from her brain would drain from her eyes. I ran home from the shop three times a day to help her go to the bathroom. I was always sure to turn her. She never had a single bedsore. In the end, the doctor told me: 'It would not have been possible to take better care of her.'"

KARACHI, PAKISTAN

"I miss that we can't go out and dance. Or visit other people. We used to volunteer at the senior center every Wednesday. She'd play the piano, and I'd turn the pages for her. The hymns were some of the last things she remembered. Music was her life. But one day she wouldn't play anymore. And I told the staff that they'd need to find someone else. So we stay here now. But I don't see this as a curse. It's an honor. This is what the Lord has given me to do. She has served this family her entire life. And now it's my turn to serve her. I might not have her mentally. But I have her. I can still make her smile. I can make bubbly noises, and blow on her, and she'll smile. Every morning we'll sit in this chair and we'll cuddle until noon. I rock this lady more than I rock my grandchildren. She likes to slip her hand under my shirt to feel my skin. And she still likes to kiss. Every once in a while she'll reach up and give me a kiss. Sometimes she starts 'yakking.' She doesn't say actual words. And it doesn't make any sense. But I never tell her to be quiet, because it's better than nothing at all."

MICHIGAN, UNITED STATES

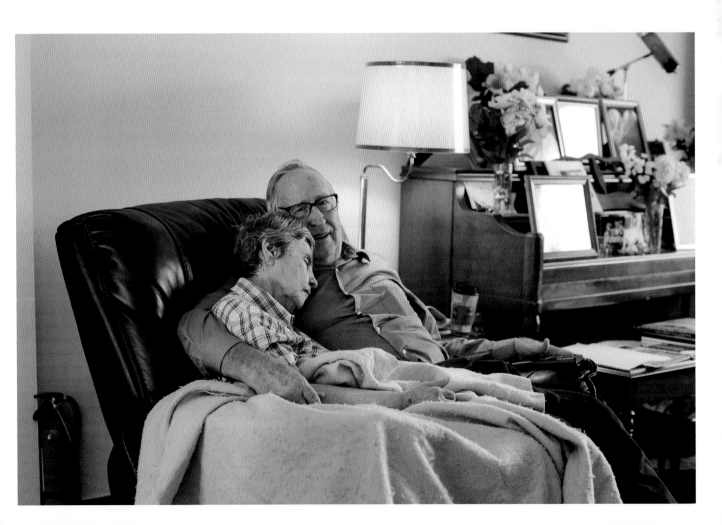

"Marriage is about two things: sexual satisfaction and building generations. Nothing more. Only useless people are thinking about love. The result of a love marriage is never satisfactory. Divorce, arguments, affairs. These things don't happen in arranged marriage. Arranged marriage is always successful. Love is for useless people. But if you're going to feel love, at the very least, make sure it's someone of a similar income level."

JAIPUR, INDIA

"My father was very strict with us. We couldn't leave the house. His workshop was across the street from our apartment building, and he'd scream if he saw us peeking out the window. It was like a prison. We'd just stay at home, make him tea and food, and watch TV. Back then it was mostly black-and-white movies starring Egyptian icons. My favorites were the love stories. But it was just a fantasy for me, because my father swatted away all my suitors. During that time I fell in love with our neighbor. He was tall, light-skinned, and wore his hair combed back. I'd wear my loveliest dresses, get my hair done, and stand outside his window. He'd always smile at me. I was pretty myself back then. I loved him. And he loved me. He told my friend that he wanted to marry me. But my father married me off to my cousin, and that's when the tragedy began. I gave birth to one child after another. I've had to work full-time because my husband is so useless. He's a total bum. But I still live next door to my first love. He has a university degree. And every time he sees me, he smiles."

CAIRO, EGYPT

"He fell in love with me because
I used to have a huge ass."

SANTIAGO, CHILE

"For the longest time it was impossible to calm her down. She was a baby you always had to carry. She hated the stroller. She hated the car seat. She'd scream for the entire journey. On the bus people would always stare at us. I tried not to pay attention, but whenever somebody expressed concern, I'd immediately pick her up. I knew that she was perfectly fine. But I was afraid of how it seemed. So I always gave in, and I sustained the behavior. Toddlers are really smart, especially Fate. So she learned that if she kept pushing, eventually she'd get her way. It wore us down. My husband and I were so tired. And eventually we had to say: 'It stops here.' The stroller was the hardest, because the rest you don't do in public. I took her to the supermarket shortly after we made the decision. And she was screaming. I kept my calm. I was wearing my headphones. But after a few minutes, a woman came charging up to me. She yanked my headphones out of my ear. She started yelling at me. 'I've been watching you for fifteen minutes,' she said. 'Why don't you talk to her? Why don't you pick her up?' Before that moment, I'd always suspected people were judging me. But it was the first time anyone had spoken up. And honestly, it was the moment I stopped caring about what others think. It's my daughter. I know that she's safe. I know that she's OK. I'm preparing her to live. To be a fruitful adult. And life isn't about getting what you want."

"I got a divorce last year. And I'm still trying to understand what happened, in a spiritual sense. The thing is—I'm a Cancer. And when a Cancer enters a relationship, we merge with that person. We see the world through their eyes. We understand their entire family history and intergenerational karma. We make them a better person by breaking down their ego and illusions. That means going on a journey to the universe inside. To the source itself. And yes, it means going a little bit crazy. But clearly he wasn't prepared for the spiritual world, because he tried to have an affair. But I knew. I could feel the bad energy. I'd been saging the house for months. And one night I logged into his iPhone, tracked him to a secluded restaurant, and found him with another woman. I pulled up a chair behind him. He was so surprised that he couldn't even explain himself. He had no excuse. All he could say was that I'm too intense, whatever that means."

SINGAPORE

"Saturn is leaving Sagittarius and moving into Capricorn today. Things that may have been otherwise will now become reality. The time for talking and thinking is over. Now is the time to do."

"I'm not looking to set the world on fire, but I need something to challenge me. It feels like I'm reaching a critical juncture and I need to make some sort of decision. Up until now I've just been floating along. I've been at the same job for a long time. I do the same things day in and day out: smoking, drinking, things like that. It's just so easy to be a consumer. It's so easy to reach for pleasure and avoid pain, so that you never have to face the future or think about getting old. I don't have anything elaborate in mind. Maybe just get out more, or move to a new place. Maybe have my son live with me for a while. I just want to prove that I can set a course and do the things I say I'm going to do. Or if I can't, I at least want to be honest with myself. So I can stop beating myself up about it."

SYDNEY, AUSTRALIA

"I just finished my first year of college. I expected it to be like a nineties movie where I'd sit under trees, read books, and meet a nice boy who'd show me his yacht. But I'm not a good protagonist. My life would be a terrible movie. I sit around in my dorm room. I sleep a lot. My grades are terrible. I got one B, but that's it. The rest were C's and D's. My parents have always been supportive, so there's nobody holding me back. I'm just not handling my freedom well. I've got to learn how to keep promises that I make to myself. The funny thing is that I hate letting other people down. Because if you disappoint other people too much, they'll turn away from you. But I have no problem letting myself down. Because I know I'm not going anywhere. I'll always be here. And I have a whole lifetime to work on my issues and bad habits. So I keep putting them off. But that's got to stop. I don't want things to get so horrible that I'm forced to change. So I'm going to join a study group. I'm starting to eat out less. I'm going to exercise more. I'm not drinking every weekend. And from now on I'm going to know my boundaries. I'm not talking to boys who treat me bad. This summer is my redemption arc."

TORONTO, CANADA

"I don't know why my mother hated me. She had a sickness that you could not see. But she convinced me that I was sick. And that everything was because of me. And that I'm a monster. She criticized everything. My way of eating. My way of speaking. My way of dressing. Anything that brought me joy—she would deny me. If I defended myself, she would hit me. I was terrified of lunch and dinner because that's when I had to face her. I spent my entire childhood alone. I just played with my cats in the garden. Or sat on the floor of my bedroom. I'd try so hard to leave my body because I didn't want to be on earth. And that's when the spirits and fairies would come to me. Even Mother Mary came to me. I was never afraid of them. They'd comfort me. I remember being seven years old, sitting alone beneath a tree, talking to the fairies. Another little girl walked up and asked what game I was playing. That's when I realized nobody else could see what I was seeing. And it's been a very lonely existence since then."

PARIS, FRANCE

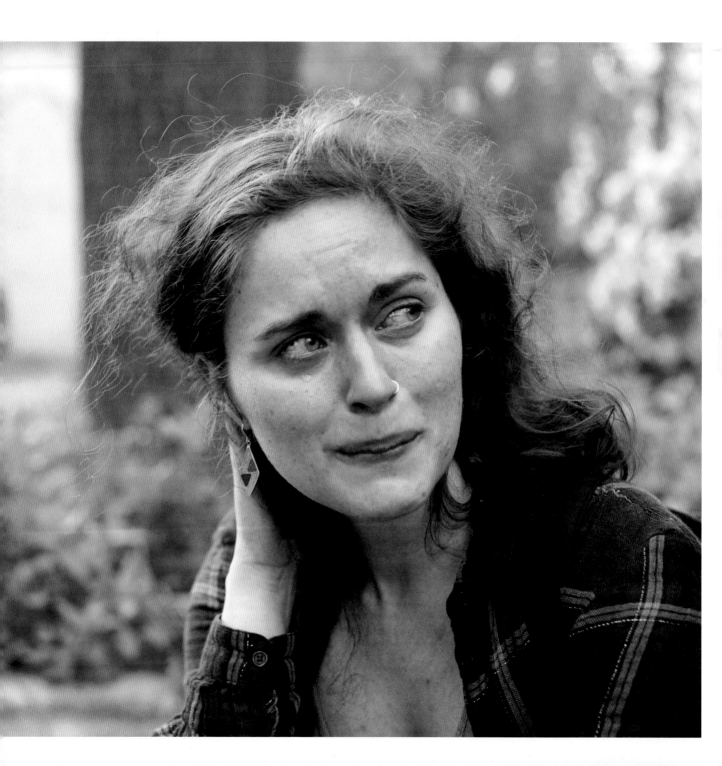

"I was almost thirty-five years old. Everyone thought I was running out of time to get married. A minister at our church decided to introduce me to a man named Hiroshi. He was a therapist living in New York, but soon he was planning a trip home to Japan. We began our relationship by exchanging letters. His letters to me were very sloppy. The stamps were crooked. The handwriting was messy. But I didn't think much of it, and we agreed that I would meet him at the airport when he took his trip to Japan. The flight was delayed six hours. I waited all day for him to arrive. And when he finally landed, he didn't even search for me! He just leaned against a pillar and started reading a book. By the time I finally found him, we had to run to catch the last bullet train. During the ride home, Hiroshi reached into his worn-out suitcase and began giving me gifts. It was nothing but junk: candies, postcards, and a folding umbrella with red whales on it. I wasn't attracted to this man at all. And his behavior was so embarrassing. He purchased a boxed lunch at a kiosk and ate it on the train. He kept saying: 'This is delicious! This is delicious!' He was speaking so loudly. I pretended not to know him. And when we finally arrived at his house, I handed him off to his mother and hoped to never see him again."

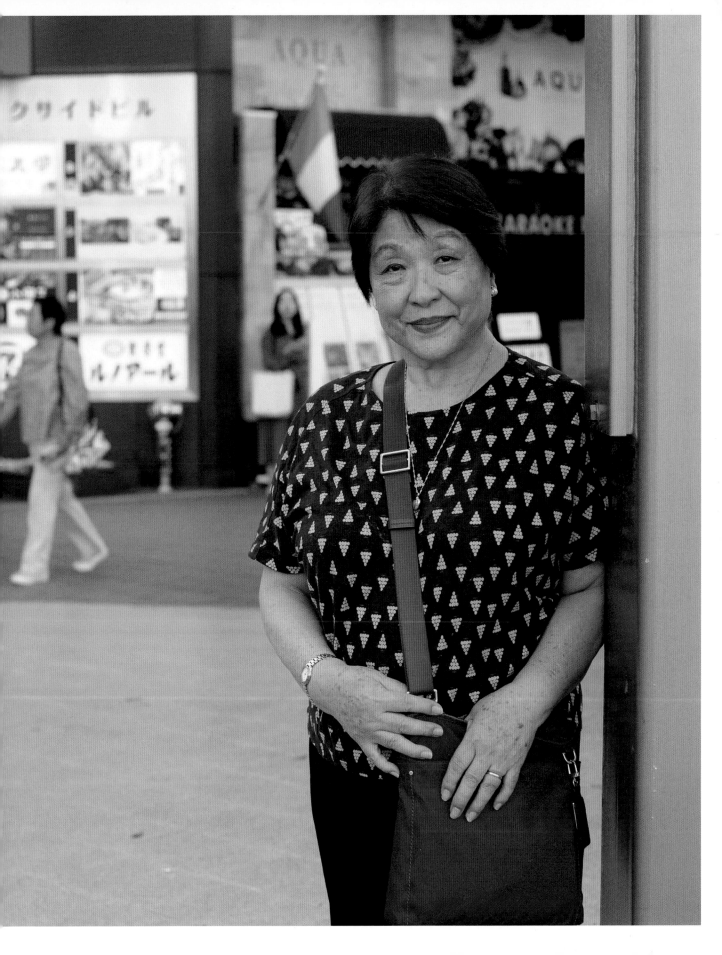

"My family was desperate to set me up with someone. So they convinced me to give the man a second chance. My brother gifted me two concert tickets, and made me promise to invite Hiroshi. We made arrangements to meet by a fountain near the train station. When Hiroshi finally arrived, he lifted a rolled-up newspaper to wave at me. The gesture reminded me so much of my father, who I very much loved. And I felt a brief moment of attraction. But other than that Hiroshi was a huge weirdo. I could barely understand him. He'd been abroad for so long that he spoke Japanese very poorly. And he was wearing this old, navy blue down coat. It looked like something from *Gone with the Wind*. During the concert he didn't even pay attention. He was scribbling in a notebook the entire time. And I think I offended him for some reason, because on the way home, he turned to me and said: 'You make me unhappy.' We parted ways with a fight. But even then my family would not give up. A few days later they invited Hiroshi over for lunch. He showed up wearing linen pants, even though it was the middle of winter. Somehow he made a good impression on everyone. During the meal, my sister pulled me into the kitchen, and whispered: 'You need to marry this poor man, go to New York, and take care of him.' So finally I relented. At the time it was traditional for the groom to exchange gifts with the bride's family. But Hiroshi didn't have any money, so he bought the cheapest pair of watches he could find. Then we went to the American embassy to register our marriage. A few weeks later we left for New York. I was so excited to see the city. I showed up to the airport in a white beret and my nicest, pink silk coat. But my happiness didn't last long."

"When we arrived in New York, I discovered that Hiroshi lived in the tiniest studio apartment. It was quite the shock. My first memory is opening the window, looking across the alley, and seeing two men shaving each other. Those first few months were nothing but hardships. Hiroshi was very demanding. I began to wonder if he'd only married me because of my background as a secretary. Once I cooked him dinner and he shattered it on the table. That night I called my sister crying. But she told me that I couldn't come home, and I needed to keep trying. There wasn't an ounce of romance. Hiroshi hated holding hands. We never kissed. And we slept on a pullout sofa with exposed springs, so even the sex was painful. Despite this poor treatment, I always pitied him. I came to know more about his past. I learned that his father had been killed during World War II. Then his mother abandoned him so that she could marry another man. Hiroshi carried deep trauma inside of him. Every night, before we went to bed, he'd insist on practicing his Japanese. Often he'd recite traditional fables, and I'll always remember the first one he told me: 'Once upon a time, there was a boy and a girl who were waiting to be born. God confided in the boy, and told him: 'I've decided to give this girl a hunchback.' But the boy begged him not to. He pleaded with God: 'Give me the hunchback instead.' So God granted his wish, and the boy was born with a hunchback. The girl grew up to be the most beautiful girl in the village. She had many suitors. But the boy was very lonely. One night he knocked on the door of the girl's house, and told her the story of how he'd taken her hunchback. She was moved to tears. And to show her gratitude, she agreed to marry him.'"

"Hiroshi was always adamant about not wanting kids. Someone at our wedding had asked him how many children he wanted, and he looked like he was going to faint. But I got pregnant three years into our marriage, and as soon as Hiroshi heard the heartbeat, he seemed to have a change of heart. He started coming home for lunch—which he never used to do. One day I was preparing soup in the kitchen, when suddenly my water broke. I was only twenty-two weeks along. It was far too early. And I noticed there was blood. I crawled into the living room, and Hiroshi carried me outside. He flagged down a Con Edison truck and convinced the driver to take us to the hospital. When we arrived, the doctor told us: 'Your baby wants to be born, but he will not survive.' After the delivery, Hiroshi saw the form of our son. We decided to name him Taro. It was the first time I'd ever seen Hiroshi cry. He was normally such a quiet person, but he stepped behind the curtain and starting screaming. He wailed like an animal in pain. Ever since his childhood, he'd lost everyone in his life. His younger brother died as an infant. His father died in war. His mother abandoned him. Even the grandfather who adopted him passed away. His entire life Hiroshi had been by himself. After we lost our child, I wanted to comfort him. I wanted to hold his hand. But he preferred to be alone."

"Two years later Hanako was born. It was the fifth year of our marriage, and suddenly everything changed. In that moment I fully became Hanako's mother, and was much less Hiroshi's wife. I'd studied child psychology, so I knew how to raise children. And it gave me more control in our relationship. Hiroshi was forced to rely on me for advice. Together we'd decide what books she would read. What activities she'd do. What schools she'd attend. Both of us loved her so much. Hiroshi was so focused on our baby daughter that when he carried her, he'd put his shoes on the wrong feet. Every night when he came home, he'd bathe her and take her on a walk. He became kinder. More considerate. Not only to her, but to me as well. If the baby cried in the middle of the night, Hiroshi would let me sleep and he'd attend to her. I grew to love him as Hanako's father. Never as a woman loves a man. But as a woman loves the person who is helping raise her daughter."

"Hiroshi passed away two years ago. Part of me felt liberated. So much of my life had been in service to him. He was maybe eighty percent of who I was. Sitting in an empty apartment, it became clear how many of my decisions were made because of Hiroshi: what to laugh about, what to cry about, what meals to prepare, what groceries to buy. When I went to the store, I was always seeking out things that he liked. It was muscle memory. Even after he died, I found myself walking down the same aisles. Choosing his favorite items. By the time I realized, I'd have to go back and return everything to the shelf. He developed dementia in his final years. He became more dependent on me. He'd get confused. Sometimes he'd go missing. On our last Valentine's Day together, he went to the supermarket and got me a heart-shaped cookie. It was the first Valentine's gift he'd ever gotten me. But he never apologized. And I wanted apologies. For the bad things. Just a simple sorry. After he died I could feel a bit of my old self resurfacing again. I returned to my hometown. I began to laugh out loud again. So loud that I could hear myself. And I began to think of all the ways my life could have been different. Would I have been happier with someone else? I thought of all my other suitors: this one was more handsome, this one had more money, this one would have been kinder. But I believe that Hiroshi was my gift and my challenge from God. He was the boy who'd taken my hunchback. Right before he died, he was in terrible pain. He kept groaning: 'It hurts, it hurts, it hurts.' I leaned down and whispered into his ear: 'I've finally realized, that my Christ was in you.' In that moment the pain subsided. The groaning stopped. And he passed away in peace."

TOKYO, JAPAN

"He's only five years old, but he acts like an old man. He was just telling us that he was tired of our immature jokes. And he doesn't even like to play. After school, he usually comes straight home and reads."

NAIROBI, KENYA

"I'm fourteen and all my friends are crazy about being grown-ups right now. They're drinking alcohol. They're smoking cigarettes. They're trying to act vulgar. They'll do anything to separate from their parents and prove that they're independent. Personally, I'd like to be a child just a little bit longer. I love spending time with my parents. I'm not in a rush to get away. I'd like these times to last as long as possible."

ST. PETERSBURG, RUSSIA

"I don't think I'm going to miss eighth grade. It's been a tough year. A lot of my friends are struggling with depression and self-harm, and it's hard for me to watch. I just care about them so much. Growing up is so hard for some people. It's such a big thing. It's your foundation, I guess. You're becoming you. It's such a big thing and we're going through it right now. Some of my friends are struggling with loving themselves and loving life. I think they forget that we're still learning. They think that they're already who they're going to be. They think they know the future. And it's going to be horrible. And they'll never be able to fix it. But that's not true because we're still changing. And we'll always be changing. Even when we're old, we'll be changing."

NEW YORK, UNITED STATES

"The crime around here is out of control. It's not even safe to walk down the street. People are snatching bags and phones in broad daylight. And it's even more dangerous when the sun goes down. It's bad for business. Our customers are being scared away. The police aren't doing anything, so we're forced to take matters into our own hands. Recently one of my customers had his car broken into. While I was repairing his shoe, we heard glass shatter. And we saw three guys running away with his laptop computer. I chased one of them down, caught him by the shirt, and began to beat him. I made him call his brothers and tell them he was about to be killed. Sure enough, they brought back the laptop. So I let him go. But the police came to my store the next day, and told me that I shouldn't have taken matters into my own hands. They said next time I'd go to jail. But what am I supposed to do? Let my customers be robbed? Soon we won't have any customers left. If police aren't willing to stop the crime, we must do it ourselves."

JOHANNESBURG, SOUTH AFRICA

"The thing we need most is security. Without security, nothing works. We are only out here playing chess because right now, in this place, we have a little bit of security. But that's just for right now—just this moment. In this country things have never been secure for long."

"Life was easy as a child. I grew up in Burkina Faso. My father was a primary school teacher and we had everything we needed. But he died when I was eleven. And three years later my mother passed away, so I became an orphan. I was left with my brother and sister. They were very young. Almost too young to remember. And we had nothing. I had to learn how to take care of them. My brother especially was very traumatized. But I swore, swore, swore: we would never leave school and we'd never be separated. I dropped out of seminary and enrolled in a technical school. I fought hard. I sold small things. I started a theater company. We were contracted by NGOs to perform educational skits in remote villages. Then I studied social media and learned how to be a community manager. I have my own business now. I help artists and organizations with their digital presence. I have eight clients. Through all of this my brother and sister have been allies in my fight. We talk all the time. Even though I'm in Europe right now, I know everything that is happening in their lives. I paid for their education. I taught them what my parents taught me. Be honest. Work hard. And never give up. The best thing to do is never give up."

ROME, ITALY

"I grew up in Spain right after the civil war. When I was eleven I was
sent to a Catholic boarding school. They fed me and sheltered me. But
they only taught me religion. They were training me to be a priest. I was
taught to fear God. I was taught to fear the outside world. I was taught
to fear everything. I left the grounds one day when I was twenty-eight. I
went to a barbershop and got my hair cut by a Frenchwoman. I had never
really spoken to a woman before. She told me I was cute. That same day
I bought a newspaper. It was the first time I'd ever bought something
with my own money. When I returned to the school, I was changed. I had
discovered freedom. I began to realize their lies and so I wasn't useful to
them anymore. A few months later I met a woman in church and fell in
love. We got married and had three children. I left all of it behind, except
for the fear. Sometimes I still feel very afraid for no reason. That will
always be a part of me."

MONTEVIDEO, URUGUAY

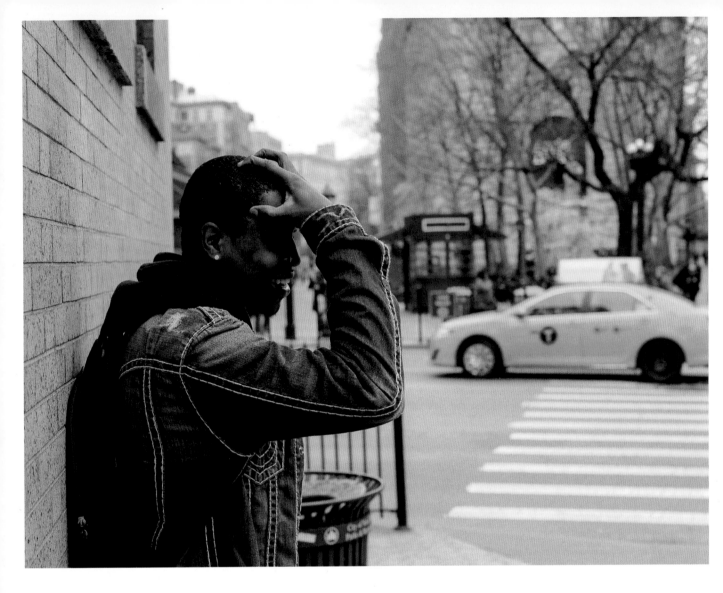

"My friend convinced me to go to church last weekend for the first time in five years. At the end of the service, the pastor told everyone to line up at the altar for a one-on-one prayer. I was the fifth in line. Everyone else got short prayers. Just a few seconds and they were done. But the pastor looked at me with a weird face. He announced that he had a vision of me getting locked up. Then he had the whole church form a circle, and he put his hand on my face like this, and he started shaking my head for fifteen minutes. He said he was trying to cancel my destiny. My friend was laughing and filming the whole thing. I've got to admit though—it's got me nervous. I'm going back this week to see if I can get some more details."

NEW YORK, UNITED STATES

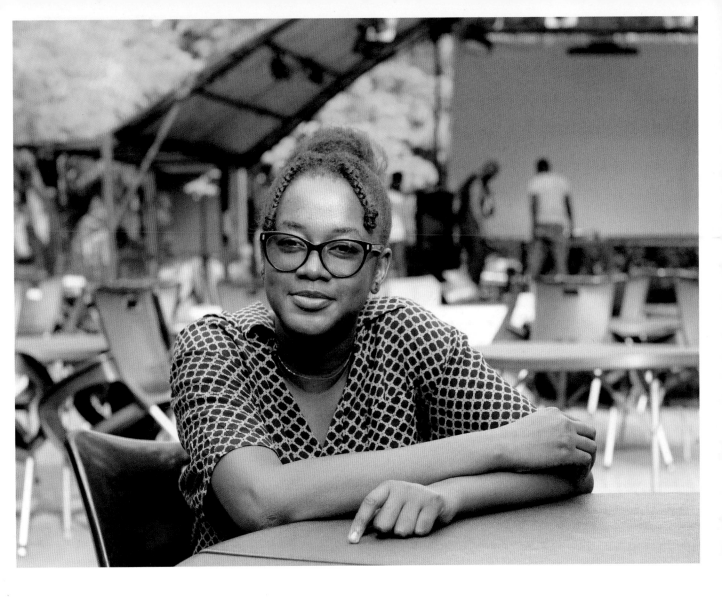

"In my church you're either Christian or possessed by demons. We have services four times per week. Luckily zoning out looks a lot like praying. I'm not saying that I don't believe any of it. I just have a lot of questions that nobody will answer. Whenever I ask a hard question, they just show me a Bible quote that says I shouldn't ask questions. It doesn't make sense to me. I think I'm becoming a nihilist. Honestly, I don't see any reason why people should be born. You exist, then you strive to attain something to make sense of your existence, and then you don't exist anymore. Can't we cut out some of those steps? It's just too much work. I didn't sign up for this. And when you finally die, instead of everything stopping, you have to become conscious again? Heaven doesn't sound that great. Supposedly there's a lot of singing and trumpets. That sounds exhausting. I'd rather be sleeping."

LAGOS, NIGERIA

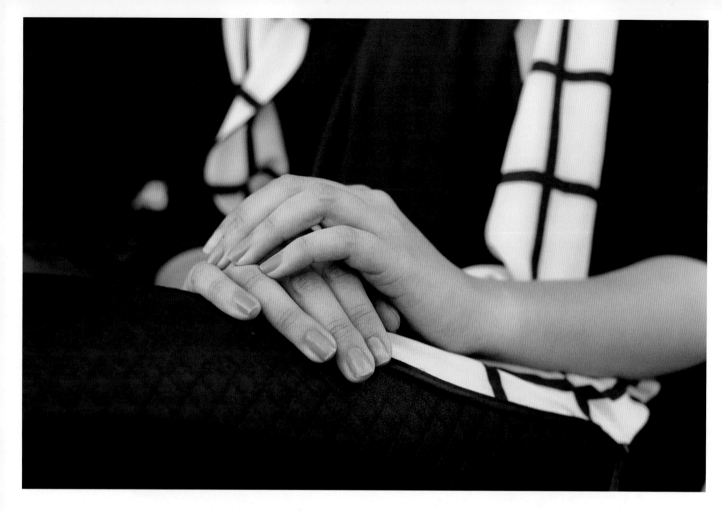

"I like to sit alone and think about the world. I wanted to be a philosophy major, but there is no philosophy class at our universities. The only class offered is Religion and Philosophy. We aren't exactly encouraged to decide things for ourselves. Any philosophy we have must be built on the existence of God. So I switched my major to physics. It still allows me to think about the world. And if someone wants me to say that a thing is true, they need to prove it with a formula."

TEHRAN, IRAN

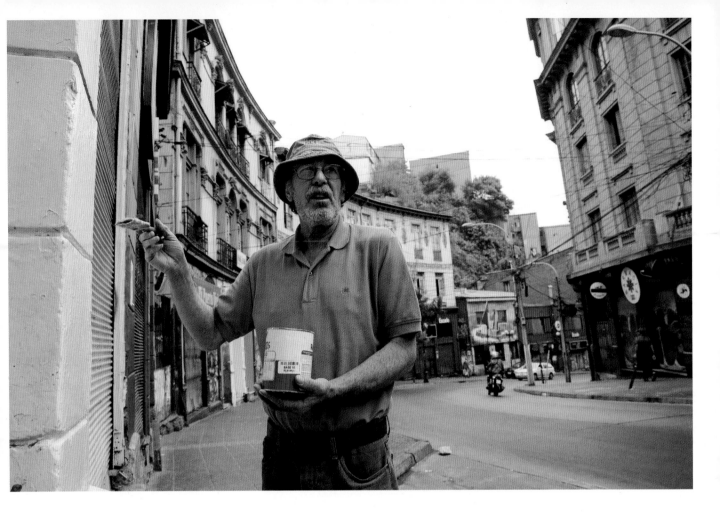

"One night I was talking with my wife about how perfect our life was. It was twenty-five years ago. We had four children. We'd just saved enough money to buy a new house. We felt so lucky. I remember she said: 'What if God takes something from us?' The next day I came home from work and found my wife screaming. She was holding our oldest son. He'd stuck his hand in the washing machine and electrocuted himself. We couldn't revive him. We rushed to the hospital but the doctors said there was nothing they could do. I begged them to try. My friends from the church came and we all started to pray. And the doctors were able to bring him back to life. He became a case study. Today he's twenty-nine. He has learning problems. He can't read or write. But he has a job as a security guard. He enjoys his life. And to this day, I believe in miracles."

VALPARAÍSO, CHILE

"I attribute my success to getting to know God early in life. Where I grew up, it was easy to go wayward. And it was risky to go wayward. Thankfully I studied the Bible enough to know the definition of sin. It taught me right from wrong. If I'd been out there trying to figure it out myself, I'd have taken too many wrong turns. I'd probably have gotten pregnant at a young age. I definitely wouldn't be an architect right now. Maybe some people can do it without God. But not many people in my neighborhood were reading books about morality and ethics. We weren't being taught the seven habits of highly effective people. But we did have the word of God. I relied on it. And it carried me through."

LAGOS, NIGERIA

"We must teach religion in our schools. We must start them really, really young. As soon as they know how to point out basic things like 'rock, milk, tree.' That is the best time to start. Not too much. Just one hour a day until they are about seven. Enough to teach them the basic prayers and Arabic alphabet. It has to be compulsory. You don't have to force them to believe. But you must force them to study. It's the most important thing in life. All of us have animal thoughts and lust. Only with God do you start having rules. Even the Christians have rules. I have a Christian relative. They pray to God as well. And the Hindus, well I don't really understand Hinduism, but they have something too. You must have a higher power. When a man lives without God, it's very dangerous. You have no reference, no principles, no precepts. You are almost equal to animal."

JAKARTA, INDONESIA

"When you're a kid, Jesus sounds like a hippie or Bernie Sanders or something so it all sounds pretty nice. But then the rules get confusing. You go to Catholic school and some guy in a dress named Brother Roy starts beating you 'cause you got in a fight. It's sorta like Gitmo in there. And you start to realize that all these rules are just to keep people down. To keep women down especially because they have the ultimate power of not fucking you. I do like the Jews because their version is less full of shit. A lot of those Talmud guys are so smart that they're practically just atheists who love fairy tales. And Buddhism is pretty cool too 'cause it's all in your head. No pope. No mandatory meetings. Anyway, let me know if you figure it out. I don't know shit. I just dress well."

"My dad is a Rasta man. He was born
in the mountains. A real, real Rasta
man. He had a marijuana farm, so we
only ate when people bought our weed.
And we never ate meat. Only fruits and
vegetables. Whenever we caught fish
in the sea, he'd make us throw them
back. There were ten of us, so we never
had a big education. But he taught us
to love people. And to love God. And
to be happy. Sometimes after school
we'd all go swimming at a place called
Pirates Cave. The land was owned by
a man named Dread Lion, and he had
lots of dogs. We could never walk across
the property so we swam the whole
way there. And if Dread Lion ever saw
us, we had to quickly jump off the cliffs.
That's how I learned to dive. Now I
dive for the tourists and they give me
tips. I save the coins in a little pan, and
pick at it when the seas are rough. I'd
like to buy a little house one day. And
maybe have a boat. And a nice woman
to take care of me. But if I don't get
all the things I want, I won't complain.
I'm going to love God the same way.
And treat people the same way. And be
happy the same way."

NEGRIL, JAMAICA

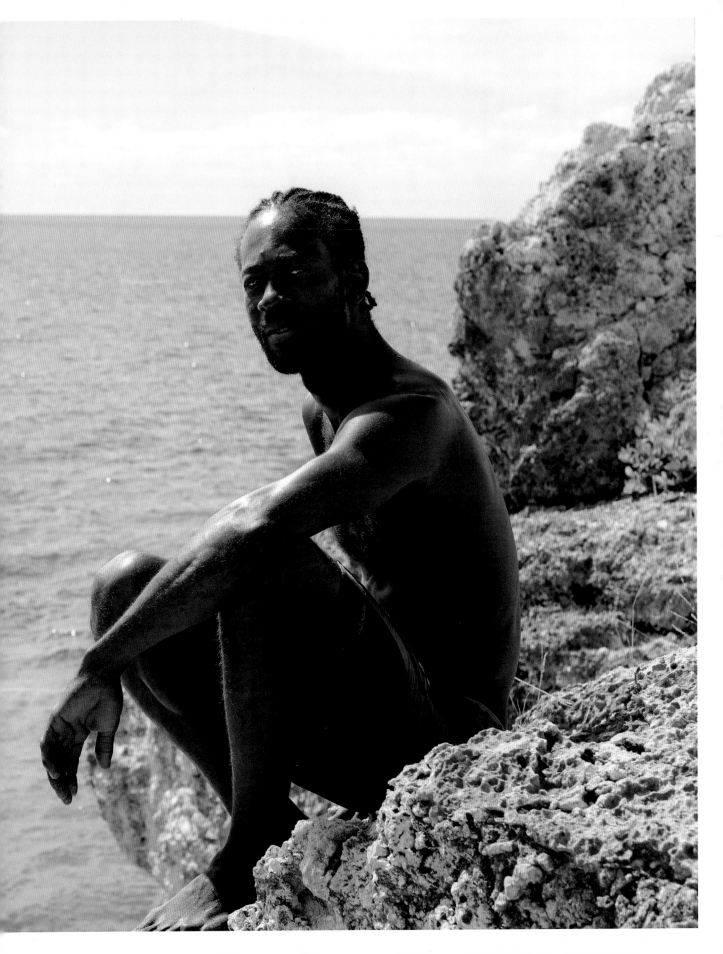

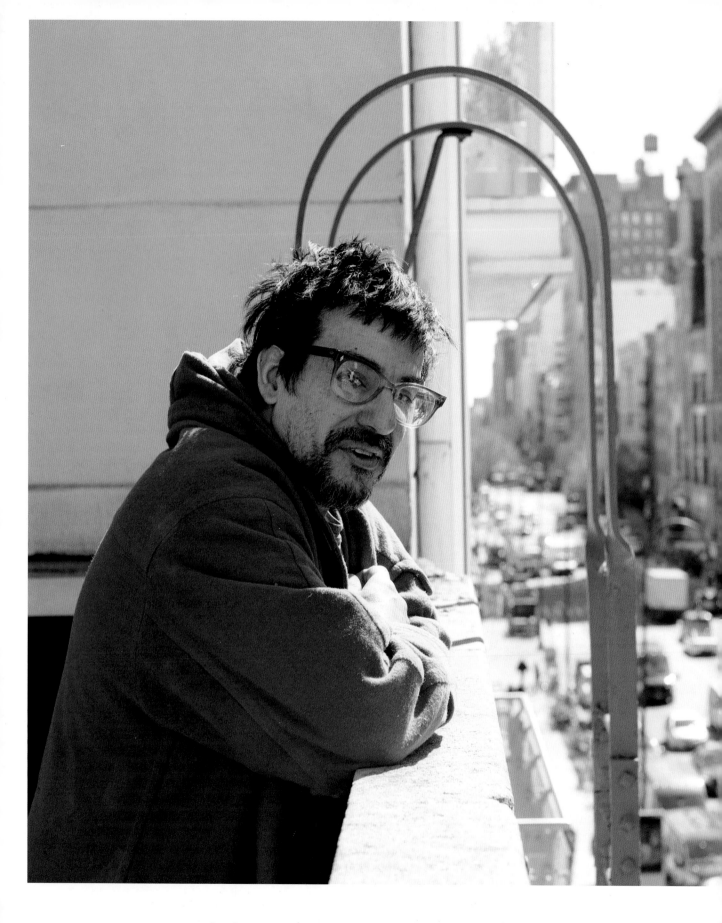

"I was raised with that Jewish intellectual worship of knowledge. But all my professors in college were small-minded nasty little bitches getting off on their own power, wanting me to parrot them while telling me they didn't. So I decided I was a nihilist and that I was going to do as many drugs as possible. If the goal is to spend your whole life trying to get rewards to trigger chemicals in your brain, why not go straight for the chemicals? But that didn't work out very well. It quickly became less of a philosophy, and more of a massive drug addiction."

"You could make a horror movie about my life. My mom died of cancer when I was five, and my father tortured me. I mean tortured. Really tortured. Chained me to a chair. Slapped me with leather. It was like Jack Nicholson in *The Shining*. Every single day. He'd never say a thing. He'd just kick down my door and come after me. I was born into hell. And now I'm nervous. I spent twelve years alone with a demonic presence. Really nervous. I play the piano to calm myself down. I always have these thoughts that aren't even my thoughts: *fat fuckers, fucking bastards, fuck all of them*. They're my father's thoughts. The violence is inside of me. My energy is black, black, black. I used to kill little birds when I was a kid. Then I moved on to cats. By the time I was seventeen, I was beating the shit out of everybody. Bigger than me, taller than me, I didn't care. It was more torture to keep it inside. If I kept the violence inside, I'd mutilate myself. Suicide myself. A few years ago I set a guy on fire. It was three a.m. He was passed out beneath a bridge. Just some druggie. I didn't feel a thing. I felt like laughing. If anything, I felt free."

MONTREAL, CANADA

"My sister was murdered when I was twelve years old. Her husband killed her because of jealousy. After that it was just me and my mom. I stopped studying. I became the black sheep of the family. I left the house and went my own way. There was a gang in the neighborhood. They gave me a place to live. They gave me marijuana and cocaine. I stayed high all the time. And they gave me work. My job was to collect protection money from local businesses. There were five of us who made the rounds. When I turned fourteen they told me I was ready to 'test the knife.' There was a shopkeeper named Maria. Her husband was a pain in the ass. He would always scream at us and call us sons of bitches. So we stabbed him over and over. There was blood everywhere. I felt like throwing up. Afterwards I felt empty inside. So I just did more drugs. And the way I looked at it—if my sister got killed, why shouldn't other people die? It's the way of the world."

BOGOTÁ, COLOMBIA

"Drug dealing was delicious. I had a pistol, I had girls, I had funk. Everyone saw me as important. I helped defend the favela and maintain the rules. You couldn't rape, you couldn't kill, you couldn't hit a woman without permission. Everyone knew the rules and nobody could break them. Or else you might get erased and fed to the crocodiles. I had no problems with violence. I'm cold-blooded. My adrenaline goes up—but that's it. Afterwards it's back to nothing. People feared me. People respected me. But then I got set up. One of the 'higher-ups' wanted my girlfriend. So he accused me of stealing. It was all lies. He even tried to say I smoked crack. They beat me with sticks. They broke my fingers. They knocked out my teeth. They took my girl, my clothes, even my dog. And now I live on the streets. I've got nothing left. I used to get everything for free. Now if I ask for food, I'll get chased away."

"These two tears are for my mother. She had heart problems from all the drugs. I remember going to her funeral but I don't remember her face. When I dream about her, all I hear is her voice. We don't have a conversation. It's just her voice, saying: 'Come here, Jeff. Come here, Jeff.' After she died, all that mattered was surviving. Nobody showed me love. Maybe things would have been different if I had parents. Maybe I'd have a place to live. Maybe I'd have accomplished something. So I don't feel guilty for anything. Why should I? God killed everyone who cared about me. Does he feel guilty about that?"

RIO DE JANEIRO, BRAZIL

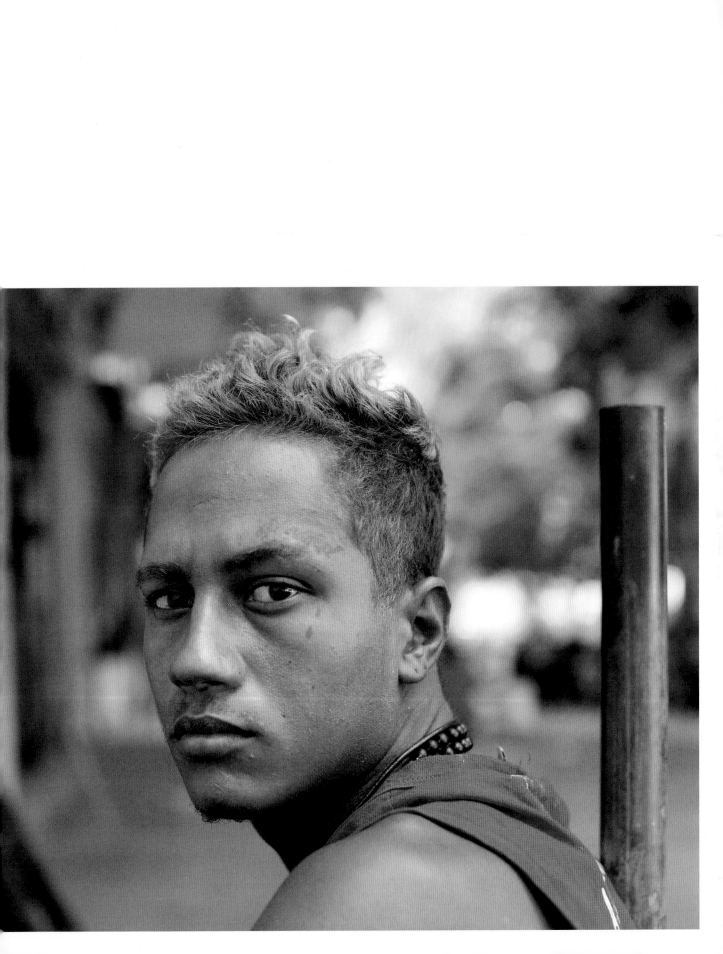

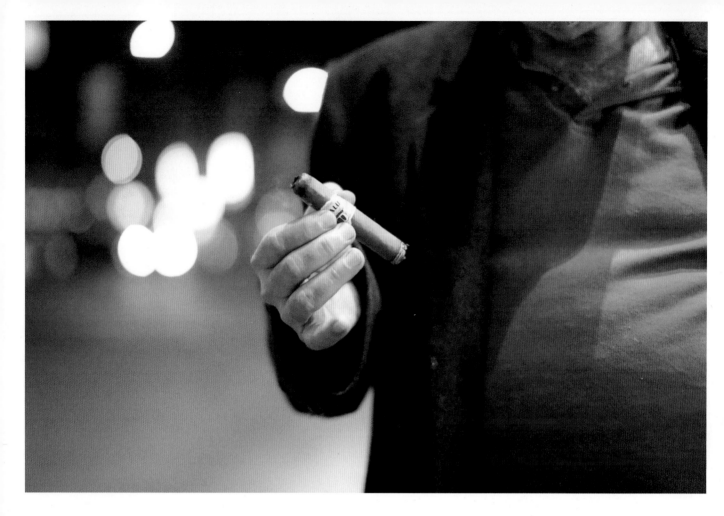

"Honestly, I liked her more when she was drinking. She was a very high-functioning alcoholic. She was spontaneous. We'd do unplanned, crazy shit like drive to the ocean and look at whales. But once she got sober, all of that went away, and ritual became very important to her. You couldn't talk to her for an hour without hearing a mantra from AA. And she got very Catholic. She started celebrating religious holidays and going to talks. I tried to participate. I even went on this trip to Spain where we followed the path of a saint. Everyone in the tour group seemed to be so inspired. We'd stop at these small churches and everyone would contemplate and pray. She was happy. She'd say things like: 'This feels so real to me.' But I didn't feel it. It's not that I felt disdain. I wanted to feel it. I just couldn't. I knew then that our connection had been frayed. Because so much of travel is sharing an experience. And we weren't sharing the same experience anymore."

NEW YORK, UNITED STATES

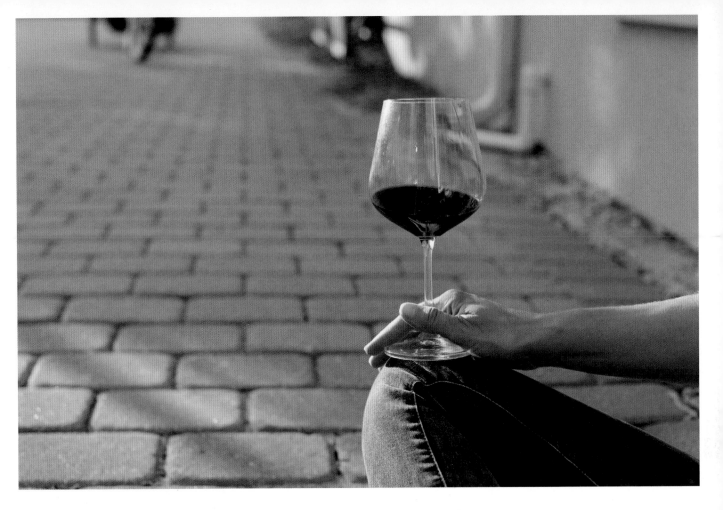

"If he really loved me he'd leave me alone. He'll call and say things like: 'I wonder if I'm still in love with you.' And: 'You're the most important person in my life.' And: 'I don't want a relationship, but I don't want to lose you.' Then he'll want to see me for a day. Or a weekend. And that always gives me hope, because I'm still in love with him. Despite everything that's happened, I still see him as my person. And that's what makes me hate myself. Because he knows that. He knows I'm not strong enough to stop responding to him. He knows that I can't cut him off. And that he can get everything out of me that he wants. But nothing he doesn't."

ROME, ITALY

"Even if we have equal rank, a man always
tries to take charge of the situation."

BUENOS AIRES, ARGENTINA

"We let her pick the kite."

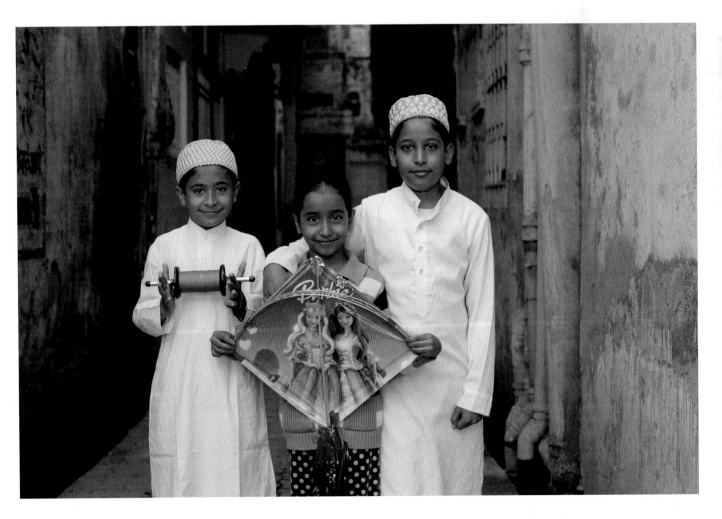

"I knew it would be a girl. I had a dream that I was holding a girl."

"Why God gave me only girls, only he knows."

"We'd get advanced warning when the American B-52s were going to bomb the enemy positions. These were the most frightening times of the war. We'd stuff cotton in our ears and our nose and shut our eyes tight and crouch down against the ground. The bombs didn't drop in one place. They spread out like sand. And if you weren't ready for them and happened to be standing up with your ears uncovered and your eyes open, the pressure alone could burst your heart or break a vessel in your brain. When they dropped their bombs, I don't think those pilots knew what it was like on the ground."

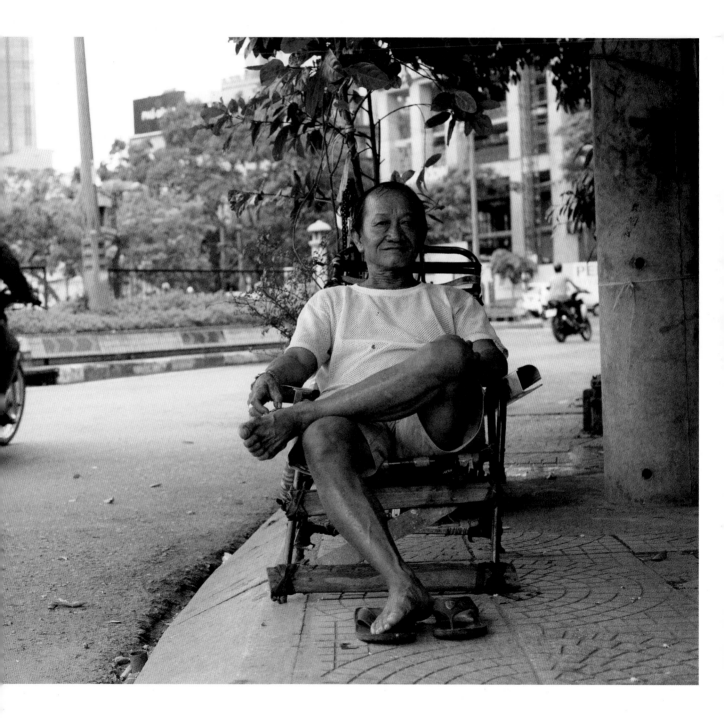

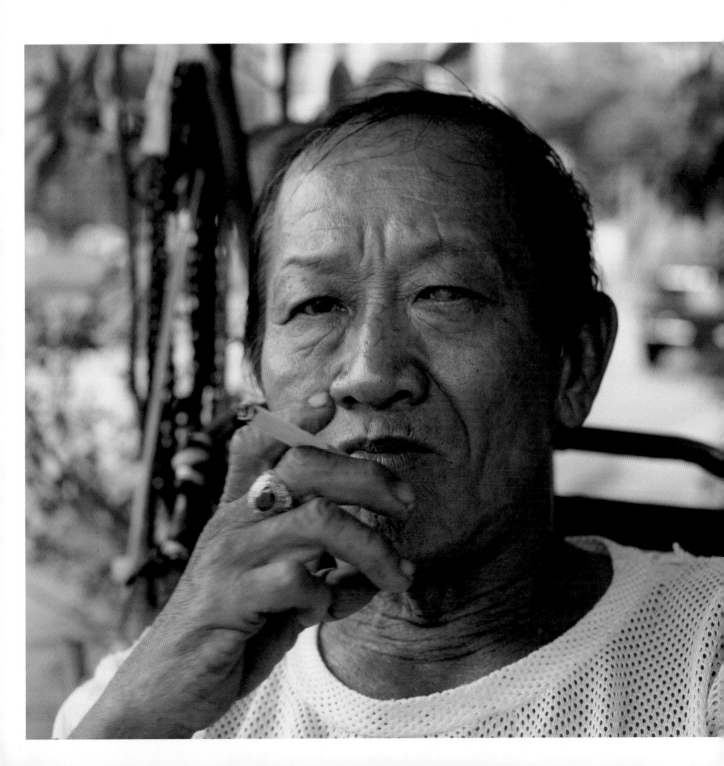

"I was in the infantry. We were stationed in Laos when we heard on the radio that the treaty was signed and the war was over. Everyone started celebrating and screaming and lifting each other in the air. None of us cared that we'd lost the war. We were so tired of fighting. When we heard the news, we started waving our arms and celebrating with the same North Vietnamese soldiers that we'd been shooting at the day before. The times had made us fight each other. But we were all still Vietnamese."

HO CHI MINH CITY/SAIGON, VIETNAM

"He's like an angel. When he was younger, he would pass by our store every day. He couldn't speak back then. He couldn't even say his name, but he always passed by the store and gave off the warmest feelings. My father began to invite him in, and soon he was coming by the store every day to play. When he started spending time with us, he began to improve very quickly. We told him we needed his help with the shop. We think that all he needed was something to hope for. He began to tell us all about his feelings. He visited with everyone who came into the shop. He learned bits of English and Japanese. He changed our lives so much. My father loved him like a son, and he loved my father. They would always laugh together and dance together. When my father died, he was very sad for five months. He still prays for my father every time he eats a meal. Lately, all he can talk about is a girl in his class that he wants to marry. She also has Down syndrome. Every day he talks about the wedding he will have, and he invites everyone he sees. He has invited over five thousand people so far. He tells each person what they are supposed to bring to the wedding. His father will not allow him to get married. But we are thinking about having a 'wedding party,' and inviting everyone in the town."

JERUSALEM

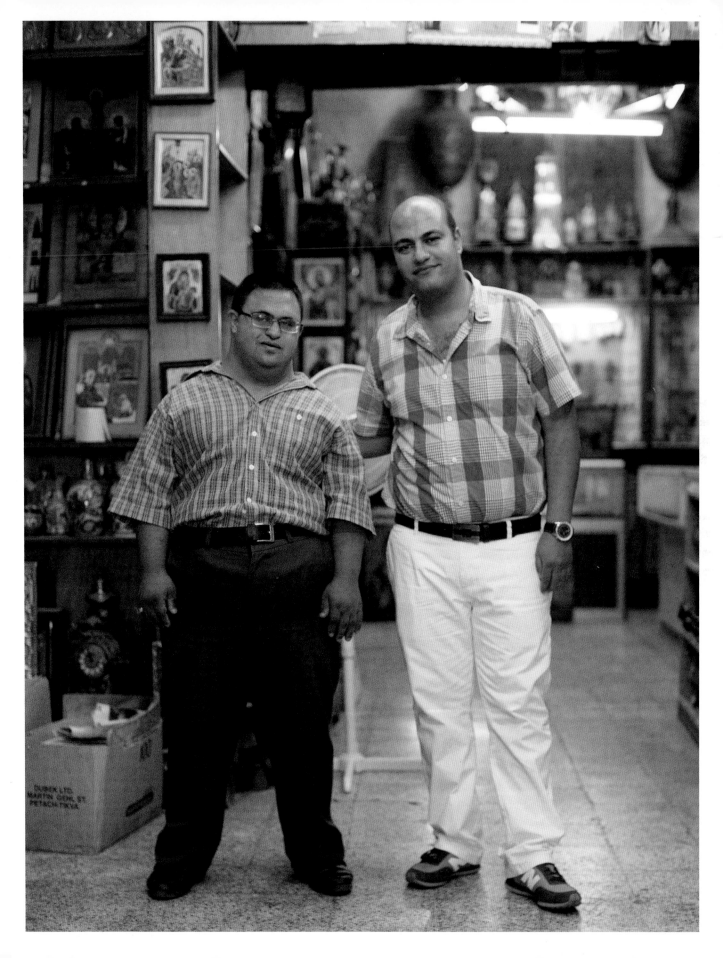

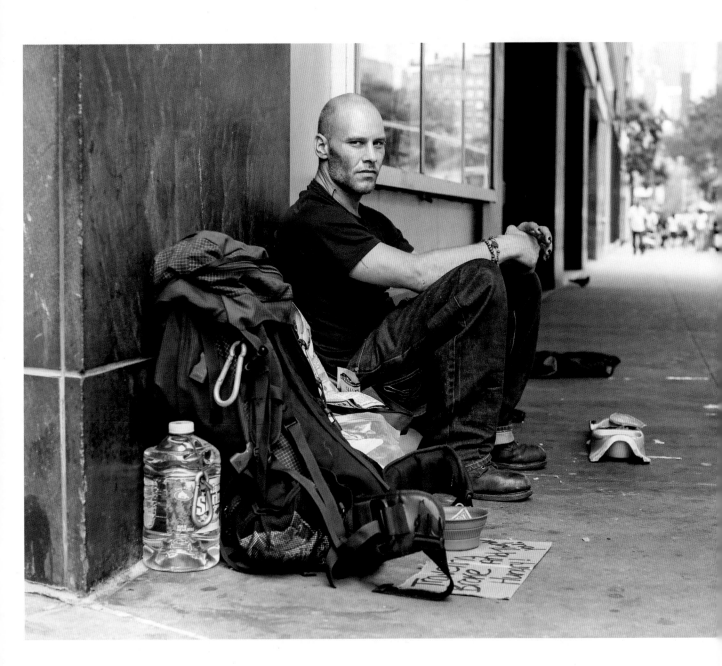

"My dad gave me up to the boys' home when I was four. He told me that he was taking me fishing. He got the poles, the bait, everything. I was excited. He said he knew about a new spot. We pulled up to this huge building. He told me to wait in the car while he ran inside and got permission from his friend. Then he came back with two men. 'I'm sorry,' he said, 'but you have to stay here.' I kept screaming: 'I'll be good! I'll be good! I'll be good!' And he kept saying, 'It ain't you. It ain't you. It ain't you.' I ripped his shirt off his back trying to keep him from leaving, and he drove off without a shirt. I was in that home for thirteen years. It was a very abusive environment for everyone there. The staff's favorite form of punishment was the 'full burn.' First they'd make you take your clothes off and lay on the carpet. One of them would sit on your back, and the other one would pull you all the way down the hall. The worst was the Ice Man. If I saw him today, he'd be dead. He was like one of those guys you see in the movies, where even when he smiled, it was ice-cold. He'd come in your room and tell you that you had a date with the Ice Man. Then he'd fuck you and make you suck his dick. Then afterward, he'd tell you when your next date was going to be, just so you'd have to worry about it all week. Ten of us tried to escape when I was seventeen. I had a date with the Ice Man coming up so I figured I had nothing to lose."

"We escaped in the middle of the night. We were all seventeen except for two really young kids who wanted to come with us. We had no plan really. The only time we'd ever left the boys' home was when they brought us to Barnum and Bailey's circus one time. Other than that, we knew nothing about how to survive in the outside world. The first night, two of us went into a grocery store and tried to steal a bunch of food for the group, but the owner called the cops. We all ran different directions when the cops came. I was the one they chased. I started to run up this mountain and I remember them shouting to me: 'It's going to snow tonight!' All I had on were Nikes. And that night a blizzard came. I'd never been in a blizzard before. So I tried to get off the mountain, but it was dark by then and snowing hard so I fell thirty feet into a ravine. I was unconscious for a long time. When I woke up, I was covered in snow, and my foot was frozen solid."

NEW YORK, UNITED STATES

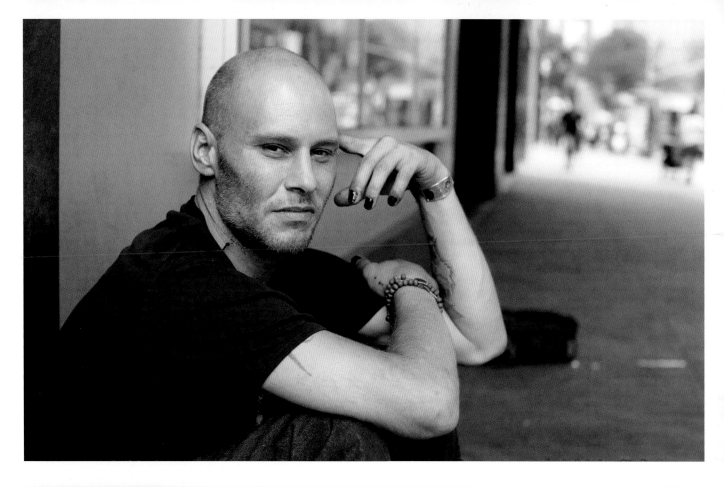

"I have nothing to complain about. I'm originally from Sudan. I love it there. So many happy memories. I got so much love from my family because I was the youngest. Since then I've lived in five different countries and I've enjoyed every single one. I don't have a partner, but I have plenty of great friends. I don't have children, but I'm a lovely uncle. I don't take any medicine. I sleep well. I can walk around. I don't know what to say. Every time I think about it, I conclude that I'm happy. I wake up smiling. I lived in Germany for several years. And they have these cameras along the highway that photograph you when you're speeding. I've got a huge collection of photos because I love to speed. It's always just me alone in my car. And I'm smiling in every one of them."

JOHANNESBURG, SOUTH AFRICA

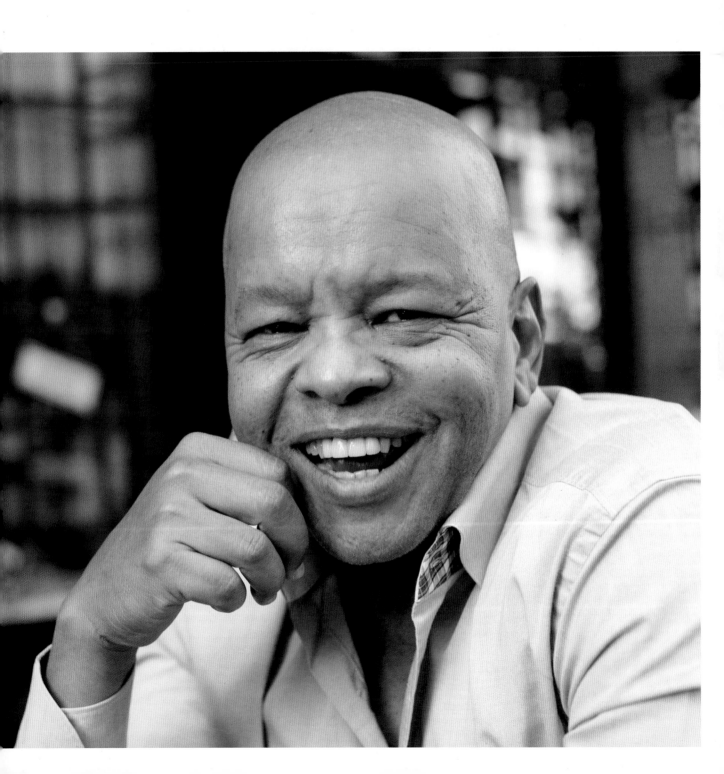

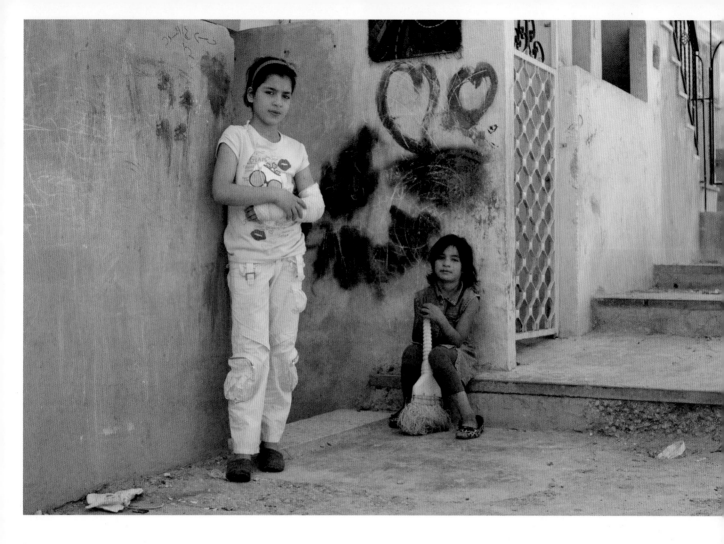

What happened to your arm?

"I was walking down the stairs and looking at the stars."

"My parents aren't giving me the freedom to be responsible. Mama's fine. But Papa is an Egyptian father. He wants me to always be in a safe, cozy home. Recently I wanted to go on an educational trip to Sri Lanka. I begged him. I said, 'Please, I'll be living with a family. I'll call you ten times a day.' But he wouldn't listen. I locked myself in my room and cried. I wanted that experience. I wanted to meet beautiful people, and eat beautiful food, and take beautiful photos. I know my dad very well. He just doesn't trust people. He thinks that I'm naïve. He thinks that everyone who helps you wants something in return. But that's not why I help people. I love people. I love languages. I can even speak a little Hindi. I want to see every village and every city. I even want to work for NASA one day. I love physics and astronomy. But Papa thinks astronomy is a bad idea. He doesn't get it. It's not that he doesn't understand the stars. He just doesn't understand me."

ALEXANDRIA, EGYPT

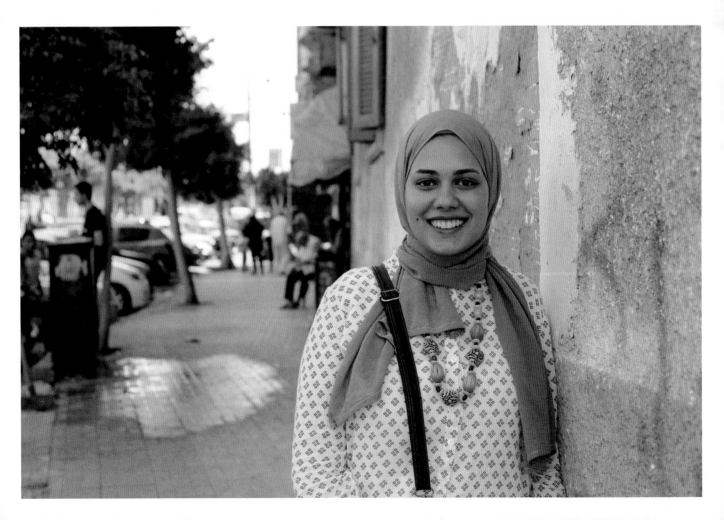

"My father was a Fascist. He was trained to be a terrorist in Mussolini's army. He was anti everybody. The Irish were 'micks,' black people were 'niggers,' and Jewish people were 'kikes.' His main weapon was pain. He raped me, locked me in closets, beat me with broom handles. He sent me to the hospital many times. He'd threaten to blow my brains out in the middle of the street. I absorbed a lot of his emotional energy. Sometimes his voice still comes out of me. When I'm really angry, and cussing myself out, I sound just like him. It's him inside me, speaking to me. But I didn't become him. My grandfather saved me. He lived with us. He always told me: 'Your father is a nut.' He hugged me and kissed me. I swung between two extremes: the love of my grandfather and the hate of my father. My grandfather knew how to love. My father couldn't love because he was too filled with terror. He didn't have the tools to love. Once when I was fifteen, I walked over to my father and gave him a big hug. He kept his arms stiff by his side. I said, 'I love you, Dad,' and his body started trembling. There was a terrified child inside of him. He wanted to love. And he wanted to be loved. He just didn't know how."

NEW YORK, UNITED STATES

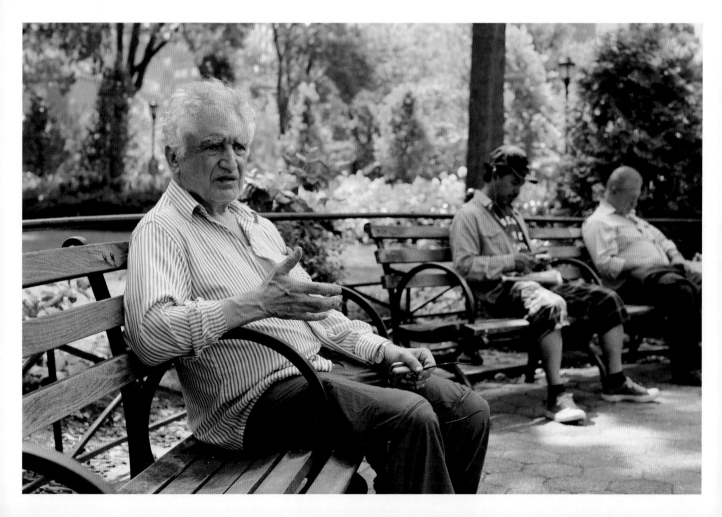

"I have no idea why my mother stayed with him. We lived in constant fear, never knowing what would make him angry. I was determined to grow up and leave the house as quickly as possible. My younger sister got the worst of it because she kept trying to win his affection. She'd tolerate being hit. She'd beg him to stop. But I just ignored him. I shut him out of my world and avoided all interaction. The moment I heard his car pull up, I'd run into my room. My father lived for his company, so his mood was always dependent on his job. One day he lost face at the office. He came home very late, after all of us were asleep, and tried to hang himself in the attic. I woke up to my mother screaming. She was grabbing his legs and trying to pull him down, while shouting at us to get the neighbors. My sister and I went for help. While we ran down the street, I remember hoping that we wouldn't make it in time."

TOKYO, JAPAN

"Every single night I call my dad before I go to sleep and he tucks me in even though I can do it all by myself, and he lies on the bed next to me and he hugs me and tells me that he's proud of me and that I'm a champion. It always helps me fall asleep. And he says that it helps him fall asleep too."

ROME, ITALY

"You can feel in the streets that everyone is worried. We come from a very small town. The engine of our entire economy is a candy factory, and people are getting laid off. I don't like my job. I package the candies and I have to stay indoors all day. When I was younger, I would think about quitting. My bags were always packed. But everything changes when you feel a small hand gripping your finger. Now I'm terrified of losing my job. Every morning we have a routine. Whenever I don't feel like going to work, he says, 'Come here,' and he gives me a hug, and that changes me. He's my battery charger."

CÓRDOBA, ARGENTINA

"My wife passed away last month. She started shivering when she came out of the bath, and then she fainted. I took her to the hospital but she had a heart attack before I could admit her. I'm trying to stay busy. I'm OK when I'm at work, but the minute I enter my home, I begin to think about her. Her photographs are still by my bedside. Thankfully my ten-year-old grandson has been sleeping with me. He watches my shows with me. And he talks constantly. He goes on about his school and his class and his teachers. A lot of what he says is nonsense, but I enjoy it. And when he falls asleep, I fall asleep."

JAIPUR, INDIA

RANDOMNESS

THINK OF THE STORIES that you normally see in a newspaper. Or the headlines that you see on the news every night. You'll notice many of the same themes as major Hollywood movies: Conflict. Drama. Violence. Sex. It can sometimes seem that our news outlets are more concerned with entertaining us than informing us. And this is nobody's fault. In order to make money in media, you must be entertaining. Nobody can survive by being boring. There's too much competition. Even *The New York Times* is forced to entertain. The most reputable outlets entertain their audience with the truth. They tell true stories. But even then, they know that it's not the truth that generates profits—it's always the stories. Stories keep us tuned in. Stories sell newspapers. Stories get clicks. Yes, truth matters. But when it comes to the bottom line, journalism isn't a truth business. It's a story business.

This became clear to me early in the creation of *Humans of New York,* when I'd sometimes attend large protests to collect portraits of the attendees. There might be ten thousand people gathered peacefully: protesting a piece of legislation, or an election, or a war. And the media would be there. I'd sometimes be joined by cameras from every major newspaper and television station. But these cameras would not be evenly spread throughout the crowd. They'd be crowded around the most provocative image—the angriest man, the strangest costume, the single burning trash can. There was little competition for the truth. Everyone was too busy competing for the most compelling angle. If there was a single violent person, wearing a mask, and

breaking store windows—he'd be surrounded by cameras. That is the image that would be shared with the world. Certainly not a lie. But just as certainly not the truth.

It's not only protests that are covered this way. It's entire neighborhoods. And cities. And countries. Some places are only written about when something extreme happens: like a murder, or an explosion, or a war. Only then do the cameras come running, because conflict makes for a great story. Unfortunately this means that much of the world is only seen through the lens of conflict. And when these are the only stories we hear, the world seems like a pretty scary place.

But even in the world's most dangerous places, 95 percent of the life being lived has nothing to do with violence. It's much less exciting than that. It's about falling in love. And raising a family. And making friends. And struggling to provide. And battling addictions. And fighting cancer. These are the stories that are really happening all over the world. They're the stories that you'll hear when you aren't searching for violent conflict. These are the stories you'll hear if you stop random people on the street, and invite them to share a bit about their lives.

For all of these reasons, one of the most important elements of *Humans of New York* has always been its randomness. The people featured on these pages were chosen randomly on the streets of cities around the world. They weren't asked about politics. They weren't asked about terrorism. Their stories were not collected to fit a greater narrative. These people were invited to speak

on the subjects that they deemed most important to their lives. Most often they'd speak about their relationships, or their children, or their efforts to provide for their family. Some of the stories are violent, because those stories exist. But the important distinction is that the stories were not selected for this reason. They were selected at random.

For many months after I visited Pakistan, Pakistani people would come up to me on the street and say: "Thank you so much for showing a positive image of our country." I was extremely appreciative of the sentiment. But I would correct them slightly. I'd tell them: "I showed a random image of your country. Not a positive one." But in a world where stories are selected for their negativity, randomness can easily be mistaken for positivity. When people are chosen at random—they are always nicer than we expect. They're more loving. More tolerant. And more peaceful. And that's great news for all of us. Because it's people that make up our neighborhoods, our cities, our countries—and our world. ◆

"When I was the age of this boy, my father had a stroke. My family used all our savings to take care of him. And after we'd spent everything, my father gave up the ghost. We were left in a desperate situation. There was no money left. There were six of us living in a single room. I was only in fifth grade, but I had to go to work. I carried oranges on my head and sold them in the street. Then one day I met the owner of a print shop. He was a friend of my brother. He fed me every afternoon, and he began to teach me his profession. He told me: 'Never view yourself as having nothing.' And he showed me that I could change my life with skills alone. Now I have my own shop. And anyone who has an interest, I will teach them. I've taught fourteen boys already. This boy has stopped going to school. But we can't allow him to be idle. We must keep him busy because there's criminality all around us. Every day we see drug dealers walk by. I point to them and I ask: 'Do you want to be like them? Or do you want to be like me?'"

LAGOS, NIGERIA

"I'm not his father. I'm his friend."

How'd you meet?

"I love his mother. And it was a package deal."

"After I finally learned the ropes, they changed all the rules."

"I should have invested the money I stole."

MADRID, SPAIN

"I'm a fund manager. There's this idea in society that pushing paper is bad, but making widgets is good. People think there's a nobility to making steel or fixing cars. But go ask your grandfather what's more important to him: his car or his pension? People like to say that the markets are just a game, and it's quite trite. I think it's meant to be an insult. But it is a game. It's like figuring out a sudoku puzzle. And that's why I enjoy it. Look, I've got a friend who's a back surgeon. Top in the country. He's far wealthier than I am. But do you think he actually enjoys opening up a new back every day? There's the occasional emotional moment, but day to day, he's just earning his crust like the rest of us. But when you ask what keeps him going, it's that every case is different. He enjoys the puzzle. Don't get me wrong, I've met a few surgeons with a God complex—you know, the whole 'I save lives,' Mother Teresa kind of deal. But for most of them, they're just playing a game like me. Except there's a body in front of them, instead of the markets."

LONDON, ENGLAND

"If there's a chance then it's worth a try. Even if nobody else wants to try, I will try. A lot of these kids have exhausted all their options. They may have had several surgeries elsewhere and it's either hospice or one more try. And I know if I can get this tumor out, the child has a chance. I take 100 percent responsibility for the outcome and I don't like to lose a drop of blood. So it's a lot of stress. I have four grafts in my heart. My neck muscles are always tense. Some of these surgeries have probably taken years off my life. But tumors kill kids in very horrible ways. So if there's a chance, I will try. I've only lost five kids on the operating table. And I've wanted to kill myself every single time. Those parents trusted me with their child. It's a sacred trust and the ultimate responsibility is always mine. I lose sleep for days. I second-guess every decision I made. And every time I lose a child, I tell the parents: 'I'd rather be dead than her.' And I mean it. But I go to church every single day. And I think that I'm going to see those kids in a better place. And I'm going to tell them that I'm sorry. And hopefully they'll say, 'Forget it. Come on in.'"

NEW YORK, UNITED STATES

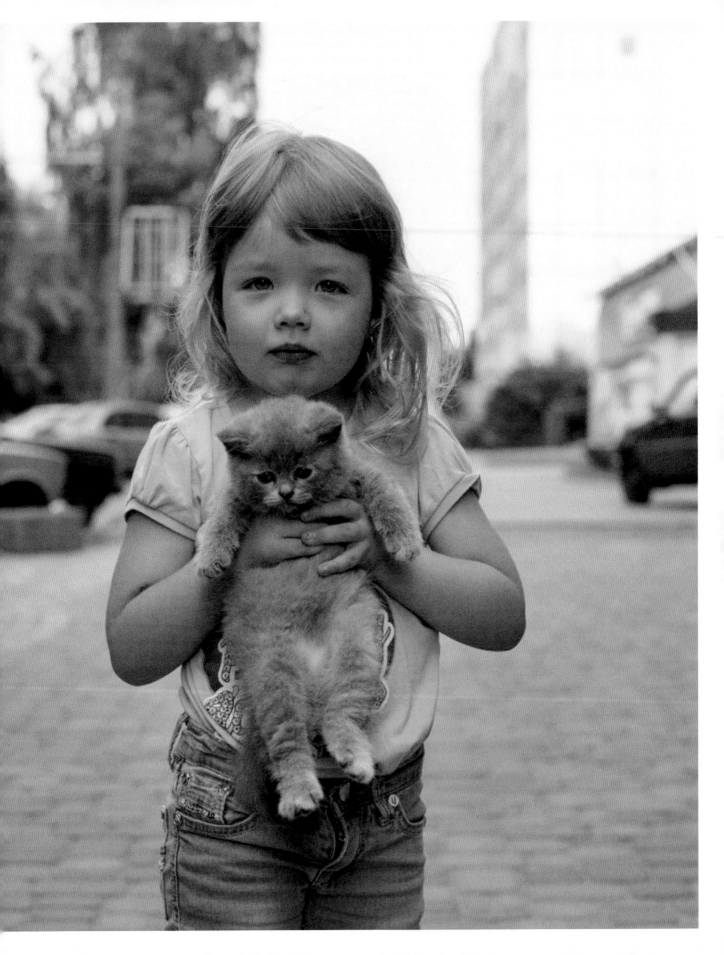

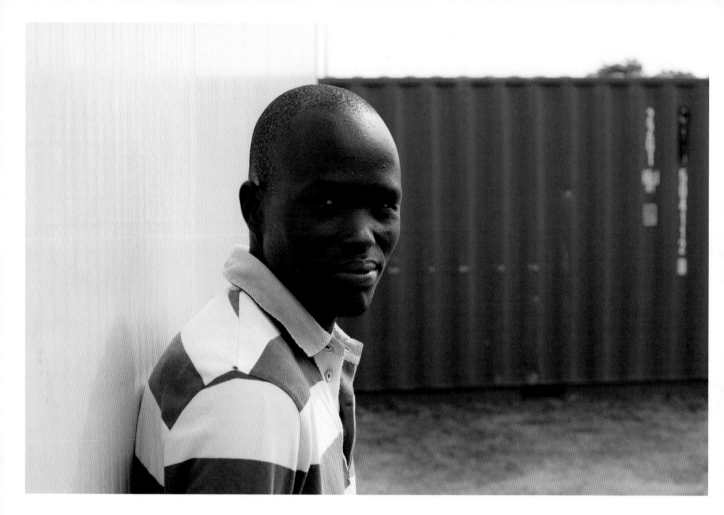

"The army came door-to-door asking for donations. I was only seven years old, and my mother's only child. She fought with my father because she didn't want me to go. But he insisted. A few days later, he dressed me in a brand-new white robe and told me I was going to school. I was very afraid when I first arrived at the military camp. But there were many children there who I grew up with, so I eventually felt more comfortable. In the morning we would go to school, and in the evening we would train with the guns. After a few weeks, they marched us to Ethiopia for additional training. But we never made it there. We ran out of food and water on the way."

Are you angry with your father?

"I speak with him regularly now. I've forgiven him. And in the end, I would have never been educated if he hadn't sent me away. But I was very angry with him when we were dying. On our march to Ethiopia, the children who gave up would sit down in the shade. We would tell them not to sit but they'd say, 'Go on without us. We'll catch up later.' But they never did."

TONGPING INTERNALLY DISPLACED PERSONS SITE, JUBA, SOUTH SUDAN

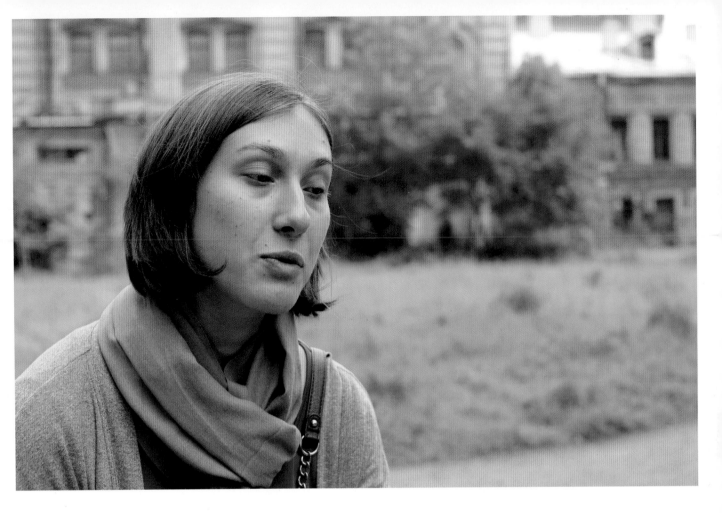

"My father left our family when I was ten. We never had a good relationship. I wanted him to realize that I needed support and love, and somebody to take care of me. I wanted him to understand me. I needed him to say 'I'm sorry.' But he never did. Whenever we talked, all he cared about was getting across his side of the story. He died in his sleep last year, right after my birthday. And now I'm forced to forgive someone who is unable to say 'I'm sorry.' I feel like I'm playing this game of chess. And I have to keep making moves, or nothing will ever change. Except that there's nobody sitting across from me anymore. And I can only guess the moves that he'd make."

ST. PETERSBURG, RUSSIA

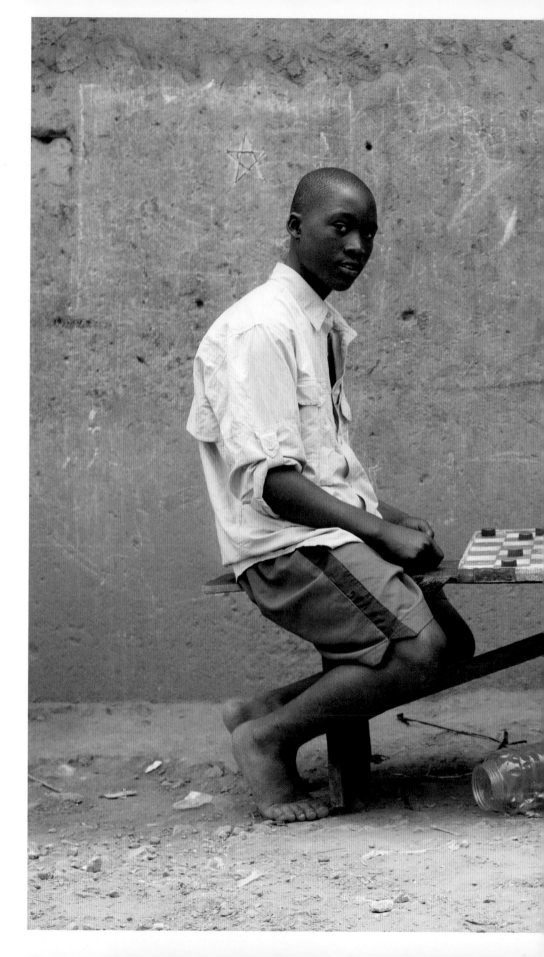

"He's too scared to
sacrifice his pieces.
He hasn't learned
that sometimes you
need to lose two to
gain three."

KAMPALA, UGANDA

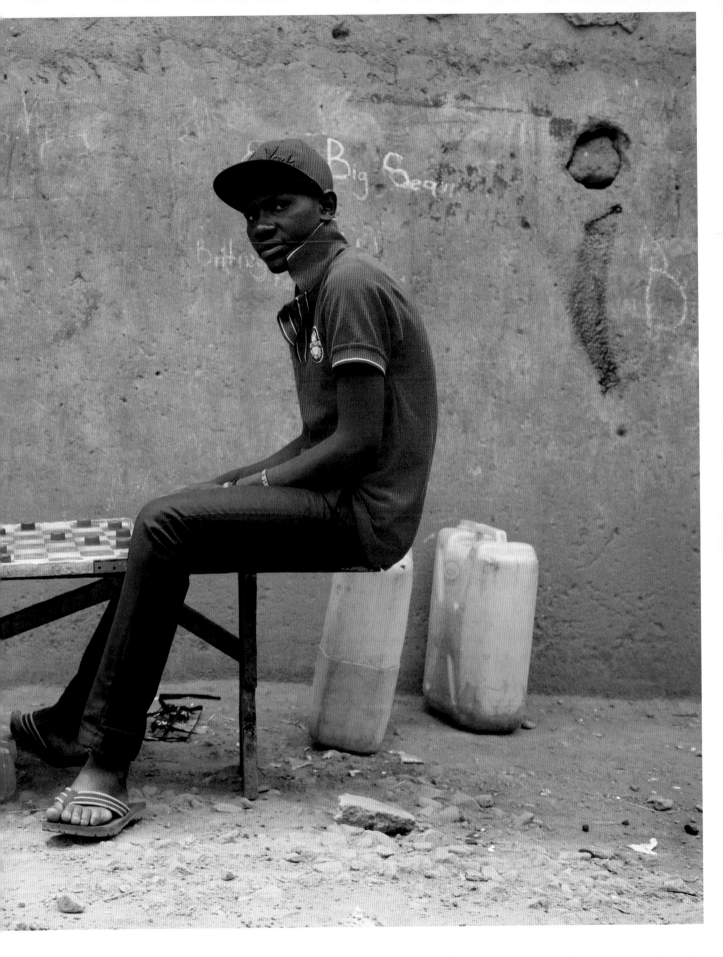

"It started when she was nine years old. The first thing I remember is the arguing about food. My parents would tell her to eat. She'd say she wasn't hungry. There was weighing of the food. My father would lose his temper, but she still wouldn't eat. Once, he got so angry that he hit her. From the age of ten to thirteen she went to a hospital in Barcelona. Occasionally she'd come home to visit, but mostly I only heard from her through letters. Nobody explained to me what was going on. They only told me she was very sick. I didn't even hear the word 'anorexia' until several years later. Things got even worse when she came home from the hospital. The illness was even more ingrained. She's twenty-five now. There have been periods where she seems to be getting better, but it always gets worse again. It's taken a toll on my parents. Both of them look like they're in their seventies. My mom is on antidepressants. The therapists have told them that the disease has gone on for so long now—that it will probably be lifelong. Whenever I try to ask my sister about it, we always argue. She gets frustrated. She feels attacked. So I've stopped trying. It was only two months ago that she finally admitted having a problem. We were walking home from a family dinner, and she told me everything started when she was nine years old. She was meeting a group of friends at the mall. And a group of boys started making fun of her. She had a lot of freckles back then. And bright red hair. And maybe she was a little bit chubby. But just the smallest bit."

MADRID, SPAIN

"When I was a teenager my dad gave me a fifty-euro bill, and he wrote a message to my future children. Something like: 'For you, little one. From Grandpa.' But my addiction was stronger than the gift. And I spent it on food. I kept a little trash can hidden in my closet. I'd use it five or six times a day. It was always about control. I couldn't control much in my life, but I could control this. I had the power to make people worry about me. I had the power to make the numbers go down. Eventually my parents stopped keeping food at home. They put a lock on the fridge. My whole day was structured around food. I tracked everything I ate. And at some point in the day it would feel like too much, so I'd throw it up. I felt disgusting. I felt like people could smell it from a mile away. So I kept to myself. And what do you do when you're all alone, and you don't have anything, and you want a little pleasure? You eat. Then you throw up. It was so hard to stop. If it had been as easy as chopping off my hand, I would have done it. But it's not like cigarettes or alcohol. You can't just kick food out of your life. You have to confront it. You have to get back to normal. Even now it's inside of me. I know I'm still vulnerable, especially during my low points. But it's not my life anymore. It started with single days. Nights where I'd lie in bed and realize I hadn't thrown up. Then weeks would go by. I'd have major fallbacks, but by then I'd tasted normalcy, and I wanted more of it. You miss so much of life with your face in a toilet. So I'd start over again. Now I have things in my life more powerful than the addiction. Recently I told my dad about the fifty-euro bill, and how I'd spent it, and how guilty I felt. He told me not to worry, and gave me this new one. It's not the same. But this time I'm going to keep it."

BERLIN, GERMANY

"I'm seventeen. I'm doing my best to convince myself that we're all beautiful in our own way, but it's not so easy. I look at all the pretty things my friends have: their bodies, their lips, how they wear their hair, or their makeup—even their personalities. Some have such pretty personalities. I wish I could be one of those people who laugh and talk for hours without stopping. Instead I just hide in the back of class and try not to draw attention to myself. I wear baggy clothes. Anything not to be noticed. But I'm trying to change. I'm trying to get out of my comfort zone. I'm searching for plus-sized models online. Women who are bigger, but still confident and beautiful. I'm wearing less black. I never used to wear colors because they emphasize your curves. But now I'm wearing colors. I even wore a dress recently. Not to school, of course, but to dinner with my grandparents. It was blue and had white flowers. My dream is to eventually go to the beach. The water was such an important part of my childhood. My grandparents had a little beach house and we'd go every summer. But I haven't been to a beach in over five years. Well, I did go once. But I sat on the shore, and watched everyone's stuff, and took their photos for Instagram. Next time I'd like to actually go in the water. Wearing a swimsuit. If I can do that, and have the time of my life, and feel that I'm allowed to show myself—my insides and my outsides— then I'll know I'm finally where I want to be."

AMSTERDAM, THE NETHERLANDS

"I always hated being a girl. I didn't want to grow breasts, or have periods, or wear dresses. Because it was terrible being a girl where I grew up. We weren't allowed to do anything. The boys could do whatever they wanted, but girls had to be protected. And controlled. And watched over. Even at university, we had a curfew of six p.m. And my father had to fax his permission if I ever wanted to leave the campus. It wasn't until I attended graduate school in London that I finally tasted freedom. I was almost thirty, and everything I understood about being a woman came shattering down. Suddenly I was allowed to do anything I wanted. I could wear more comfortable clothes. I could walk down the street alone. I could explore. I could find my own style, and space, and identity. And I could do all this without being noticed. Because men weren't conditioned to stare at me. Society wasn't conditioned to judge me. I could finally be invisible. It felt so nice. I'd never understood the privilege of being invisible. I could sit on a bench and watch people go by. I could take photographs. For the first time in my life, I was finally allowed to be the observer."

SINGAPORE

"I knew immediately. I get a breast exam every year, so I know what normal is supposed to look like. I could see the tumor on the screen. It was messy. It was black. But I didn't feel shocked. I was calm. My surgery was scheduled for Valentine's Day. And you know what? That was the most beautiful Valentine's Day of my life. Because I spent it taking care of myself. I had a difficult childhood. Then I had a very hard love story that lasted for twenty years. And when that came to an end, I escaped into my work. I was like a hamster in a wheel: faster, faster, faster. It was easy to rationalize because I work in Women's Rights. I felt involved in something bigger than myself. But I just wrote reports about the situation. Honestly I changed myself much more than the country. I was worn down. I had no free time. And my children are grown, so I was wondering if I had any reason to live anymore. Then four months ago the cancer came. It was a blessing in a shitty package. It was something I couldn't control. And I was forced to accept that. Right now I'm not doing anything. I'm visiting with friends. I'm taking time to relax. I'm feeling grateful. And I'm asking myself big questions: 'Where would I like to live?' 'What would I like to do?' Questions I never had the time to ask. But most importantly I'm taking care of myself. Now if you'll excuse me, I'm late for my massage appointment."

PARIS, FRANCE

"I'm rebooting my life entirely,
again. It's time for Andrew 5.0."

NEW YORK, UNITED STATES

"My mom is afraid of me studying abroad because she thinks I'll stand out too much. I asked her: 'How is that any different than here?'"

KARACHI, PAKISTAN

"There's a big contrast between my fantasies and my life. I use art to bridge the gap. I'm starting a new project where I'm covering nude bodies with paint and laying them on canvas. The naked body is very natural to me. It's a matter of truth."

TEHRAN, IRAN

"I was twenty-two years old when I met Hitoshi. I was working as a nurse, and he was a TB patient at my hospital. He was very handsome. He almost looked foreign—like a Spanish flamenco dancer. But he was in such terrible shape. All of us thought that he'd be the next to die. I felt so sorry for him. One day the hospital held a haiku contest, and the nurses were in charge of picking a winner. There were over one hundred entries, but I chose his. It was about a flower unfolding with the calmness of a galaxy. At night I'd sit by his hospital bed and play the harmonica. Back then all the boys could play harmonica, but his lungs were too weak. So I'd play it for him. After he was discharged from the hospital, we decided to marry. We spent eighteen good years together. We had three children. If he'd ever have gotten completely healthy, I know Hitoshi would have been a great man in society. But he was always weak. He died at the age of fifty-two, in the peak of the summer heat. That was over forty years ago. But every month, on the anniversary of his death, I go to his grave, on the mountainside, and play ten melodies on the harmonica."

TOKYO, JAPAN

"I never thought I'd come back to New York. I have a lot of bad memories here. It can be an ugly place. My ex-husband lives here. On September 11th, I was on the street below the second tower. So there are things I'd just prefer not to remember. But recently my mother got sick and I came home to take care of her. I was in a bit of a rut at the time. I'd fallen away from my passions. I was just working to pay the rent. And one evening I was walking by the river and I passed a place called Hudson River Community Sailing. They offered free sailing lessons. I don't know why I stopped. I was intellectually convinced that sailing was not for me. I was getting older. I was out of shape. But I decided to give it a try. And I got hooked on it. I got kinda obsessed with learning to sail. I remember the first time I was out there alone. It felt amazing. I was in the middle of the Hudson, the wind was blowing, I could see the whole city, and my hand was on the tiller. It seemed like I was doing something impossible. I'm not white. I'm not male. I don't own a boat. I don't even have money. But I'm in New York City and I'm fucking sailing."

NEW YORK, UNITED STATES

"It was 1971. I was twenty-five, and I'd just gotten out of the army. Life was hard back then. Ninety percent of people were jobless. There were too many people to feed. And nothing ever went as planned. At the time I had only one dream: to fly on a plane and escape. It was everyone's dream back then. But it was an impossible dream. The average Korean could never fly. We didn't even have the opportunity to get near a plane. We could only watch the Air Force flying overhead. But one day our president announced a work exchange program with West Germany. Two thousand people applied, but only seventy-three were selected. I was chosen to work in an auto engine factory. On that day, I wasn't even jealous of the president. Fifty of my family members came to the airport to see me off. I gave away my money, jewelry, everything. Nobody knew if I was going to live or die on that machine. They sat me near the window. I was so nervous. When we finally took off, everything became real. My heart felt numb. I could see my whole country below me, getting smaller and smaller. Cars, people working in fields, and then the ocean. My dream had finally come true."

SEOUL, SOUTH KOREA

"This is a picture of me before I lost my job. It was only a year ago but I barely recognize that person now. I was thirty pounds heavier. I was much more confident. It felt like a guardian angel was guiding my steps. Things always seemed to work out for me. When I look at this picture, I see a man who's wearing a mask. The man in the picture wanted to be seen as a person who does important things. He wanted to be seen as confident, and harsh, and a leader. He wanted to be seen as an attorney. Now I just want to be seen as a person. Someone who's calm. Who's balanced. Who loves his friends and family. And who's kind."

MOSCOW, RUSSIA

"I turned my wife into a meme."

"When I was ten years old, I had a bad disease
that caused me to lose consciousness and when
I woke up, I was blind. I screamed: 'Mom, I
can't see anymore!' And we both started crying.
It's been a very hard life for me. Nobody would
give his daughter to a blind man. If I dwelled
on how lonely I am, I'd have died a long time
ago. My only friend is the radio."

KARACHI, PAKISTAN

"I used heroin for ten years. It wasn't a very good life, as you'd expect. I had my son taken from me. I lost my job at the Fiat factory. I spent all my time trying to find money, find dealers, and stay away from police. I hated myself. I couldn't face anyone. Then one day my friend's dog had puppies. I'd never had a dog before, but I always liked animals—so I told him to give me the smallest and ugliest one he had. The one nobody else wanted. And that's how I got Joe. Joe was the angel of my life. We understood each other. There was no need for words. He followed me around all the time. He slept next to me on the street. The moment I opened my eyes in the morning he would lick my face. He gave me self-esteem. I was a complete loser but at least I could take care of Joe. I could bring him to the park. I could bring him to the vet. I could raise enough money to get his medication. He's the reason I was finally able to quit heroin. Because if something happened to me, what would happen to him? So I got clean. It was hard but I got clean. Joe lived for another thirteen years. He got a tumor in 2012 and held on a few more months. I barely survived it. I was able to stay off drugs, but I promised myself that I'd never get another dog. It's just too painful. But two years ago I found Leica beneath a mobile home. She was all skin and bones. She'd been abandoned. I didn't have a choice. For the first few months, I called her Joe. But I had to stop. Because Joe's gone. And the name doesn't really matter, anyway. It just matters that I love her."

ROME, ITALY

"She lost her back legs when she got hit by a car. She'd already been returned to the shelter twice already. She's a lot of work. It's almost like having a child. You need to be very patient. You always need to change her diaper. It's very hard to find a babysitter. But I've had her for one and a half years now and I can't imagine life without her. Everyone loves Lucy. And Lucy loves everyone. She can't wag her tail, so I was worried that I'd never know if she was happy. But she tells me with her eyes."

ROSARIO, ARGENTINA

"I didn't even really like animals. But my daughter said she wanted a pet. So I brought home this kitten, and told my daughter: 'It's your responsibility. I'm not going to get involved.' But now the kitten loves me more than the girl. I call him JJ. He's always the first one to greet me when I come home. When I leave for work, he lays on my flip-flops by the door. He always wants to be with me. Right now we're coming back from a trip to the store. My daughter is a little jealous. She's always trying to steal him from me."

MEDELLÍN, COLOMBIA

"I regret that my cat isn't here. I photograph better with my cat. I'm sorry, the cat is the topic of the day with me. My husband has passed away, and my son got married, so the cat fills up my life. I do have friends. But within those four walls, it's just me and the cat. In a way he's become a substitute for the love of my son and husband. He witnessed our lives together. He ties everything together. He's the most important person in my life. Yes, I call him a person. He has a very human energy. He has his own personality. He has his own preferences. He even has a human name: Rodion Romanovich Raskolnikov, which is the main character in *Crime and Punishment*. Whenever Rodion sits in my lap, I tell him that he's the most beloved creature in all the world. And whenever I leave the house, I say: 'The Lady is leaving now, but she will surely come back to the cat.' But Rodion is sixteen now. He's causing me so much worry. We were just at the vet this morning. And I've begun to notice that he's conserving his energy. When he's walking across the room, he'll stop—and he'll rest. And I know that one day soon he'll stay still forever. And when he passes, I'll bury him in my friend's garden outside of Warsaw. Then no more animals, ever. Some things happen to us just once in life. And there will never be another cat like this one."

WARSAW, POLAND

"I happened to be reading *Crime and Punishment* when it was time to choose our major, so now I have a Russian literature degree."

"Nobody knows that I smoke so I made sure to walk a couple blocks from the hotel. I'm trying to calm myself. Our annual general meeting is tonight and I'm in charge of the whole thing. I've been planning it for months. I took a long time off to raise my kids, and I've only been back working full-time for a year. I want to make a good impression. Our organization has never really had a woman in leadership before, so it's a big deal. And it's a big deal for me. This isn't about my husband or my kids. It's something just for me that I can embrace fully. And I want to succeed. I want my children to know that I'm Mommy, but I'm still myself."

NEW YORK, UNITED STATES

"My young son is very curious. Every time I come home, he asks me so many questions. He wants to know all about my day. It's motivating for me because I always want to have something exciting to tell him. But recently I've been out of work so there isn't much to say. I've been going on so many interviews without any luck. I don't try to hide anything from him because he sees that I'm striving. I just tell him: 'I'm looking for a job that suits me, and I still haven't found the right one yet.' But today I finally found a new job selling security equipment. I'm starting tomorrow. So I'm very excited to go home and report the good news."

MANILA, PHILIPPINES

"When I tried to hug her, she'd tell me it was too hot for hugs. So I learned to stop trying. We never had conversations. I thought it was normal. It was all I knew. I always thought the relationship between a mother and a child was about giving and receiving orders. But when I was ten years old, I went to a friend's house to do a school project. At first I remember feeling sorry for him. His family was so poor. There was almost nothing in the house. But when we walked inside, his mom gave him such a big hug. And she was so happy to see him. And that was the saddest moment of my life. Because I never knew that was something you could have."

RIO DE JANEIRO, BRAZIL

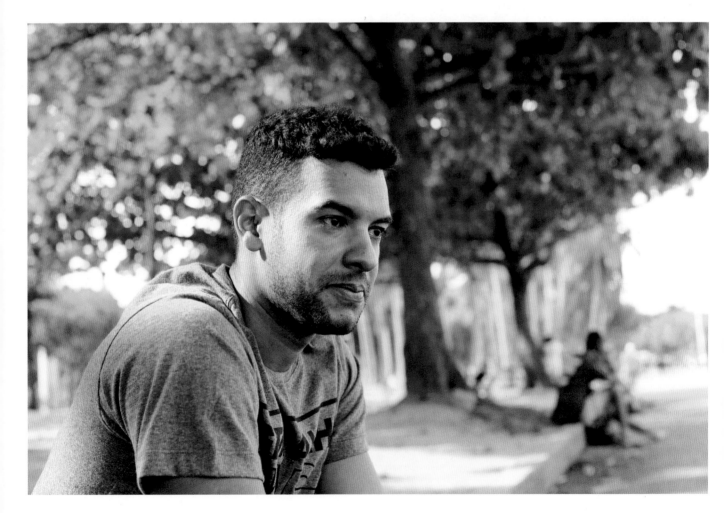

"We came out together. It felt safe because we had similar backgrounds. We'd both been in long-term relationships with men, so we didn't need to explain ourselves. Everything felt comfortable. She was the chaser at first. She had no brakes. It was a Big Love: really fast, really deep, really far. And she was the one who first verbalized it. She put a name to it. We came back from a holiday in Beirut, and she said: 'Now this is a serious relationship.' And from that moment things began to change. Now I'm the chaser. I always feel anxious about her true feelings. I see every little thing as a rejection. Like when she goes to sleep without saying goodnight. Or when I see her spontaneously smile with her children, in a way that she doesn't with me. And then there's touch. I need it. It helps calm my anxieties. It gets me out of my mind. It can be really small—just two seconds on the back of the neck, and I can feel grounded again. But without it I feel complete rejection. And she didn't have a problem with it for the first six months. But now she says she feels a bit cramped. She needs a little space. And then I wonder if it's me. I think of my dad. Always needing hugs, always needing kisses, always needing reassurance, too much, too much, too much. My mother felt suffocated. So I think: 'Maybe it's me.' And honestly, when I think it's a problem with me, for a moment I feel reassured. Because that means it's not a problem with us."

AMSTERDAM, THE NETHERLANDS

"He's always wanted kids. So I thought: 'We'll roll the dice and see what happens.' I honestly didn't think I'd get pregnant. They say it's harder when you're older, but here we are. I'm not confident that I'm going to be a good mom. I think of maternal women as women who've always wanted kids. I've known those people and watched those people and I've always thought: 'I'm not like you.' I'm afraid I'll resent the change. Everything stops for the kid, no matter what you're doing. I see my friends struggling to have a simple conversation because their kid keeps interrupting, or touching things, or running around. That will be new. But I'm trying to focus on the good parts. I am excited to teach it things. And hopefully I'll be changed for the better. But what if there's not a bond? You need that connection to stave off the resentment. And if it's not there, how do you fix that? I've got one friend who doesn't feel it very much. She's not patient with all the interruptions. She cuts her kids off and sends them away. She told me: 'If I'd known what was coming, I'd never have done it.'"

MELBOURNE, AUSTRALIA

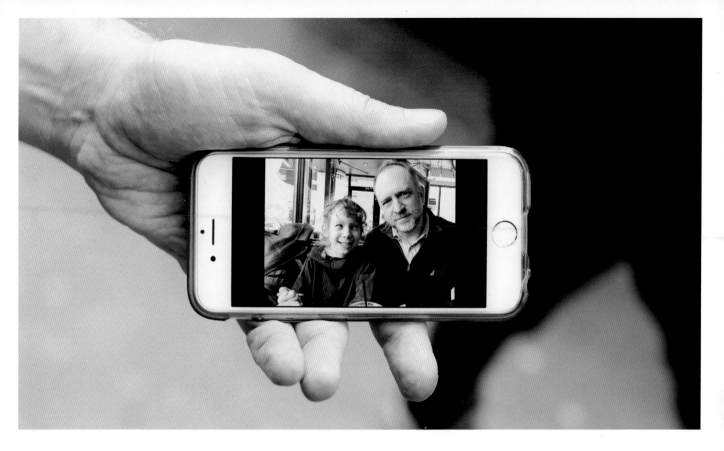

"My wife and I were eating at a rib joint in Key Largo, and we actually took out a piece of paper and made a pros and cons list. The 'con' list was pretty normal: time, money, things like that. I remember at the top of the 'pro' list was: 'Full Human Experience.' After our daughter was born, that became an inside joke with us. Every time she was screaming at bath time, my wife and I would look at each other and say: 'Full Human Experience.' The first three months were the hardest. Honestly, we wondered if we'd made a mistake. It was like a bomb dropped and eviscerated everything in our lives. But then our daughter started growing up, and learning to do things on her own, and we kept taking small steps back and getting more of our own time back. There's an unexpected sadness to getting your life back. It's like you're getting laid off slowly from an equally grueling but joyful job. She's ten now. And I'll notice that she'll be reading alone for an hour without getting bored and jumping on me. We used to make tents on the bed, now it's more homework and YouTube. Sometimes she'll go in her room for a long time and close the door. Her life is becoming hers and I'm fascinated by where it's going to go. But it's bittersweet that she needs me less and less."

NEW YORK, UNITED STATES

"We're starting a new playgroup. The first day went pretty well because he had a friend there, but yesterday was not good. He didn't want me to leave. He kept screaming: 'I want my mummy, I want my mummy.' He wasn't feeling safe. He wasn't feeling sure. But I couldn't stay, because my work starts at nine a.m. I felt like I'd let him down. I went straight to the car and called a friend. It's such a hard thing to negotiate—giving your child space. It begins immediately, when he grows too big and has to leave your body. Then after that it's ongoing. There's always more space to be had. When do I let him pick out his clothes? When do I let him cross the street? When do I honor his fear, and when do I tell him that he'll be 'just fine'? Recently I've been letting him go further and further on the bike. Today my rule is this: I have to be able to see him. But within that space, he has complete authority."

AUCKLAND, NEW ZEALAND

"We're talking about how important it
is to take a shower every day."

"I had to take a bike ride to get away from my teenage daughter. She missed the deadline for her college application, but she lied and told me that she'd sent it in on time. I believed her. I decided to give her space and let her do it on her own. Then yesterday I found a letter saying that her application came too late. So I cooked her dinner. I let her have a nice meal. Then I served her the letter for dessert. We started arguing. She told me that she wants to take a semester off. She thinks I'm bossing her around and she wants to do things her own way. But I worked two jobs for this girl. I raised her on my own. I've given her everything. She was born at 11:58 p.m., two minutes before my birthday. She looks just like me. She acts just like me. And she's stubborn like me. Whenever we butt heads I think, 'Oh my God. I'm Angie. I'm fighting with my eighteen-year-old self.' Except I was already pregnant with her older brother by then. And I just want things to be easier for her."

NEW YORK, UNITED STATES

"I've detached myself from everyone
who tries to tell me what to do."

RIO DE JANEIRO, BRAZIL

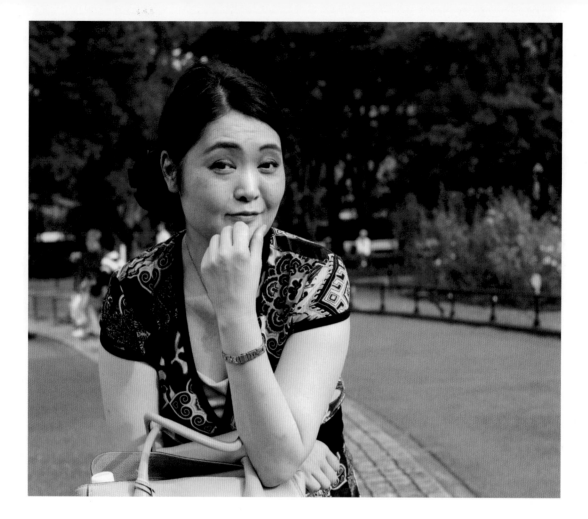

"I'd been living by myself since the age of fifteen. So he was the first person I ever met who felt like family. But he told me: 'If you want to get married, you have to stop dancing.' At that time I was dancing for two or three hours a day. He knew it was my biggest joy in life, and he resented it. He wanted all my attention for himself. So he made me quit. Things became worse when we married. He controlled every aspect of my life. Whenever I wanted to do something, it was always: 'no, no, no.' I couldn't own a cell phone. I couldn't meet with friends. I didn't have any social interaction. For seven years I stayed like this. His drinking grew worse as time went on. He became violent. He eventually beat me so badly that I ran away to a domestic violence shelter. There was a small park by the shelter, and every morning I walked through it. One morning I passed some people playing music. I stopped to listen. And I began to dance. I closed my eyes. I remembered some traditional movements, but the rest I improvised. I could hear people applauding. I began to tremble. Something overflowed inside me. It was the first time in years that I was allowed to be myself. And in that moment, I decided to leave him."

TOKYO, JAPAN

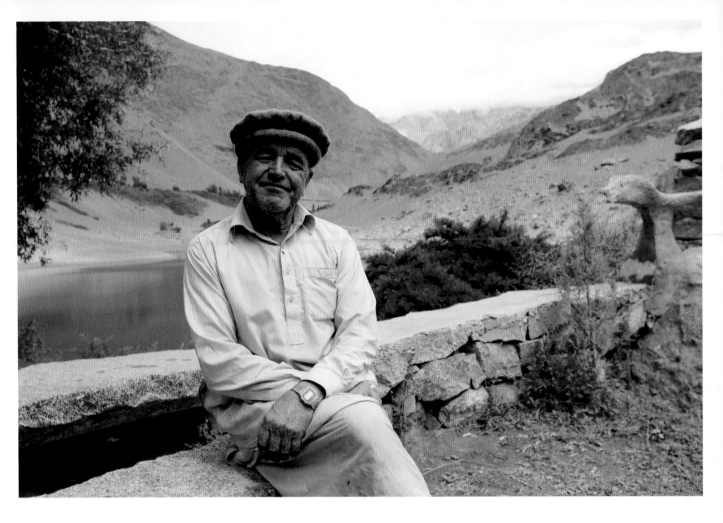

"When I'm bored, I call up Radio Pakistan and request a song, then I start dancing. I'll even dance on a rainy day. It's my way of expressing how grateful I am. I am the happiest man in Pakistan."

PASSU, PAKISTAN

"My mother's friends say that I'm just like her. She died of breast cancer when I was two years old. I had to grow up fast because my father was always working and seldom around. I was doing my own laundry at the age of seven. I figured the puberty thing out on my own. During high school, I'd leave for entire weekends without my dad even asking where I'd been. Then one year at Thanksgiving, my aunt told me that my mother had left me a letter and a video. She got so angry when I told her I'd never gotten it. I confronted my dad about it, and he said that he 'remembered something like that.' He drove me to a safety deposit box—but the box was empty. He couldn't remember what happened. He had one job. One thing that would mean more to me than anything else, and he couldn't do it. My mom's friends always tell me: 'She would be so proud of you,' or 'She was so in love with you.' But that's not the same. It's not the same as something directly from her. Something she made especially for me. Just one thing that actually says: 'This is how much I love you.'"

NEW YORK, UNITED STATES

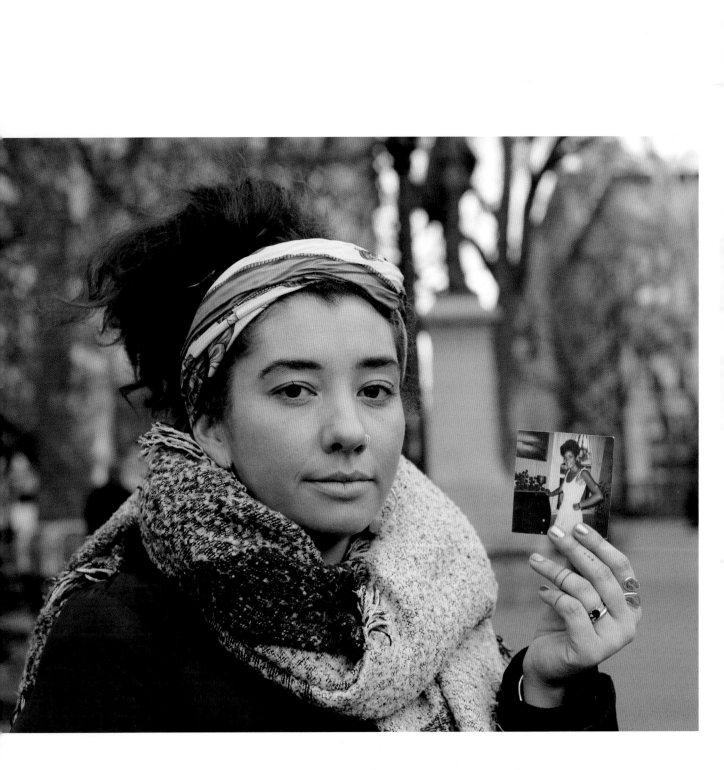

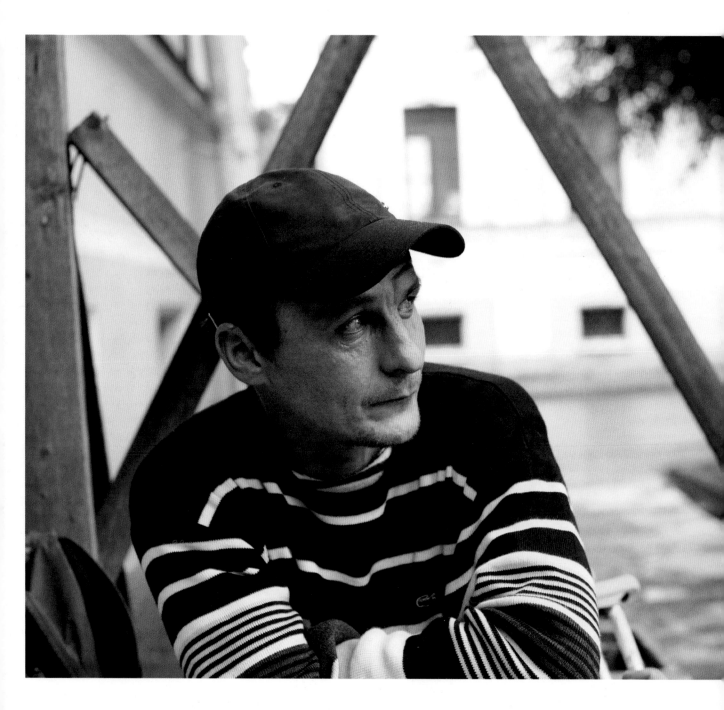

"There's a line from a Russian poem. It says: 'We love just once in a lifetime. And spend the rest of our lives looking for something similar.' I've had other girlfriends after Oksana. But I don't remember their birthday. Oksana's birthday was July 29. She was a Leo."

"My parents disappeared during the last dictatorship. They were political activists. My father was taken first in 1977. My mother was taken a year later during the World Cup. We were standing in a public square, and two cars stopped, and they grabbed me and my mother. They let me go. But my mother was never heard from again. I learned all of this later because I was only three at the time. My grandparents raised me. When I was a child they would tell me that my parents were working. I used to imagine them building a skyscraper, wearing helmets, and getting closer and closer to the top. It wasn't until the age of ten that I learned what really happened. But even then, my parents were only ideas to me. They were two-dimensional. But when I turned seventeen, I visited the town where they first met. I found their old friends and they told me stories. I learned that my father loved the Beatles. He also loved to dance. A man gave me a costume that my father would wear when he danced. And suddenly my parents weren't ideas anymore. They were people. They were Daniel and Viviana. And for the first time, I cried for them."

BUENOS AIRES, ARGENTINA

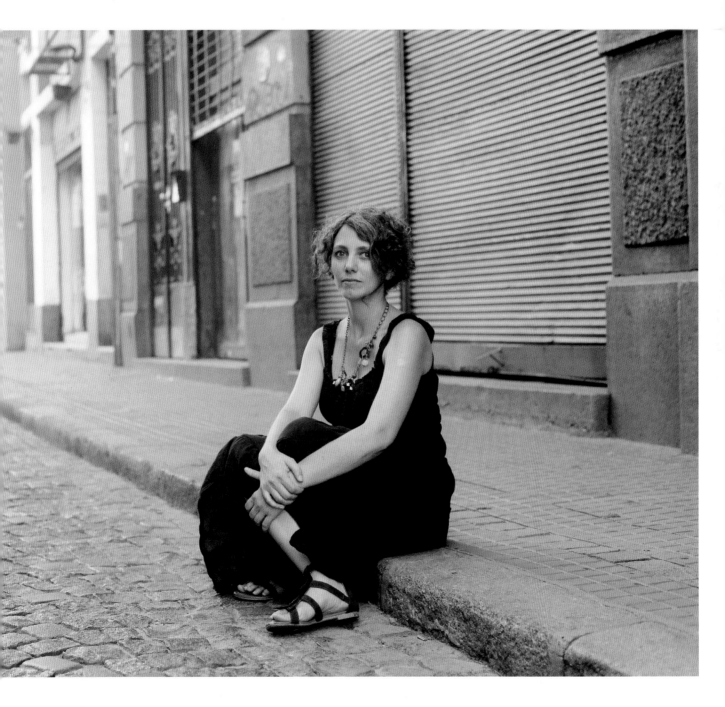

"My mom died of cancer a few years ago. In every sense she was the perfect mom. She always tried to encourage me when I was younger. I was really shy, so she always worried about me being alone. She would ask things like: 'Have you met anyone at school?' or 'Does anyone like the same things you do?' She always knew when something was wrong. I never had to tell her anything. But Dad was the opposite. He ignored me. He never did anything wrong. He wasn't an alcoholic. He wasn't violent. He was just nothing—like a chair or a piece of furniture. His only idea of fatherhood was going to work. He never reacted to anything in my life. Not the good things, or the bad things. He didn't react to me staying out late. He didn't react when I experimented with drugs and alcohol. I made my mom very sad by trying to get my dad's attention. A few years ago I got hit by a car. When I woke up from my coma, I called home to tell my parents what happened. My father answered the phone. I told him everything. All he said was: 'Your mother is asleep right now. You can call her tomorrow.' That hurt me worse than being hit by the car."

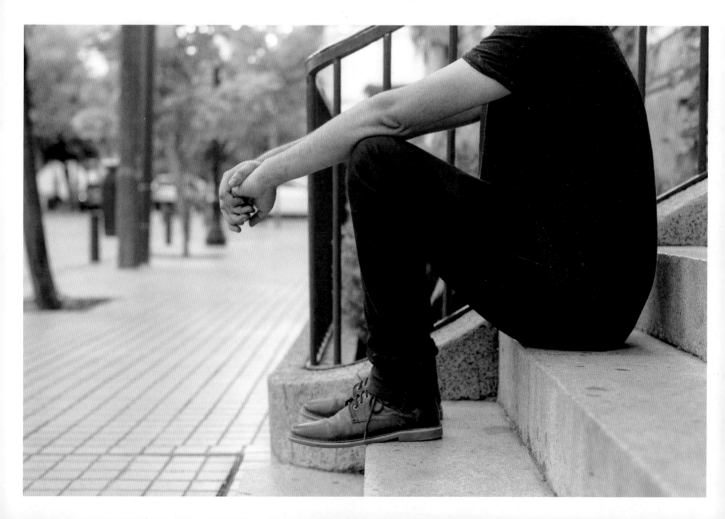

"One day I found a box of old love letters that my dad had written to my mom. They were romantic letters. They said nice things. I was surprised because I'd never seen him say those things. All of that had disappeared before I was born. My father had never told me anything about himself. Everything I know about him, I learned from my mom. She told me that the romance had been an act. She told me that she later realized he was a very cold man. But Mom always told me that we shouldn't blame him. She said he had a very rough childhood. His father abandoned the family when he was very young. His mother married another man, and sent him to live with an uncle. She raised an entirely new family and left my father behind. He had a very lonely childhood. So my mother always told me: 'You must not blame your father.' She told me that always. Especially after she got sick."

SANTIAGO, CHILE

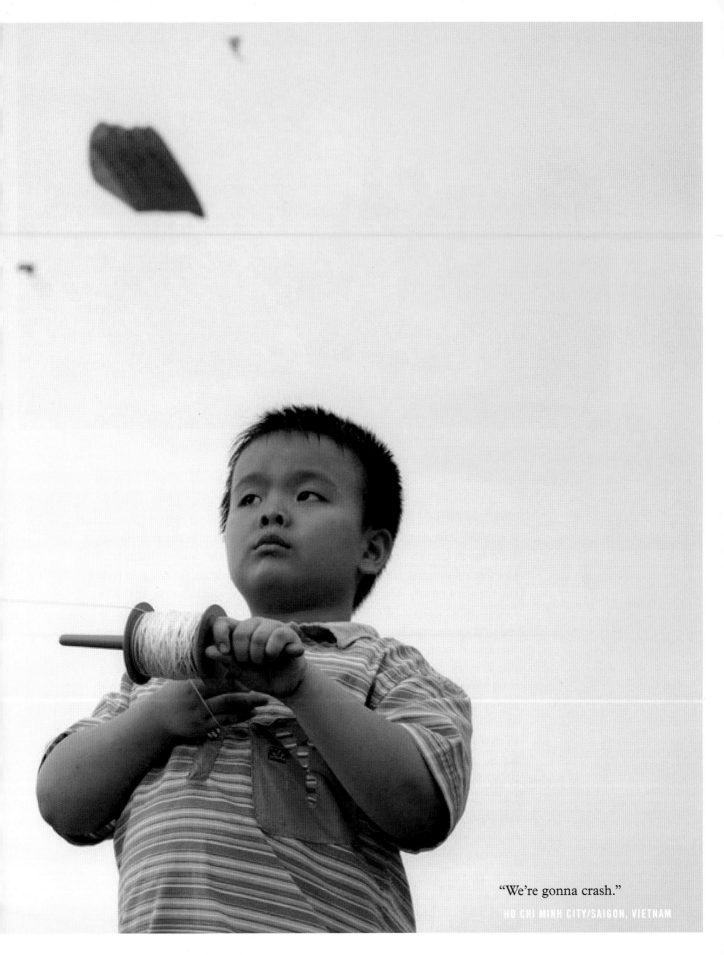

"We're gonna crash."

HO CHI MINH CITY/SAIGON, VIETNAM

"One day she told me she was getting a lawyer. I tried to play catch-up, but it was too late. Apparently I wasn't enough of a leader in the relationship. We'd fallen into too much of a routine. Or at least that's what I was told. I've been alone for thirteen years now. The hardest part for me was losing the sense of family. My youngest daughter barely speaks to me anymore. I've seen her maybe fifteen times since the divorce. I have a five-month-old granddaughter that I haven't even met. I don't understand it. I wasn't that bad. I didn't openly argue with their mother. I never had an affair. I was present. I was affectionate. Maybe I was a little strict, but she was a tough teenager. We were afraid for her. She was only fifteen and going to nightclubs. There was a lot of screaming back then: 'You're an asshole,' 'You're not my father,' things like that. And maybe her mind is still locked in that time. Now we speak maybe once a year. Whenever I ask her about it, she feels attacked. It's awkward. There's no familiarity anymore. And it's not getting any better. Time is working against us. Because I feel like I'm losing the feeling of being a dad. Of loving. Of caring. Obviously that's not true, or I wouldn't be talking about it. But everything fades eventually. At least when someone dies, you can mourn. It's so much harder when someone just disappears."

PARIS, FRANCE

"Mom turns one hundred and three this August. I try to spend four afternoons a week with her. There are a lot of things she doesn't remember. But she's great with nursery rhymes and songs. So we come down here and sing the ones that she remembers."

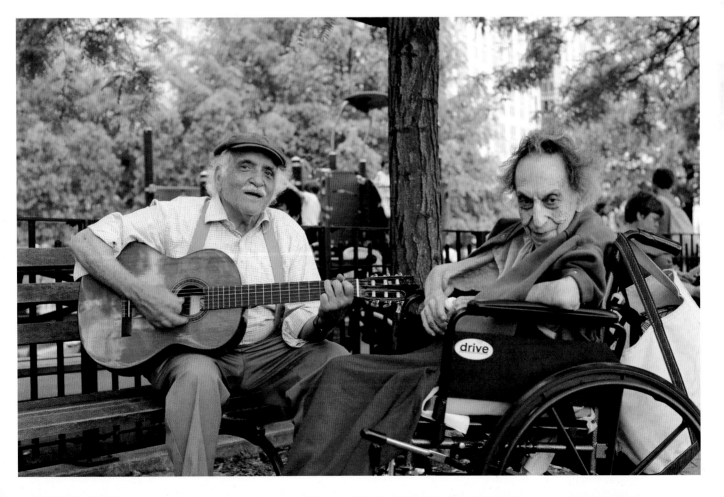

"It's a question of point of view. How can consciousness exist in a material world? Perhaps consciousness is an illusion. But if I perceive consciousness to be an illusion, then surely I must exist. These questions give me so much anxiety. I can't stop thinking about them. I'm not attentive when other people speak to me. I forget to clean my room. I don't do my homework. I can't learn my lines in drama class. It creates so many problems in my life. My parents tell me: 'You could win this award.' Or: 'You could easily make these grades. But you don't care enough.' They've taken me to ten psychologists. Never a diagnosis. They just say that I'm a dreamer. And in this world dreamer is not good. Dreamer means child. I need to become an adult and do material things. So that I'm stable. So that I can buy a house one day. So that I'm not just living beneath a bridge—thinking these thoughts. But it's so hard to find the energy. Before I begin, I must know if life is absurd. I can't live in an illusion. I want to be lucid. I need to know that I'm doing things for a reason. That I'm expending energy for a reason. If death is the end of all this—and nothing but emptiness after that—then it's a terrible problem. It would be better to not exist than to exist in a world without meaning."

LONDON, ENGLAND

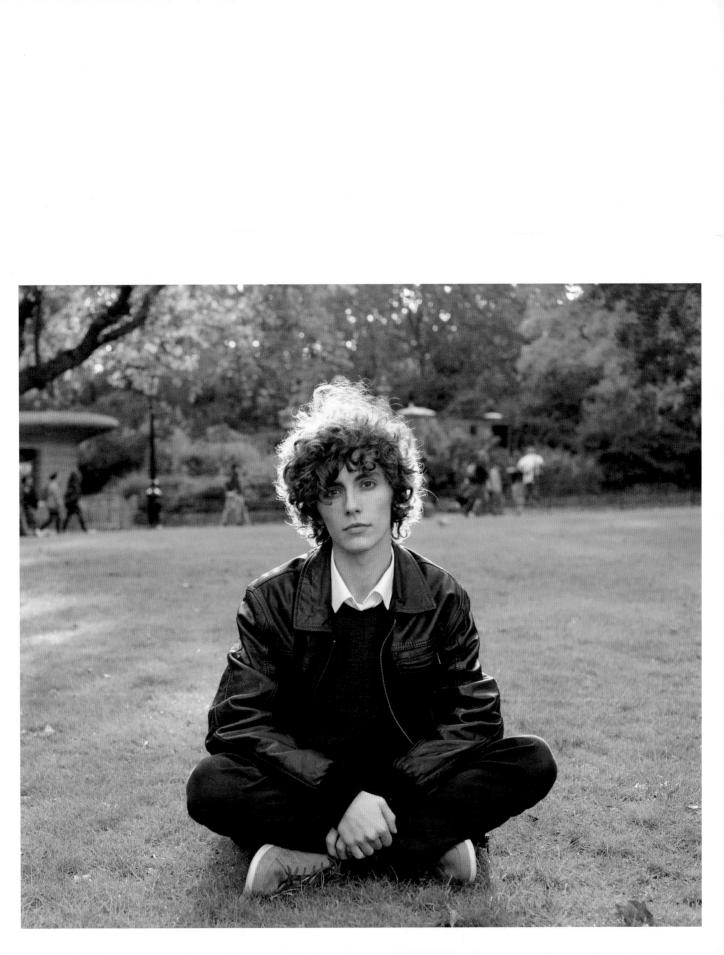

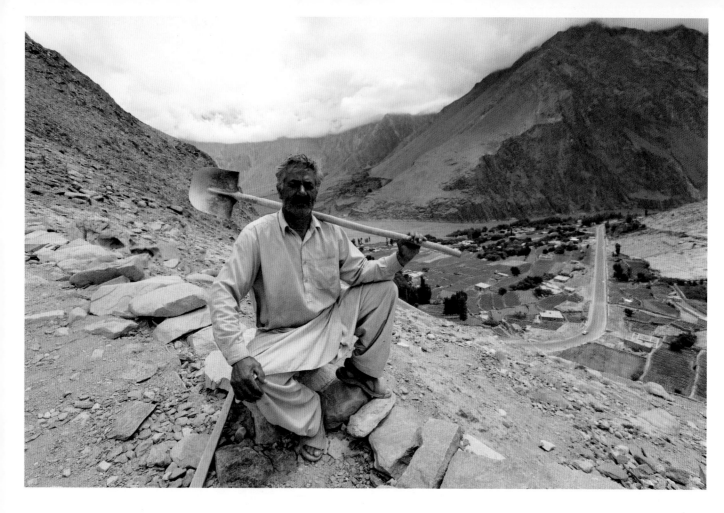

"My life is on repeat, every day. This area is surrounded by water, but my village has no access, so every morning I make a two-hour trek to the glacier so we have something to drink. During the day, I work to maintain this road. I get one hundred dollars a month. In the winter, I make daily trips to cut wood so we can stay warm. I can't leave this land because it's all I have. There is no happiness or sadness in my life. Only survival."

PASSU, PAKISTAN

"My husband is a mechanic, but his business is slow. It's not enough. I'm selling this so my children can go to school. I want them to go above me. I want them to be a great someone in this country. When I see them happy, I feel happy. Every time I pay their school fees, they tell me: 'Mommy, you are the best mommy.' So I'm out here all day in the sun. Then I go home, I cook, I bathe, I put them to bed, and then I go to sleep. I've been sick with malaria this past week. I haven't been able to work. My husband wants me to rest but the kids are beginning to cry from hunger. The stress is too much for him alone. When I was lying in bed, I just kept praying: 'God, help me go sell.' But every time I went outside, my fever was too much. My body felt too cold. And I had to go back inside. Today is my first day back to work. I woke up with no headache, but it's so bad right now. There's pain all over my body. I'm just hoping to sell enough to buy tomorrow's supply."

LAGOS, NIGERIA

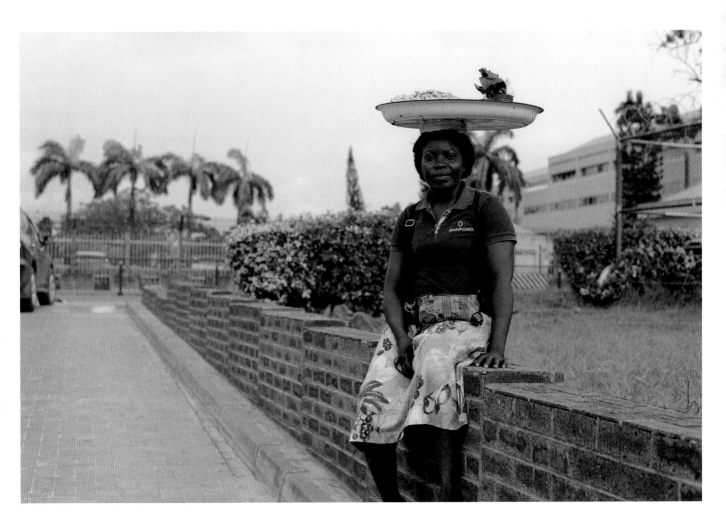

"The landlord doesn't care how much
furniture you've sold this month."

KAMPALA, UGANDA

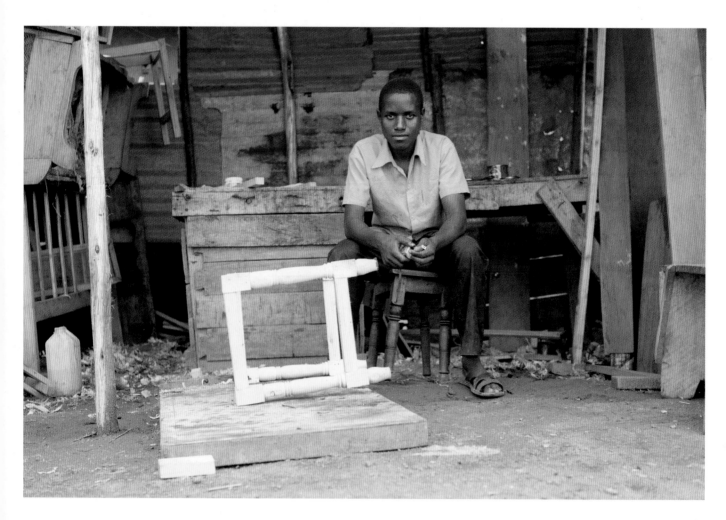

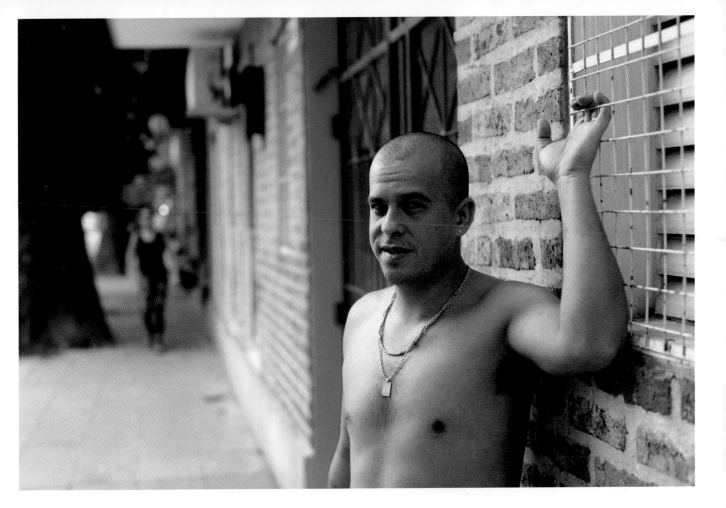

"All the workers on my oil platform were laid off five months ago. I didn't save the money when I had it. Now it's been six months since I last worked. I even had to ask my mother-in-law for money last Saturday so I could buy milk for the kids. I have to do something. Maybe I can drive a taxi or something. If I don't get a job soon, I think the family will break apart. My wife is always asking me what I'm going to do. It's like she doesn't even understand what's happening in the economy right now. Even my four-year-old son feels that something is wrong. He's started to ask me when I'm going back to work. I lie to him. I tell him I'm on medical leave. I don't want him to feel this stress too."

BUENOS AIRES, ARGENTINA

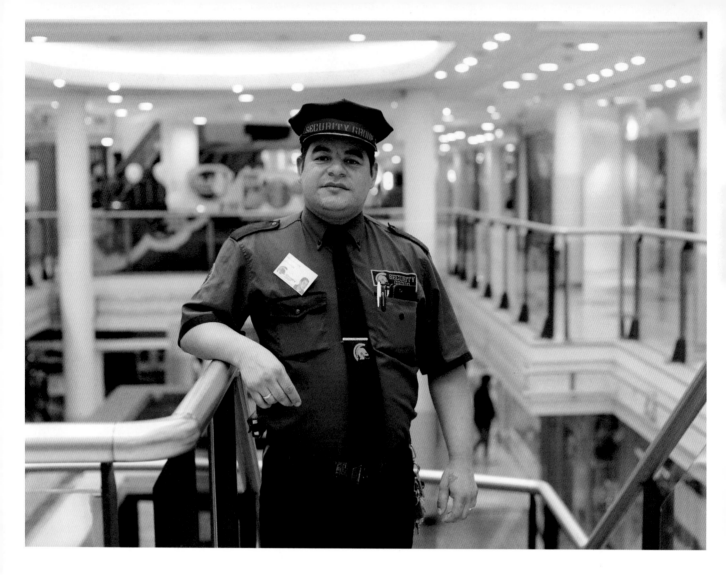

"Last December my wife lost her job, and now we're struggling to get to the end of every month. Around the twentieth, we always realize there's no money left. Half of my paycheck goes to rent. And we're still in debt from our wedding. We can't afford to go out anymore. Our diets have changed. Now it seems like money is all we talk about: what bills to pay, what to keep, what to leave out. She thinks I spend on the wrong things. I think she spends on the wrong things. So we end up arguing. But I have faith we will pass this test. Both of us came from difficult backgrounds. She was adopted. My mother abandoned me when I was young. We both know what it means to struggle, and that's why we chose to be together. I came to this city from a small town because I was looking for happiness. And I found my happiness in her. So we're going to figure this out."

ROSARIO, ARGENTINA

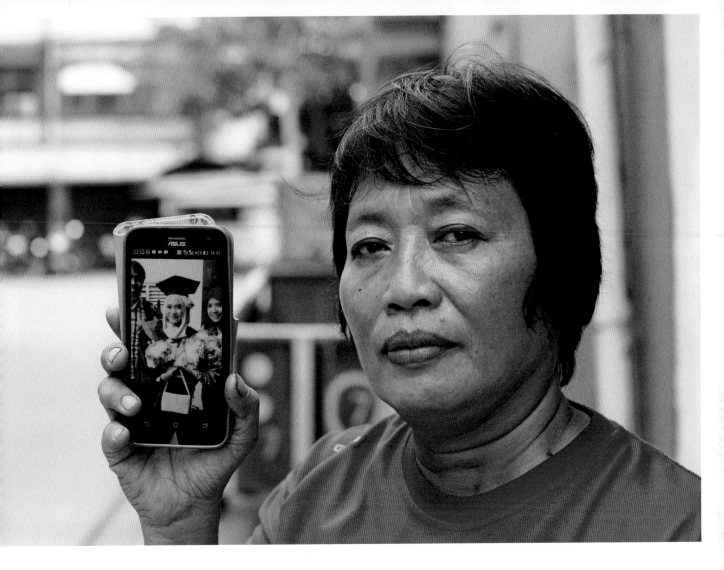

"My daughter was about to graduate high school when I lost my husband to a motorbike accident. She wanted to go to university but there was no one to support us. I'm an old-fashioned person. I'm not very smart. I only graduated from junior high school. But I wanted her to be better than me. I asked our relatives for help, but they all refused me. Out of desperation I approached my landlord. And she was the only one who supported us. She told me: 'Get back on your feet so your daughter will have a chance.' She loaned us half the tuition. The other half I earned by working morning to night. I was doing laundry. I was doing dishwashing. I was going around selling cookies and cakes. My daughter graduated recently and became a midwife. All my hard work paid off. We've been paying back the loan. And a few months ago she asked for my bank account number, and she's been putting money in every week."

JAKARTA, INDONESIA

"I wanted to be a billionaire by the age of thirty. It was a literal goal. I wanted to be the African version of Bill Gates or Warren Buffett. My parents always told me to work hard, and the money will come. It just seemed like the prize you got for checking all the boxes. And I always checked the boxes. I made straight A's. I went to Howard University. I worked at Goldman Sachs after graduating. The plan was to make money, build relationships, then return to Ghana and create some businesses. But my first business took too long to get off the ground. Then I got frustrated and poured all my savings into another business. Both of them were self-sustaining for a while, but it's been a struggle since then. Right now I'm trying to raise more funds and it's not going well. And I'm a far reach from where I wanted to be. My confidence is shaken. I'm unsure of my next step. And I'm approaching forty. I'm trying to manage the disappointment by changing my perspective. I try to remind myself that I have a beautiful wife and son. I've employed people. And I've had some great experiences. I no longer feel the need to be a billionaire. My new goal is to have a successful business that I can work at every day. But in the back of my mind, I keep wondering: 'Am I developing a more realistic perspective? Or is this what quitting sounds like?'"

ACCRA, GHANA

"My family has been making these leis for generations. People place them on the lap of Buddha statues. It's a very holy flower. It bought my great-grandmother a house. And paid for my engineering degree."

"I'm thirty-nine years old
and I've achieved everything
I've ever wanted. Now I have
absolutely no idea what to do."

RIO DE JANEIRO, BRAZIL

"I didn't want to be a mother. I was eighteen. We weren't in love. I had goals I wanted to accomplish. So I made the hardest decision of my life. It's not legal here. So I researched it on the internet. I did it myself. In my room. If things had gone wrong, I could have died. Seeing it come out of me was the worst moment of my life. And I couldn't tell anyone. Not even my parents. So I carried the secret with me. I felt like this thing was always in my chest, but it was stuck there. All day I'd act normal. Then at night I'd go to my room and cry."

"My boyfriend left as soon as I got pregnant. I was terrified to tell my father, but he discovered my pregnancy test hidden in a drawer. He didn't speak to me for a few days. We'd always been close, so I knew something was up. Finally he asked me if I wanted to tell him something. I began to cry. I thought he was going to kick me out of the house. But he just went to speak with my mom in the other room, and when he came back, he asked what I planned to do. I told him I wanted to keep the baby, and from that moment on he was very supportive. He cooked me all kinds of dishes whenever I had cravings. He gave me words of encouragement. He started saving money in case I needed a cesarean section. But during my seventh month he came down with a fever after wading through floodwater. We dropped him off at the hospital, went home to get clothes, but he died by the time we got back. It was so sudden. I had no idea what I was going to do. I got all my strength from my father. It seemed like keeping the baby had been a mistake. It's been a tough few years. I had to drop out of school and find a job, but my son is doing well. He's very smart. He comes home from school with stickers and stars. He's a 'Mama's boy.' It's been hard, but I've proven to myself that I didn't have to end a life just because I couldn't face it."

MANILA, PHILIPPINES

"I want to have my own career. I don't want to depend on anyone else. But there's a view in our society that an independent woman doesn't belong here. She is not 'one of us.' So if you want to do some things on your own, they expect you to do everything on your own. And that's difficult. Because wanting to be independent doesn't mean I want to be alone."

KARACHI, PAKISTAN

▶ "I've fallen in love with literature. I try to read for one or two hours every day. I only have one life to live. But in books I can live one thousand lives."

RASHT, IRAN

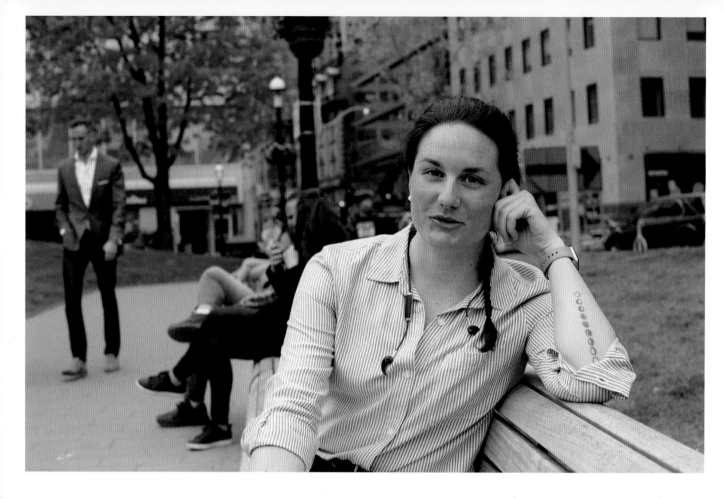

"Honestly I just fell into it. I started as an engineering major. Then one night I was slaving over my physics homework, while my roommate sipped tea on the couch and read a novel. So I decided to be an English major like her. Ten years later I'm working as a copywriter at an advertising agency. You know that feeling when you're pulling into the driveway, but you can't remember anything about your ride home? That's a bit how it feels. Like I blinked and I'm eight years down a career path that I just sort of fell into. There's plenty to be grateful for. It's a good enough job. I'm not living paycheck to paycheck. I can afford to have fun and take vacations. But my job is not my passion. And every story you see elevated on social media is: 'I loved this thing. It became my passion. And then it became my career.' There's not many people saying: 'My job isn't my passion, but I love mountain biking on the weekends. And that's enough for me.' I think the feeling I'm trying to resolve is a sense of 'enoughness.' There's so much I love about my life, but I spend most of my time at work. Is it OK to get my joy outside of work? Or does my passion need to be tied to my livelihood and a sense of responsibility?"

TORONTO, CANADA

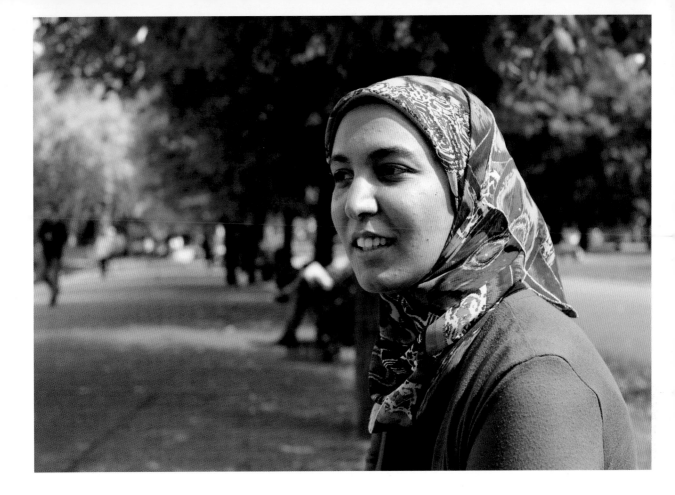

"I didn't feel anything. It's not even a holiday here. I woke up early, walked through the streets, and listened to prayers on my headphones. I might have bought myself a cupcake after dinner. If I was back in Egypt, I'd have gathered with the whole family for dinner. We'd have a specific type of juice—dried figs, dates, apricots in water. On the way to the mosque we'd give all the children treats. Everyone would speak to each other in the streets. It's quite beautiful. You see all the happiness around and think—'Yes, it is Eid.' But here I celebrated all alone. My plan has always been to go back home eventually. I knew if I wanted to go further in journalism—I would need to study in the West. But the plan was always to go back. I always imagined having a family, and getting married the traditional way. But I'm finishing my doctorate in November. And now that it's getting close—I'm not so sure. It feels like maybe I'd be sacrificing myself for tradition. I'd be like everyone else: becoming a mother, raising my children, and nothing else. Maybe I could become a lecturer at a nearby university. But there's not a research culture. It's not about innovation. You can easily get stuck teaching the same content for years. I want to keep going to conferences. I want to travel—not just for tourism, but to do something important. To develop myself. To share my ideas. To have people say: 'We learned from you.' I don't have to be better than everyone else. I just want to contribute. But at the same time—my mother is back home. She's all alone. She's growing old. And I don't want to miss this part of her life. I'm not sure what to do. But I need to decide soon."

LONDON, ENGLAND

"I'm trying to be an artist, but my parents just don't understand. I showed a painting to my mom, and I was like: 'Do you like it?'

And she was like: 'I guess, but why is there a cigarette? Are you smoking now?'

And I was like: 'No, Mom. The cigarette represents pain.'

And she was like: 'Did we not love you enough?'"

TEHRAN, IRAN

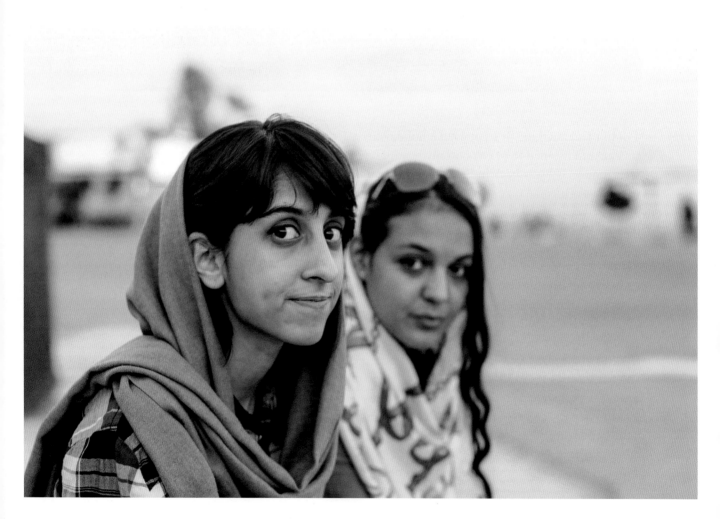

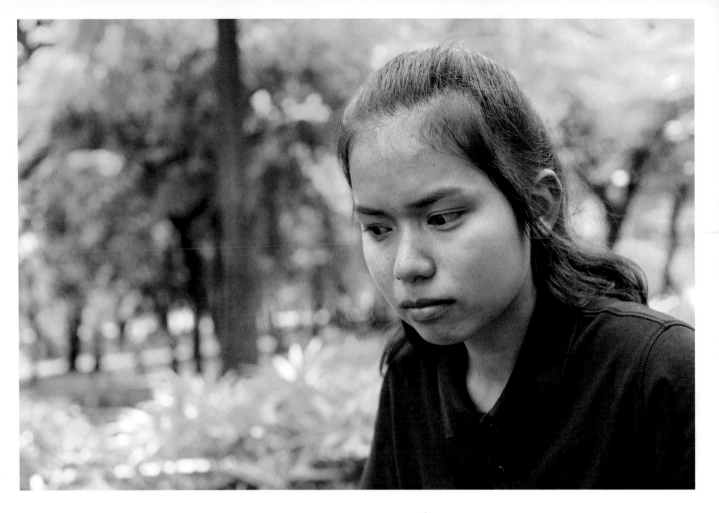

"My dream is to be a teacher one day. I think I'd love it. I really love small children, but my parents are farmers. They can't afford to send me to school. And universities are opening for registration next month, so I need money for tuition. Right now I'm living with relatives in the city. I'm waking up at seven a.m. and trying to sell bags at the mall. But I can only make three hundred dollars a month, and it's not enough. It's so expensive to live here. I have to pay rent. I have to feed myself. And it's too hard to save money. Every day after work, I sit on this bench and think. Maybe it's better if I just go home. But I wanted to be a teacher. I didn't want to spend my life working in the sun."

BANGKOK, THAILAND

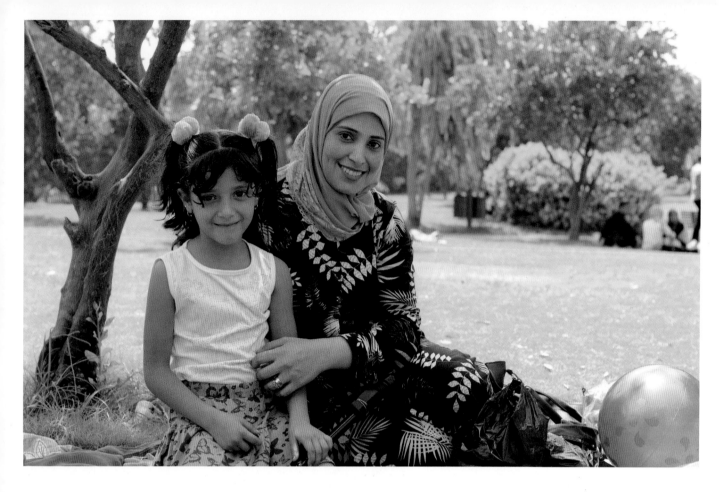

"I'd always dreamed of getting a college degree, but I got married right after high school. We started having children right away, so it wasn't easy to convince my husband to let me study. The one time I tried to mention it, he immediately said no. But a few years later we were in the passport office and I saw an advertisement for a university. I pulled on his sleeve, pointed at the sign, and said: 'Let's take a look. It's only a look.' That very same day I enrolled in classes. Each night I'd wait until two a.m., after everyone's demands had been answered, and the whole house was asleep. Then I'd begin my studying. I'd work until morning, wake the children up, and prepare them for school. Only then could I rest. It was exhausting but I was so happy. It felt like I'd gone back in time and my kids were my siblings. During my third year I was pregnant again, and I was terrified that I'd go into labor during my final exams. But I got my diploma. It was the happiest day of my life. My husband was thrilled for me. Everything is different now. I understand the world. I used to be afraid to leave the house. But now I feel powerful. And it shows."

CAIRO, EGYPT

"When I was six months old, I was dropped off at an orphanage in Northern China with a little note pinned on my shirt. It only had the name of my village. The orphanage named me Gaoanna, which translates to 'Girl From High Mountains.' My mother decided to adopt me after she received my picture in the mail. She was forty-five at the time. She had recently gotten divorced. She'd never had children. So it's just been the two of us my whole life. I remember one time in high school, we got in an argument and my mom got very emotional. She started crying and said: 'We can't fight. It's just the two of us. We have to stick together.' At that moment I realized how much I had changed my mom's life. She'd known from the start, of course. But it was something I needed to learn."

NEW YORK, UNITED STATES

"They didn't say a word. They just started firing into the air and lighting our houses on fire. The burning began on the north side of our village, so we fled south into the forest. We walked all night through the dark. I could hear people in the forest all around me. We were too afraid to rest. When the sun began to rise, everyone panicked and started to run. I noticed two children leaning against a tree. Both of them were crying. The boy said nothing. The girl would only tell me that her mother had been killed. When I asked if they wanted to come with me, they nodded yes. I'm taking care of them the best I can, but it's difficult because I already have a large family. I think they are happier now. The girl has made some friends in camp. But she still keeps asking about her mother."

ROHINGYA REFUGEE CAMP, BANGLADESH

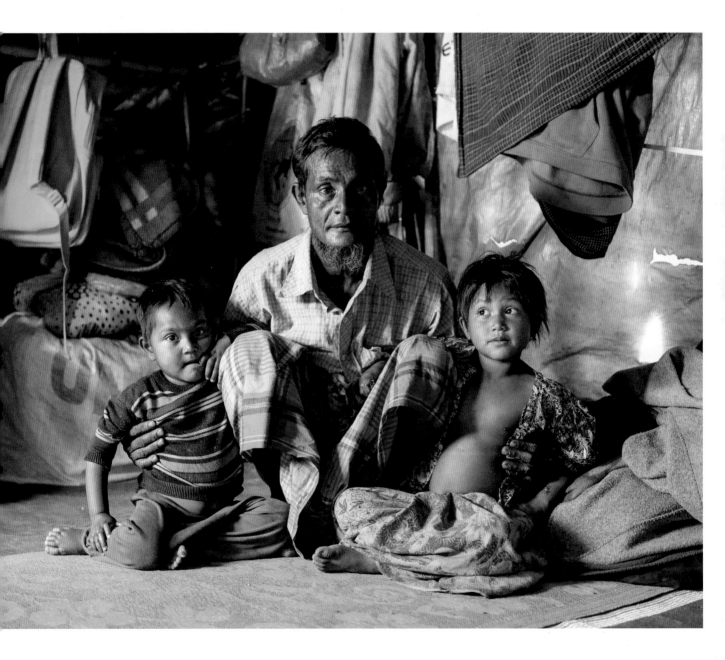

"Ms. Purevsuren is everything to me. She's the best special education teacher in all of Mongolia. She loves all of her students. When my mother died two years ago, my school wanted to send me to an orphanage. But Ms. Purevsuren volunteered to take care of me. She has children of her own and her salary is low—but still she takes care of me. She lifts me up. She pays for all my expenses. She cooks me food every night. She even gathered a collection to buy me this judo uniform. It's the first time I've ever worn new clothes. My mother would be so happy if she could see me right now. She'd be so thankful. I want so badly to win a medal, but I know that's just a small thing. One day I will truly pay Ms. Purevsuren back. I will become an adult. I will make her proud. And I will take care of her when she's old—just like she took care of me."

SPECIAL OLYMPICS WORLD GAMES, ABU DHABI, UNITED ARAB EMIRATES

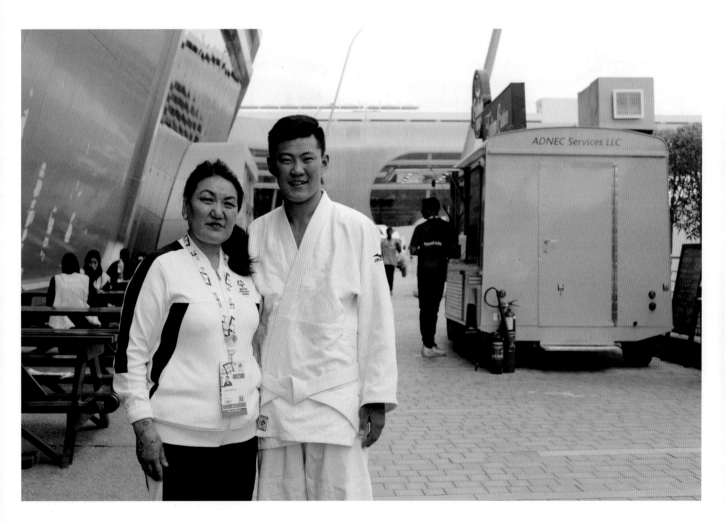

"Papa loves Ibrahim. He's my beloved. He's my whole world. I have four other sons, but I love him a little more because he needs it a little more. The doctors recommended an abortion but I wouldn't hear it. He was only three pounds when he was born. He needed half a liter of milk per day. I'd skip my own breakfast just to buy it for him. I took him to nurseries when he was very young because I wanted him to be comfortable with other children. I found a charity that offered speech classes, and I took him five days a week. Anything that I have, I will give him. I only worry what will happen when I'm gone. I'm getting old. I had a major heart episode two weeks ago. I collapsed in the street and all I could think about was him. My wife can't support him alone, and I'm afraid other people won't be as nice to him. If someone makes him angry, he's very difficult to control. But I have patience. I'll hold him. I'll pat him on the shoulder. I'll do whatever he needs. I just hope he'll always have someone to do the same."

CAIRO, EGYPT

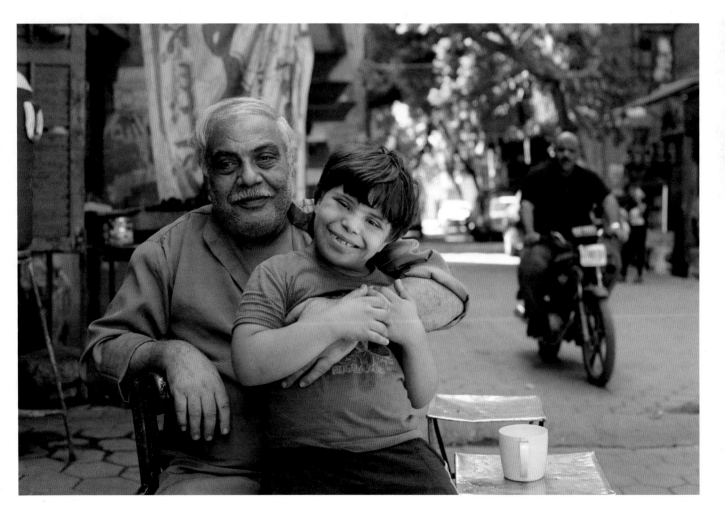

"It was the shortest day of the year: December 21, 1987. I'd stepped out of the office to go on my lunchtime run. I was jogging along the river—just a few hundred meters from this spot—and I noticed somebody pointing into the water. There was a man out there. He'd jumped off the Waterloo Bridge. I could see him in the middle of the river, waving his arms. Now I'm a total sissy when it comes to the water. When I go to the beach, I don't just race into the sea. I go inch by inch. Like a sissy. But on this day I took off my shoes and leapt into the river. It was a very high wall, and the whole way down I'm thinking: 'Shit, this is going to be cold.' But as soon as I hit the water, I got my mind on the job. I swam fifty yards until I reached the man. By that time he was unconscious, but I pulled him toward the shore. A police boat arrived and hauled us out with ropes. They took me to the station, filed a report, gave me some old clothes, and sent me on my way. There were no newspaper articles. No interviews. I told nobody except for my boss, because I had to explain why I was late for my 2:45 meeting. But I did get one little thing. Hanging in my home, at the top of the staircase, there's a certificate from the police commissioner. It says: 'Gallantry Award: Rescued a Drowning Man from the River Thames.'"

LONDON, ENGLAND

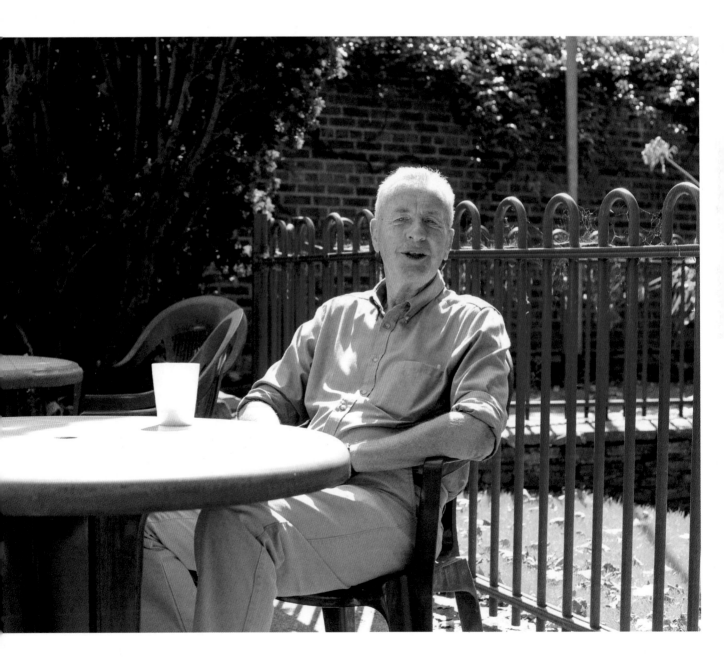

"This is the first time in my whole life that I got a gold medal in the World Games. I was very calm and controlled my emotions. When I left home, my mom said to focus hard on my trainings and make Egypt proud of you. Sometimes when I'm on my horse I pretend like my mom is right beside me and not all the way back in Cairo. I want to thank her so much. She does everything for me. My dad is in heaven and I want him to know that I miss him and that I love him so much. All the time, I hear him saying 'do a good job' and 'take care of yourself.' I want to thank God for helping me win a gold medal. I want to thank my brother Islam for calling me yesterday and saying: 'I hope you win the gold medal.' That helped so much. I also want to thank my Coach Dahlia because she is a person that I love. She is almost like my little sister. Right now I feel like life is so beautiful. I feel a smile all over my face. I love everyone. And I am feeling very much like everyone loves me because I'm beautiful."

SPECIAL OLYMPICS WORLD GAMES, ABU DHABI, UNITED ARAB EMIRATES

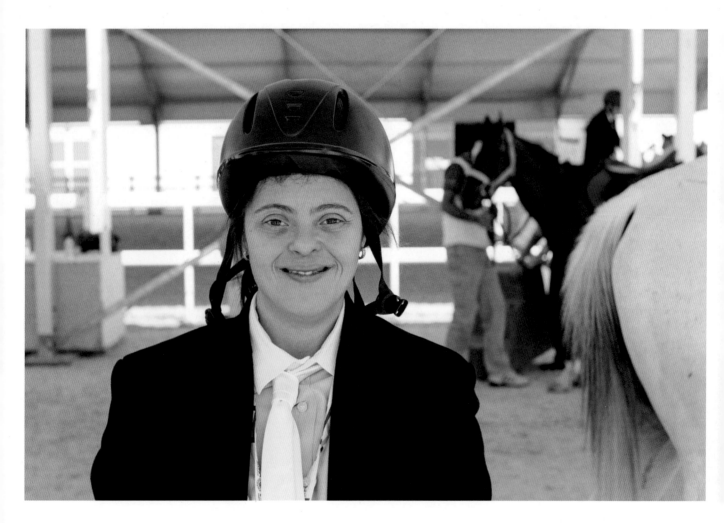

"I do lifesaving training every weekend. Sometimes we have races where we have to paddle out to buoys in the middle of the ocean. There was one really tough race a few weeks ago. The ocean was messy like today but the waves were even bigger. And there were lots of bluebottles. Those are like jellyfish but worse. My dad said that I didn't have to race, and half of the competitors dropped out, but I chose to do it anyway because I wanted to prove that I could be a lifeguard. On the outside I was ready to go but on the inside I was really nervous. Once the race started, some of the girls turned back because the waves were so big, and others were nose-diving and falling off their boards. But I made it all the way to the end and got fourth place. Everyone was congratulating me because fourth place is huge for me."

SYDNEY, AUSTRALIA

"I drive an MTA bus. I don't want to do that for the rest of my life. I've got to wake up at four a.m. every day. That's not working for me. So I'm trying to get my music off the ground. I've been handing out these CDs all day. But it's tough. I've only sold three so far. But one of the guys who bought a CD was from Algeria. So now I get to say that they play my music in Algeria."

NEW YORK, UNITED STATES

"I can draw a lot of things. I can draw trees, the sun, clouds, my mom, and my dad. I once drew a picture of a house that was so good, I had to hide it so nobody would steal it."

TEHRAN, IRAN

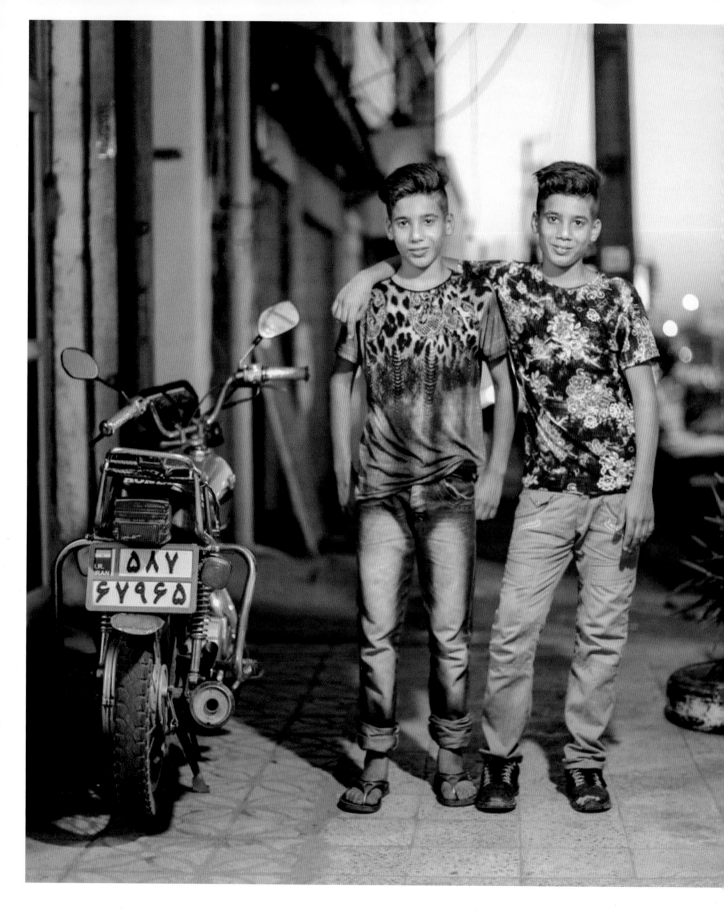

"He tried to take a social studies test for me once. But we got caught because he wrote his own name."

"My brother and I got in a fight, and now he can't get a job. So he's actually convinced I put a voodoo spell on him."

"I've been doing construction since I was fifteen. Every night when I'm heading home, I always look back to see what I've built. It gives me a great sense of joy. A few years ago I built a children's park not far from here, and on the last day, when they finally opened the gates, and all the children came running in, I started to cry."

SÃO PAULO, BRAZIL

STRUGGLE

I ALWAYS BEGIN WITH A STRUGGLE. After I've approached a person—and have explained my work and obtained their permission for an interview—I begin with the most abrupt question possible: "What's your greatest struggle right now?" Sometimes I catch the person in a moment, and there's no need to dig deeper. There's something on the surface. Something heavy, that the person has been carrying around, waiting for an invitation to unload. Maybe they just signed divorce papers. Or their father's funeral is next week. Or their son just quit rehab for the third time. These are the battles being fought all around us, just beneath the surface of polite society. Beneath the small talk. Beneath the sports, and the weather, and the politics—there's a lot of pain. It's pushing out from within. And sometimes all it takes is a question to bring it out.

There's an old cliché that "everyone has a story," but there's a reason it's a cliché. Every person has a story because everyone has a struggle. The heart of a story is the struggle—the obstacle that has been faced, and hopefully overcome. It can be an obvious physical feat, like climbing a mountain or rescuing someone from drowning. It can be a mental battle: like depression, or addiction, or schizophrenia. It can be comedic or tragic. But none of these particular elements are the reason that struggles are crucial to a story. Struggles are crucial because they're transformative. Struggles change people. And a well-told story merely follows the arc of that transformation.

It may seem depressing—walking around all day, asking people about their struggles—but the struggle is merely a starting point. It's where the story begins. It's an opportunity for reflection, and understanding, and growth. Great stories never end with the struggle. They always end with the person. Ralph Waldo Emerson famously wrote: "Every person I meet is my master in some point, and in that I learn of him." Despite having interviewed thousands of people, I still learn something new from each person I meet. Everyone has a unique expertise. The quickest way to find a person's expertise is by learning their struggle. What they've battled. What they've carried with them the longest. Because it's what they've thought about the most.

There's one final power in struggle, and I've learned it through ten years of telling stories: our struggles connect us. We relate to the challenges of other people much more than we relate to their victories. We empathize with pain much more than joy. The moment we truly see ourselves in another person is when we realize that we've felt the exact same pain. I'm not sure why this happens, but it happens. Maybe pain is the most universal feeling. Maybe there is an invisible, connective thread that runs between the loneliness of an old man and the hunger of an impoverished child. Maybe pain isn't divisible. It's singular and searing. Maybe it sinks deeper into the psyche. Whatever the reason, when another person feels it, we feel it ourselves. Recognizing pain in another person is the primary driver of empathy. It's the beginning of compassion. And the more vividly

that pain is expressed, the more clearly it's articulated, the more compassion it elicits.

We live in a time when we're sharing more of our lives than ever. So you'd expect people to feel connected. And heard. And understood. But instead there's an epidemic of loneliness and isolation. But you'd never know it by scrolling through social media. You'll see nothing but happy families, and milestones, and achievements, and celebrations. It would appear that everyone is living in abundance, because we tend to specialize in sharing our joys. We see joy as the ultimate prize in life. The ultimate signal of our capabilities. We think our joy will make us seem desirable as friends, or coworkers, or lovers. And maybe it does create a sense of desire. Or even a sense of envy. But it doesn't create a sense of connection. I think that's one of the reasons that *Humans of New York* grew so quickly on social media. Because it injected a dose of vulnerability onto a platform where everyone was trying to appear unbroken. In an endless scroll of people proclaiming their victories, you'd stumble across a person sharing their struggle. And it was different. Different enough to make you stop. And read. And connect. ◆

"I read a lot on the subject. I studied the texts. And I decided it was permissible to take it off, so that's what I did. My mom was terrified of what people would think. She asked me to delete all our mutual friends on Facebook. She said if I didn't wear the hijab, then I couldn't live at home. So I packed four big bags and went to live with a friend. It was the first time I'd ever slept out of my house. Over the next few weeks, I sent my parents messages every single day. I always told them where I was, what I was doing, and who I was with. I wanted to show that I forgave them, and that I was still their girl, and that one day things would be normal again. They didn't respond for three months. Until one holiday my uncle called and invited me home for dinner. My parents started crying as soon as I walked in the door. They'd prepared a huge meal. They said that they didn't mean it, and that they love me a lot, and that they're proud of me. Things are very good now. We get along even better than when I obeyed."

ALEXANDRIA, EGYPT

"When the presidential plane was shot down, people began to gossip about the impending genocide. The streets were empty. Nobody was traveling long distances. We started to hear tales of violence. Relatives from other regions would arrive on our doorstep with horror stories. My father came home one day and told us about a Tutsi janitor at his university, who cleaned clothes for the students. He'd been tortured to death with his own iron. I grew very depressed during this period. I wanted to be alone all the time. Some nights my family would sleep in a nearby church for safety, but I'd remain in the house alone. I could feel something terrible in the air. Then on April 21, the genocide officially came to our town. The militia gathered up Tutsi pedestrians in the city center. They brought them to this stadium. There were two hundred people in all. They put them in lines. Then they opened the doors and invited the public to fill the seats. The governor was forced to sit in the front row. He had mixed blood and was against the genocide. After the last person was executed, they brought the governor down and killed him too. His body was paraded through the streets. The killers were screaming into an intercom: 'We've killed the governor! Anything is possible! Now let the hunt begin.'"

"My father was well respected in the community. He was a university lecturer and a choir member. But he was always working, so my mother was primarily the one who raised us. Her name was Consolee. She had this deep sorrow about her. She was an orphan because her parents had been killed in the 1963 genocide. Whenever we asked her to tell the story of our grandparents, she'd just say: 'Give it time. Soon you'll see for yourself.' I tried to help her as much as I could. The eldest daughter acts like a mother in our culture, so I raised my six younger siblings. They thought I was too strict. They were always saying that I behaved like a nun. But they looked up to me too. And they loved me. Occasionally I'd help to keep them out of trouble. When my sister Francine cut her foot on a bottle, she was terrified to tell our mother because she wasn't supposed to be barefoot. I helped her conceal the crime by cutting a hole in the bottom of her shoe. At night we'd all pile into my bed. They'd beg me to tell them stories. And I always did, until they fell asleep, and I'd carry them into their beds one by one. Our youngest was a boy. He always took the longest because I had to rock him to sleep. His name was Edmond Richard, but we called him 'Bebe.' He was one and a half years old when the genocide began."

"If you are being hunted, this bush is one of the best places to hide. Every genocide survivor in Rwanda can tell you about this type of bush. It's full of thorns. But if you crawl on your stomach, you can get inside. And if you can get inside—you can finally take a rest. The best hiding places are always the most dangerous ones. Farms were no good. Everyone who tried to hide on a farm was discovered. Toilets were no good either. Because that's where they dumped the bodies. You wanted to find a place where the killers were afraid to go. The higher the risk—the less chance of getting caught. Swamps were one of the most popular choices because there were so many ways to die in there. It was easy to get stuck in the mud and drown. Most of us couldn't swim. Or the mosquitos could give you malaria. Or you could be killed by a single snakebite. But the worst were the crocodiles. I'd say fifty percent of the people who hid in the swamps were eaten by crocodiles. My brother tried hiding in a swamp. And he actually survived all these things. He made it all the way to the border with Burundi. But then a helicopter dropped fuel from above and set his swamp on fire."

"Our family was a top target because my father was so prominent. So when the genocide officially commenced, the killing squads came straight to our home. One of our neighbors peeled away from the group and ran ahead to warn us. He came down our street, screaming at the top of his lungs: 'Run away! They are coming to kill you!' My mother immediately dropped to her knees and started to pray. My father yanked her off the ground. He told us all to get out. Everyone ran in different directions. I don't know why we split up, but there was gunfire and screaming all around. I followed my mother and sisters to a nearby plantation. The baby was with us. We stayed there for four days. But I didn't feel comfortable. All around I could hear people hunting for us. They were calling our names. We needed to find a new place. I begged my mother and sisters to run away with me, but they were too depressed. They didn't have the energy to move. So I went alone and returned to our house. I was looking for our father. I crouched down in a nearby bush and waited for him to return. Early in the morning, a crowd of people came marching over the hill. My father was in the center. He was so tall that I could see his face. They marched him to this very spot, because he'd asked to be killed at his own home. I could see everything from the bush. I closed my eyes. I said: 'Please God, please change this man. Please make it a different person.' But when I opened my eyes—it was still his face. I saw everything. And the whole time I was trying to imagine it wasn't him. But when I opened my eyes, it was always him. They finished him off with machetes. When they finally left, I walked over to look at his body. He was seconds away from death. But he was still moving his head back and forth."

"On the day I watched my father die, this is the skirt I was wearing. I was only eighteen years old. I completely lost my will to live. I walked down the street like a zombie. I came to this house. The owner wasn't home at the time because she was busy looting my family's home. I tried to hide under her bed, but there was another Tutsi man there. He began yelling at me to leave. 'It's too small,' he said. 'You'll get us both killed.' So I ran outside to jump in the toilet, but the killers were already at the door. They dragged the man out from under the bed and killed him before my eyes. They were about to kill me too, but the team leader said he had 'other plans for me.' And everyone listened to him because he had a gun. He started leading me toward a plantation. He told me to comply or he'd kill me. He made me lie down on the ground. He unbuttoned his shirt, lay down next to me, and tried to spread my legs. So I grabbed his balls and squeezed as hard as I could. He started trying to punch me. So I squeezed them harder and twisted. He kept writhing around but I didn't let go until he fainted. Then I began running through the dark. I couldn't see a thing. I fell into a latrine full of shit, and I remained there all night because I was too tired to move."

"The next morning, I heard people calling my name and I decided to show myself. I was too exhausted to resist. They told me there had been a general pardon for women and children. And all of us who believed the rumor were taken to this place—the house of a Tutsi widow. I found my mother and sisters when I arrived. They were still alive, but were so weak and depressed that they could barely move. We stayed in this house for two weeks. There were sixteen of us here. Then one night a soldier came and told us that we were scheduled to be executed. My mother urged my younger sisters to run away, but none of them wanted to leave her side. I begged Francine to escape with me. She was the oldest. We had a chance. But she was too tired. She'd been raped a few days earlier. She told me she was ready for death. Eighty soldiers came to the house that night. They were carrying a list with our names. They began grabbing people. During the struggle, I jumped out the window and hid in a tree. My mother was forty-eight years old. Francine was sixteen. Olivia was fourteen. Noella was eleven. Augtavienne was seven. Claudette was four. And Bebe was almost two. I listened to their screams until I fainted."

"I woke up to find that I'd been discovered by a soldier. He dragged me to my feet and led me down the street to this alleyway. He pointed his gun at me, and told me to say goodbye to my life. At that point I felt ready to die. But that's when Mary came running out of her house. She fell at the soldier's feet and began pleading with him. 'Leave this girl for me,' she said. 'You've killed her entire family. Just leave this one for me. God sent her to me.' She offered the soldier all of her money. She told him: 'When the war is over, you can come back and take this girl for a wife.' And that's what finally convinced him. He handed me over. Mary took me inside and cooked me food. She gave me a change of clothes. She tried to wash my hair, but it was too thick, so she cut it all off. Then she hid me in the bushes behind her house. I stayed there for weeks. Every night, Mary would bring me porridge and water. She gave me a little radio so I could follow the news reports. Each day, the rebels were getting closer to our town. Mary would encourage me. She'd tell me that it would all be over soon. And that I'd be rescued. She promised me that I'd survive. And Mary was right. I did survive—because of her."

"There were twelve people in my family before the genocide. I'm the only one who survived. We recovered eight of the bodies. And we buried the bones we were able to find. I didn't trust anyone after the genocide. Even when I was rescued by the Rwandan Patriotic Front, I wouldn't take the food I was given. I thought it might be poisoned. So I'd eat raw food from the fields. I was losing so much weight but I didn't care. People looked at me like I was a statue. They assumed my emotions were frozen. They knew my family was dead, and didn't want to ask me questions. So I held it all in for decades. Who could I talk to anyway? In a nation of one million victims, how do I begin to tell my story? There's been too much tragedy for everyone. Some people lost their arms and legs. Other people were raped and given HIV. What makes my story worth telling? Who am I? Why should I ask for sympathy? And who would I even ask? So I never asked anyone. I've never asked anyone for a thing. I don't want anyone to take care of me. I don't want people to celebrate my birthday. Or cook for me. Or tell me sweet words. I'm fine with giving love. But I can't accept it. Because I don't want anything that can ever be taken away."

BUTARE, RWANDA

"I was the youngest in the family. I went to Israel first, and the rest of the family was supposed to join me. Nobody made it. We sent letters to each other for the first few years. The last letter I got from Poland came in 1941. It was from my mother. It asked me to send food. Then the letters stopped. I knew that the Germans had occupied Poland, and I heard rumors about the things that were happening. I never learned the specifics of what happened to my family. I never wanted to."

"There have been very good parts and very bad parts, but in the end, I love life. Every night before I sleep, I ask God for three more years, so that I can make it an even one hundred. Then I recite a blessing that my mother gave me when I left her in Poland. It was the last time I saw her. The blessing is much more powerful in Hebrew, but it says: 'Wherever you go, may people always recognize that you have a beautiful heart.'"

JERUSALEM

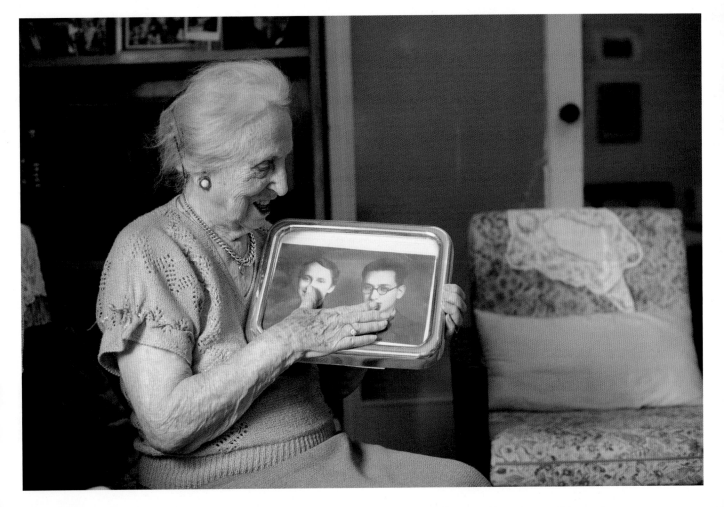

"Now I have someone
to play with!"

MANILA, PHILIPPINES

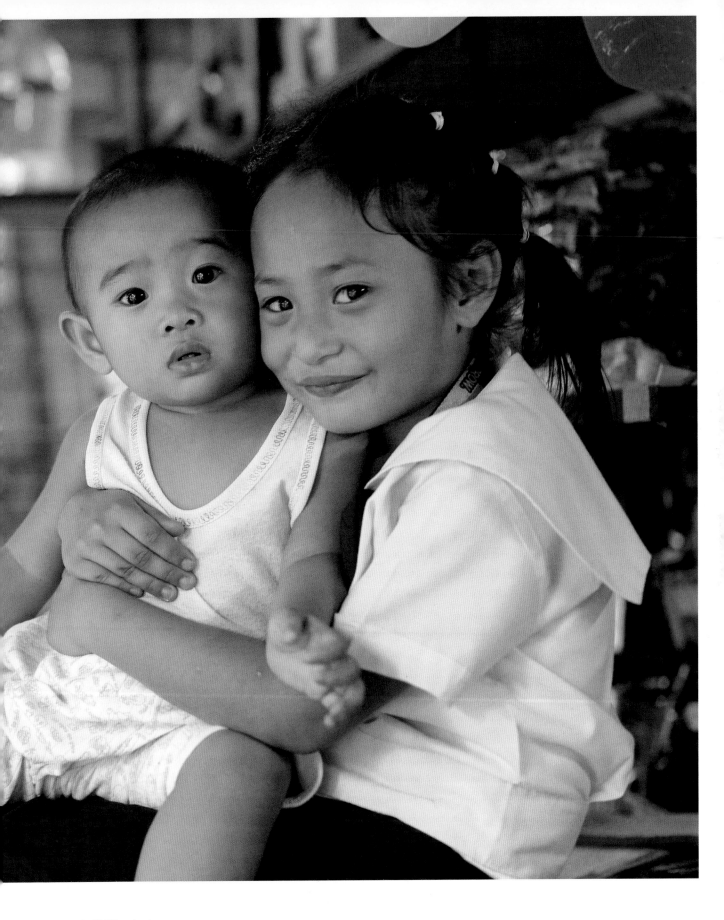

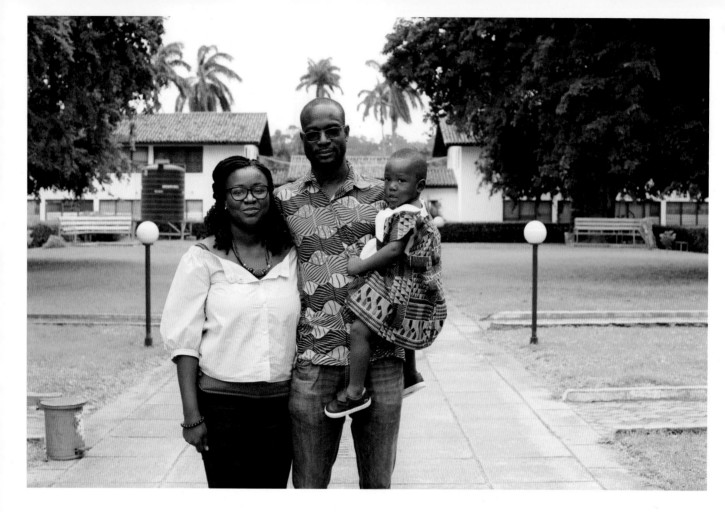

"We had a big discussion whether to raise him in Africa or move to the States. We both grew up in Ghana. But I got my PhD in West Virginia, so moving to America was an option. The job opportunities would certainly be better there. Both of us are professors, and you'd probably laugh if you knew what we got paid here. Healthcare would be better too. You don't hear of people dying in America because they can't find an open hospital bed. But despite these things, we decided to raise our son here. Because he'd never have to think about the color of his skin. We never have to explain what it means to be black. Or the rules of being black. One day in West Virginia I got an Amber Alert on my phone. All it said was 'tall black male.' I was the only one in sight so I nearly panicked. Then another day I was walking back to my dormitory. I'd just finished teaching a course. Someone drove by in a red truck, threw a hamburger at my head, and called me the N-word. It was three o'clock in the afternoon. I don't want to explain that stuff to my child. It's exhausting to be conscious of your skin all the time. You either become militant or you become defeated. And I understand why it happens, but extremes of anything aren't good."

ACCRA, GHANA

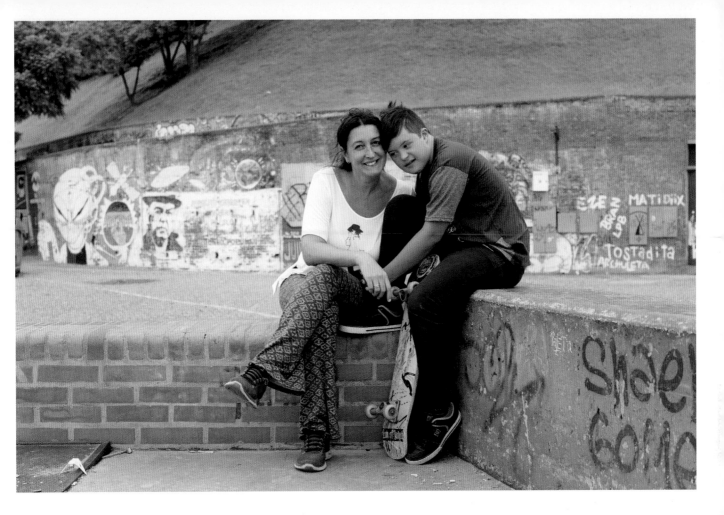

"I'm the link between him and the rest of the world. It can be an exhausting role. When things go well, I feel an increased sense of responsibility. It felt like the audience was clapping for both of us when he graduated from primary school. But I also feel an increased sense of responsibility when things go wrong. He has difficulties in crowds of people. A few years ago he got very nervous at the supermarket, and he pushed a young girl. Her father got very angry and started screaming at me. Part of me felt guilty for what happened. But part of me wished that more people understood what I go through. We haven't been to a supermarket since that incident. The best moments for me are when he's able to link to the world without me. Last Thursday we were visiting another girl with Down syndrome. And she was having a bad day. There was very little communication. So he tried to give her a box of dominos as a gift. But she refused. So he tried again. But she refused again. They went back and forth like this for a while, until the girl started to view it as a game, and she started to smile. Then he gave her a hug. A real hug with feeling. He made a connection. And it was his idea. Not mine."

ROSARIO, ARGENTINA

"People who see us from the outside think that our greatest struggle is the disability. It's not. Our greatest struggle is that we'd fallen out of love with each other. I lost a lot of my independence when Tatiana was born. I fell into a depression. He was working a lot. We grew distant. I didn't think I could ever love him again. Two years ago I prayed one night, and said: 'God, you've done so much. Please grant me one more miracle and make me love him again.' The first change came from me. He's always been the easygoing one, so I had to change first. I started trusting more. I tried to be more forgiving and understanding. I started to cook for him and organize things around the house. And he started spending more time at home. We started enjoying each other's company. We talked about things other than diseases. And we started going out together—just like this. It was like I suddenly met a friend, who became my best friend, who became my love. And our life started over again."

SÃO PAULO, BRAZIL

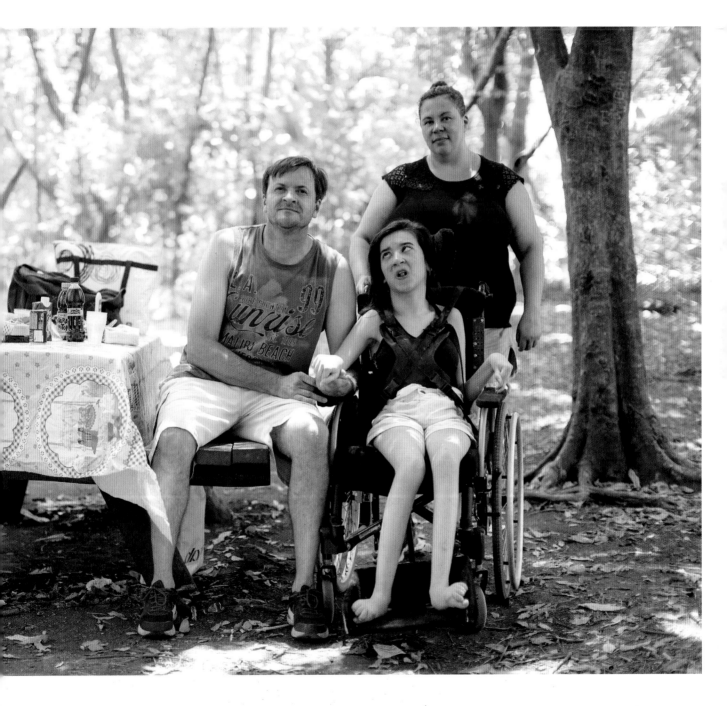

"My husband and I are artists, so we can't afford the luxury of babysitters and caretakers. And nobody's inviting him to sleepovers. I don't complain about it. But you know, a break would be nice. I could always ask a friend for help, I guess. But sometimes you don't even have the strength to verbalize what you need. One night I was alone in the hospital during one of his surgeries. I was extremely stressed. My husband had gone home to watch our other kids. There was a gypsy family in the waiting room. Nineteen of them. And even more in the cafeteria. All of them were waiting to see what happened to a sick child. They were taking up space. They were talking loudly. Occasionally one of them would make a joke and everyone would laugh. The hospital staff seemed very annoyed. But I remember feeling so envious. I'd give anything to have a tribe."

BARCELONA, SPAIN

"I'm the twenty-ninth king of the Akwamu Empire. Three hundred years ago we ruled the entire southern part of Ghana. The English described us as 'bullies.' The Danes described us as 'thieves.' Today I have one hundred twenty towns under my jurisdiction. But I didn't always want to be king. I knew from a young age that it was a possibility. I'm from the royal bloodline. But I just hoped they'd choose someone else. I was in college the first time they tried to coronate me. I was studying accounting. I heard a rumor that the king had passed away and that I would be next. So I panicked. I googled 'political asylum.' I took someone else's passport. I didn't even bother to change the picture. I'd never left Ghana before, but I took a one-way flight to New York City. I presented myself at the JFK customs counter, and said: 'You have to help me. They're trying to make me king.'"

"After I was granted asylum, I moved in with some cousins in the Bronx. My first job was washing dishes in the kitchen of an adult home. I was paid two hundred and ninety-seven dollars every two weeks. But I noticed that the private nursing assistants were paid a lot more, so I enrolled in some classes and received my certification. My first assignment was a quadriplegic named Hector. I ended up staying with him for six years. I fed him, changed his diapers, helped him go to the bathroom, everything. I really loved him. We went all over the place. We drove to Chicago and California. My shift was the overnight, so sometimes I'd drive him to the club and he'd go dancing in his wheelchair. I'd stand right next to him the entire time. During the day I took classes at Lehman College. I majored in health services. After my graduation, the whispers began once more. Family members were urging me to come home and take my rightful position on the throne. So I said goodbye to Hector and moved back to Ghana. I got a job in business until the last king passed away in 2011. And this time when the elders called on me, I was ready."

AKWAMUFIE, GHANA

"She needed people around us and I didn't understand that. I was locked on the two of us. There was a Russian writer who wrote: 'I hated the world so that I could love you more.' And that was me. I stopped talking to my old friends. I stopped spending time with people from work. And I wanted her to do the same. I was jealous, maybe. She was much younger than me so that made me feel insecure. I don't think I was being mean. I was just asking her not to go to work parties. She left me two hundred and fifty-eight days ago. We'd just come back from a holiday by the sea, and everything seemed fine. It was just like always. We were swimming, drinking wine, going to cafés. I had no idea it was coming. One morning we were having coffee in the kitchen, and she said: 'I don't love you anymore.' It was two months straight of drinking vodka after that. I lost thirty pounds. Only now is the wound starting to heal. I'm getting used to being lonely."

MOSCOW, RUSSIA

"I don't have anything personally against homeless people. But I try to avoid getting into conversations with them. Because I may be walking later with one of my influential friends, and the homeless person may come up to me and start acting like we're friends. And how's that going to look? You've got to choose who you're seen with. It's a matter of optics."

"I met James when I was twenty-nine. I don't want to say it was love at first sight—but that's what he always said. We had so much in common. Both of us grew up in foster care. We'd been homeless together for six years. Even though we lived in stairwells and tents, we'd still go on the dates. We'd go to the park, and the beach, and the movies. Everyone loved him. He was the kind of guy who'd give the shirt off his back. And we had the exact same sense of humor. But we also had the same addictions. He died of an overdose in January. We'd just gotten in a really bad fight, and we went our separate ways, and that night I got the phone call. I've been lost ever since. It's been a downward spiral. I've been using a lot. I've been really depressed. A couple weeks ago I just walked into Lake Ontario. I think I wanted to kill myself, but I don't remember much. I started swimming, and then I just stopped, and floated, until I went under. I woke up on the shore with people all around me. I'd nearly died of hypothermia. I just got out of the hospital yesterday. I'm trying to get my life back in order. I don't want to leave this body yet. I'm afraid to die. I want to live life. I'd love to work. I'd love to get back into the arts. But if I'm being completely honest, I don't see myself staying sober. Because all my friends are addicts. And they're the only family I have."

TORONTO, CANADA

"I knew my husband very well. We'd been living together for twenty-one years. So it was obvious that something was going on. Suddenly he started playing guitar and writing songs. The songs were OK, but I read some of the lyrics and they clearly weren't written for me. He started wearing cologne. He started liking new foods that he'd never even tried before. So I was suspicious. Then one night he came home crying. I said: 'What happened? Did you kill someone?' He told me that he'd gotten a girl pregnant. She'd just had the baby and didn't want to keep it. Then he asked me if I would raise it! I said: 'Sure, give it to me.' I arranged to meet the woman in the park, and she handed me the boy. He was only three days old. He felt like my son the moment I held him. I got rid of my husband a few months later. But I kept the baby. He's sixteen now."

LIMA, PERU

"I'm supposed to watch them while Mom takes a nap. If they're too close to each other, they fight. If they're too far away from each other, they cry."

"She keeps bringing home animals. She finds them while I'm working. And by the time I come home, the kids have already given them names—and there's nothing I can do. It started with one bird. But then the bird got 'lonely.' So now we have four birds. And eleven hamsters. And rabbits. And fish. Now she's started texting me pictures of dogs. I try to tell her that our house is too small for more pets. She keeps saying, 'Our house is small but our hearts are big.'"

MONTEVIDEO, URUGUAY

"I want to grow up and be like my mom because I really like her. But that's going to take such a long time. Because it took me so long to turn five. And even longer to turn six. So it must have taken her so long to grow up."

SÃO PAULO, BRAZIL

"I went to every march and protest there was when I was young. I had a peace sign on my little yellow Volkswagen. I remember lying down on the Long Island Expressway in seventy-something to protest Kent State. Crazy, I know. But we thought that would end the war. I guess it did in a way. Once, I was arrested at a protest in Washington. I don't even remember exactly what we were protesting. But there were so many of us that they herded us into RFK Stadium. I remember those crowds. You looked around and all you could see were people who agreed with you. Zillions of buses on I-95 all going to the same place. And it really made me think that the world was changing. But I was living in a bubble. All my friends were Jewish, middle-class, and educated. I didn't even know anyone who owned a gun. I thought everyone wanted peace, and a better environment, and that nobody hated anyone. Then Nixon got elected using his Southern Strategy. He tapped into so much hatred and racism. And I realized: 'My God. People are fucked up.' Then my generation started marrying, having kids, and started caring less about the world. And probably me too. You can't help it really. You have to become more self-involved. You only have so much energy you can expend in the world."

NEW YORK, UNITED STATES

"I've recently connected with a group of female friends from my past. It's been great to have a sense of community again. We were really involved in the activism of the seventies: anti-apartheid, anti-nuclear, feminist movement, things like that. Carrying banners and getting excited about it all. Eventually we drifted apart, but now our lives have recently woven back together. We've formed a little group. Our mission is to grow older 'disgracefully.' We try to knock the stereotypes of old ladies on their head. Every week we have a topic of conversation. And we have a business committee to organize events. But mainly we just have fun and do a lot of laughing. I can't tell you the group's name unfortunately, because you're a man. And that would require a majority vote."

AUCKLAND, NEW ZEALAND

"I didn't know anyone when I moved here. I came from Mexico. I was very innocent. I'd just gotten my first job as a waitress. So I put up an ad on the internet: 'Looking for serious, clean people to share a cool environment.' One of my first replies came from an engineering student. We arranged a meeting, and he showed up like he was interviewing for a job. Very well dressed. Very clean. Very polite. 'I'm extremely focused on getting my doctorate right now,' he said. 'You probably won't even notice me.' So I selected him. The first week was fine. The second week he brought a girl over. The third week he brought two girls over—and they were in the shower all night. I was beginning to get annoyed, but I hoped things would get better. Then the next week I worked a late shift, and arrived home one night to loud music playing. I thought maybe he had a few friends over. I went straight to my bedroom and changed into my pajamas. I wanted a quick snack before bed, so I went to the kitchen, and that's when I noticed white dust all over the counter. It was arranged into lines. So naturally I cleaned it up. That's when I heard people yelling at me. I turned around and saw twenty people in the living room. Nobody was wearing clothes. It was a big mess of white, pink, black, and brown. Lots of skin. Lots of hair. There was kissing and touching. Lots of groaning. I'd never seen anyone naked before. I went to an all-girls Catholic school. My roommate walked up to me, tried to take my hand, and said: 'Join us.' Instead I rushed out the door, down the stairs, and ran through the streets in my pajamas."

BARCELONA, SPAIN

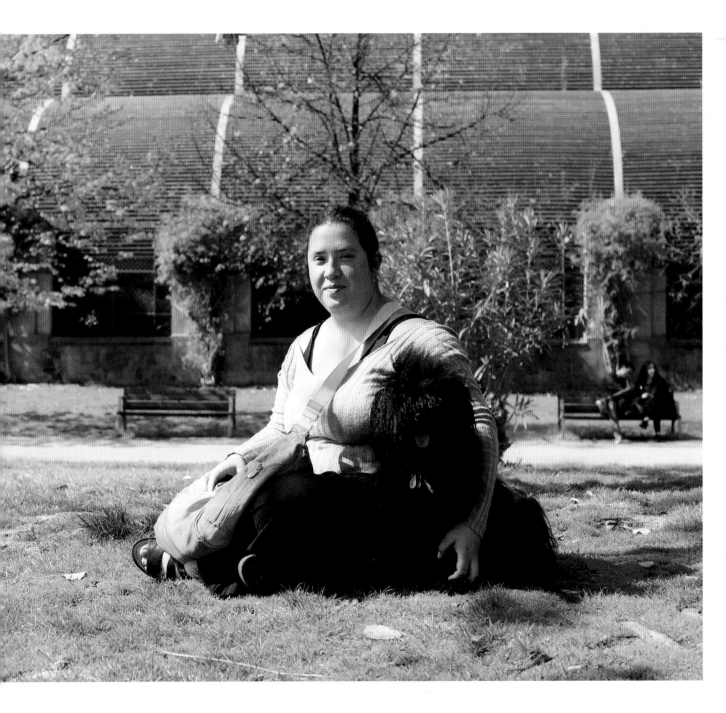

"My mom threw me out of the house at seventeen for getting pregnant, then had me arrested when I tried to get my clothes. Then she fucked the head of parole to try to keep me in jail. She was some prime pussy back then. But the warden did some tests on me and found out I was smart, so I got a scholarship to go anywhere in New York. I chose the Fashion Institute of Technology, which I hated. But by that time I was already getting work making costumes for the strippers and porn stars in Times Square. All my friends were gay people, because they never judged me. All I did was gay bars: drag queen contests, Crisco Disco, I loved the whole scene. And I couldn't get enough of the costumes. My friend Paris used to sit at the bar and sell stolen clothes from Bergdorf and Lord and Taylors, back before they had sensor tags. So I had the best wardrobe: mink coats, five-inch heels, stockings with seams up the back. I looked like a drag queen, honey. One night a Hasidic rabbi tried to pick me up because he thought I was a tranny. I had to tell him: 'Baby, this is real fish!'"

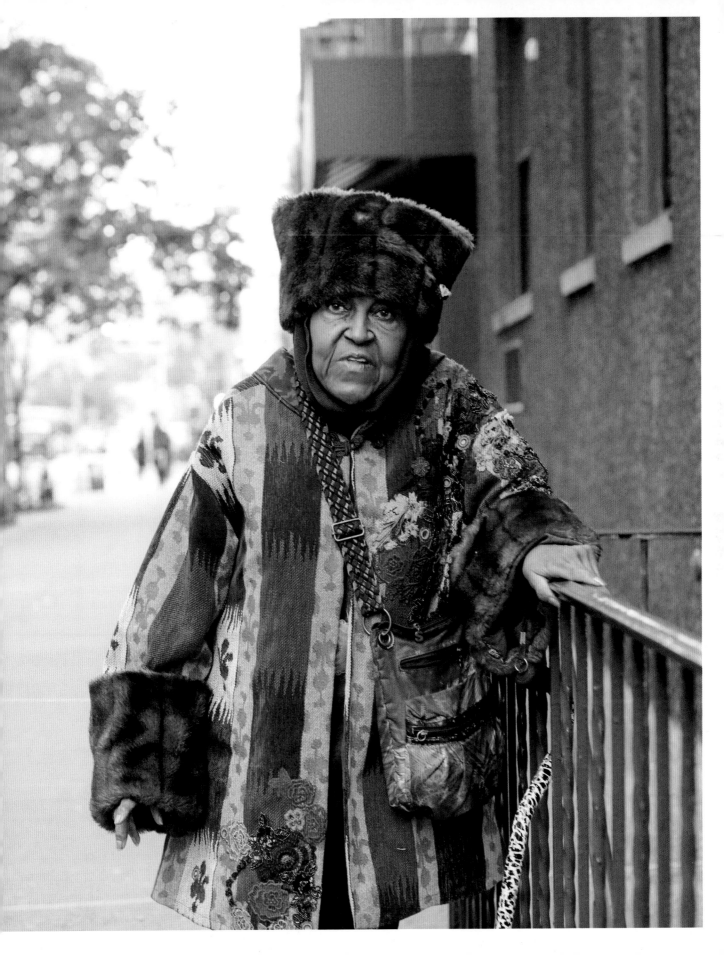

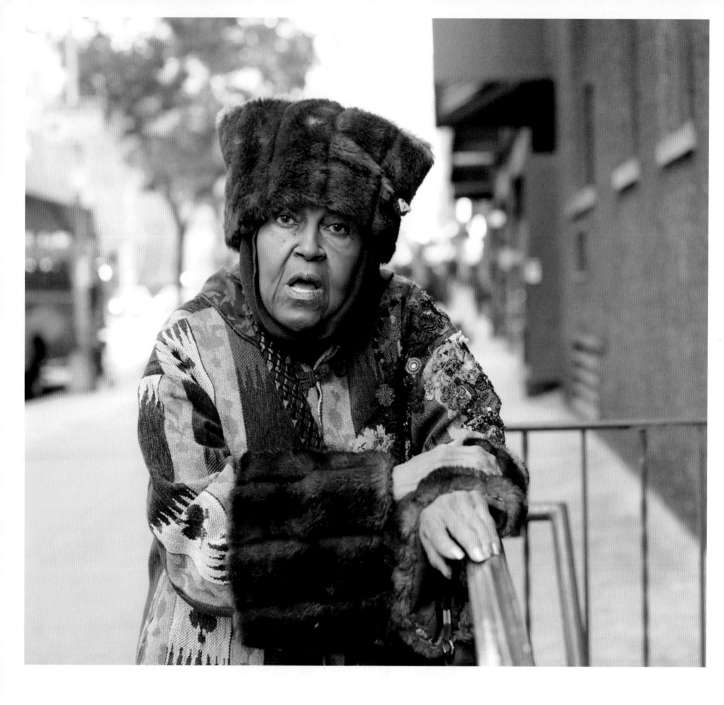

"My stripper name was Tanqueray. Back in the seventies I was the only black girl making white girl money. I danced in so many mob clubs that I learned Italian. Black girls weren't even allowed in some of these places. Nothing but guidos with their pinky rings and the one long fingernail they used for cocaine. I even did a full twenty minutes in the place they filmed *Saturday Night Fever*. But I made my real money on the road. Three grand on some trips. Every time Fort Dix had their payday, they'd bring me in as a feature and call me 'Ms. Black Universe' or some shit like that. I had this magic trick where I'd put baby bottle tops on my nipples and squirt real milk, then I'd pull a cherry out of my G-string and feed it to the guy in the front row. But I never used dildos on stage or any shit like that. Never fucked the booking agents. Never fucked the clients. In fact, one night after a show, I caught another dancer sneaking off to the Tate Hotel with our biggest tipper. Not allowed. So the next night we put a little itching powder in her G-string. Boy did she put on a show that night. Didn't see her again until *The Longest Yard* with Burt Reynolds. So I guess she finally fucked the right one."

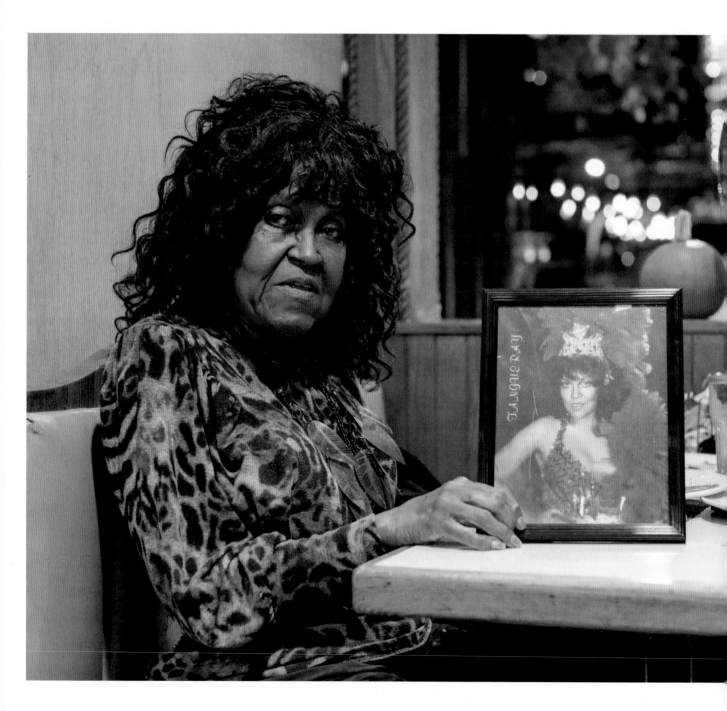

"The scene was different back then. All the adult clubs were mob controlled. It all flowed up to some guy named Matty The Horse. Honestly the mob guys never bothered me. They were cool, and I liked how they dressed. They wore custom-made suits. And they went to hair stylists, not barbers. These guys wouldn't even let you touch their hair when you were fucking them. Not that I ever fucked them. Because I never turned tricks. Well, except for one time. I took a job from this woman named Madame Blanche. She controlled all the high-dollar prostitutes back then. She was like the internet—could get you anything you wanted. And all the powerful men came to her because she never talked. She set me up with a department store magnate who wanted a black girl dressed like a maid. I thought I could do it. But when I got to his hotel room, he wanted to spank me with a real belt. So that was it for me. I was done. But Madame Blanche set my best friend Vicki up with the president every time he came to New York. And don't you dare write his name 'cause I can't afford the lawyers. But he'd always spend an hour with her. He'd send a car to pick her up, bring her to his hotel room, put a Secret Service agent in front of the door, and get this: all he ever did was eat her pussy!"

NEW YORK, UNITED STATES

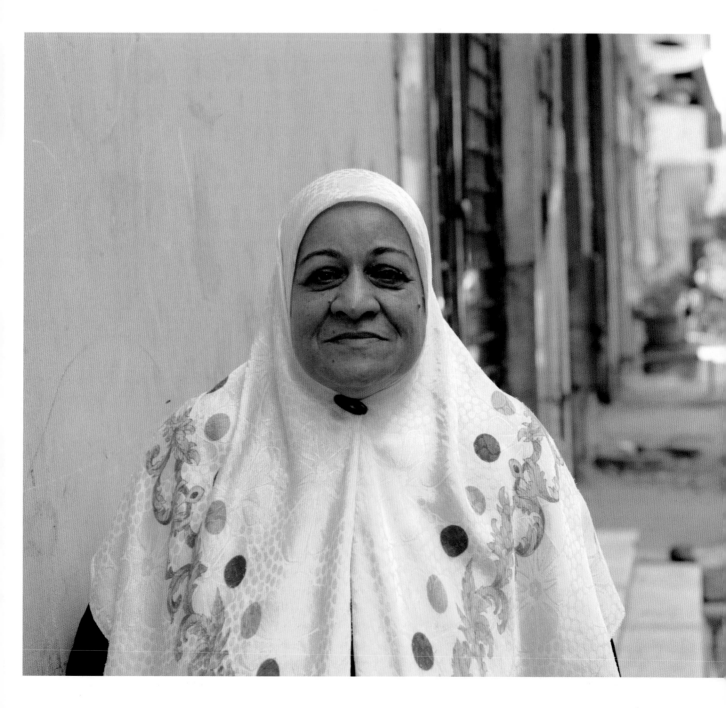

"I was far too innocent. My whole life was my family. I was married when I was seventeen. I barely left the house because my husband brought me everything I needed. I had no idea about anything, but the world has a way of teaching you. Fifteen years ago my husband died and I had to take the lead of the family. He owned an upholstery shop. The workers tried to convince me to let them handle the business, but they were hiding the profits from me. I had to take over. There was no other choice. My kids were still in school and that money belonged to them. So I began going to the shop every day. At first the workers tried to box me out. They knew I didn't understand the business so they wouldn't explain anything. They hid the numbers from me. And when a client entered the store, they wouldn't even introduce me as the owner. But I sat there and watched every move they made. I memorized everything. And after forty days, there were some new rules at the shop. The workers were not allowed to speak to the client directly."

CAIRO, EGYPT

"I first started coming to the park when I was thirteen years old. I was the only girl in the beginning. It was intimidating. The guys would try to make me angry. They'd call me 'dyke.' They'd roll their skateboards in front of me when I was skating. So I started coming out here every day right after school, when the sun was high, and the place was empty. I got better than a lot of them. I started beating them in elimination games. So they respect me now. A lot of girls used to watch from the edges because they were too intimidated to participate. But now that I'm out here every day, some of them have the courage to try."

RIO DE JANEIRO, BRAZIL

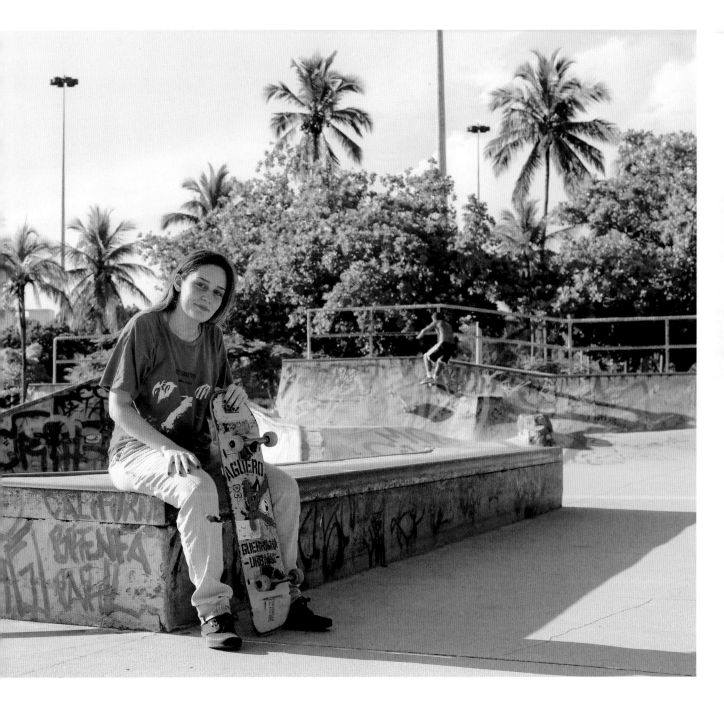

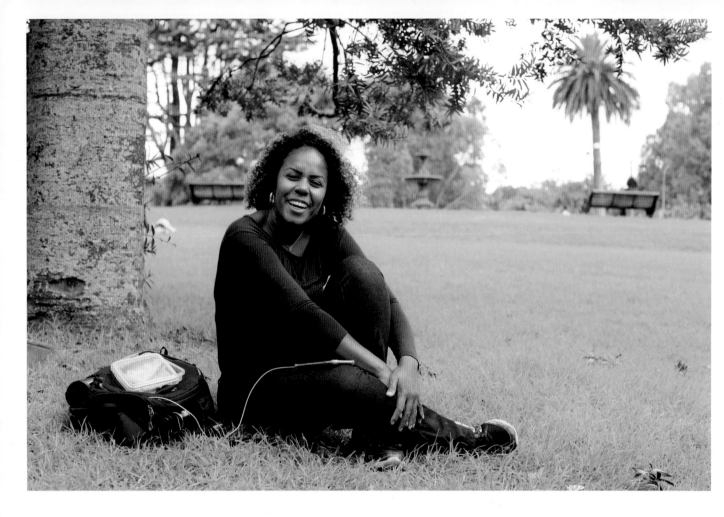

"I was a commercial senior analyst in Brazil. I started in the IT department of my company, and for twelve years I worked my way up the ladder. Eventually I was working with my own budget. I had meetings with the leaders and presidents of companies. I felt established. I felt like I could do anything if I put my mind to it. But earlier this year, our new manager fired me so that she could bring in her own people. I felt like shit. For twelve years I'd done my best for that company. And because I'd worked my way up from the bottom, I didn't even have a degree. I couldn't find another job. So I decided maybe this is my moment to take a chance. To do what I really want in life. I came to New Zealand so that I could study English, and eventually I'd like to get a degree in international trade. But I'm taking a big step back to take a big step forward. Right now I'm working in a warehouse. I'm lifting boxes and wrapping pallets all day long. And I only got that job because the owner is Chinese, and he couldn't understand my name. He thought I was a man. When I arrived for the interview, he tried to send me away. He told me the work was too heavy for me. When I told him I could handle anything, he brought me to the warehouse and handed me a twenty-kilogram box. I could barely hang on. It was so heavy. But I was smiling the entire time."

AUCKLAND, NEW ZEALAND

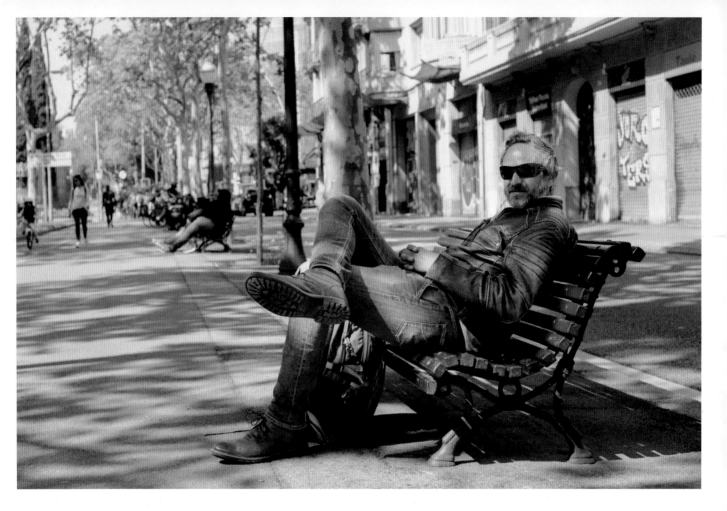

"I used to be a corporate attorney for Coca-Cola. I worked eighty hours a week. Then one day I asked my boss for a single Friday off and he said no. So I left my dog with my brother and flew to Europe. That was ten years ago. It's been super fucking chill."

BARCELONA, SPAIN

"I always knew that the environment was in trouble because my dad got me a big book about tiger conservation. But I didn't really become an environmentalist until I got to grade one. That's when I thought of many interesting ways to help. Some things you can do are reduce waste, carpool more often, spread awareness, plant trees, not cut trees, cut carbon emissions, and reduce nuclear disposal. I'm too young to start nuclear disposal because it's dangerous and I don't have the proper gloves. But I do recycle and keep plants on my balcony."

MUMBAI, INDIA

"The hardest part of first grade is 'eleven plus eleven'
because a lot of the class don't be knowing that."

"He's starting to be less dependent, but so far it's been pretty relentless and repetitive. A lot of changing diapers and feeding. The same mundane task over and over again. It can be exhausting and depersonalizing. Dad will be staying home and I'm returning to work full-time. I'm an emergency room doctor, and that's where I think I'm most useful to the world. It's great to be back. If some people love parenting, that's very lucky. There are certainly moments when it's wonderful. But to believe motherhood is the most important job in the world, you'd have to believe your child is the most important person in the world."

ROME, ITALY

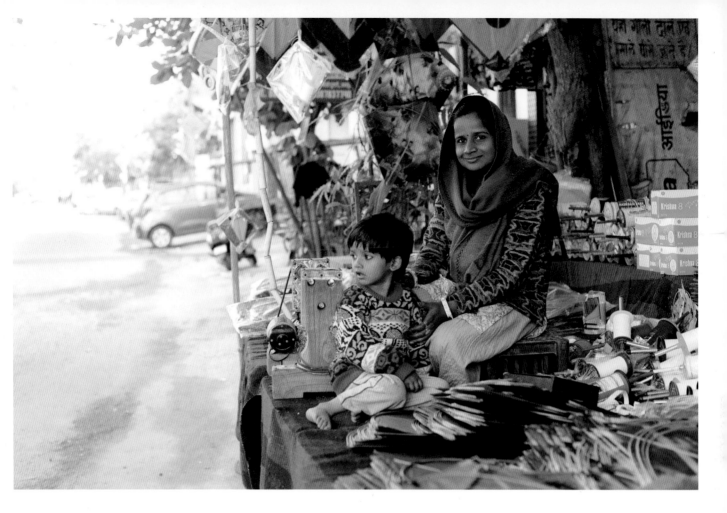

"I don't want her to depend on anyone when she grows up. From the very beginning, I've been dependent. I barely left my home until the age of eighteen. I'd only walk from school to home, and even then I'd be accompanied by my brother. I had no idea how to face the world outside. I never even learned to ride a bike. It's going to be different for her. I told my husband: 'Whatever she wants to do, I'm going to support her.' And I've already gotten a bike for her. The moment she is old enough, I'm teaching her to ride a bike."

JAIPUR, INDIA

"It took me a long time to get out of the house. My mum was afraid of the outside world. She used to walk me to primary school even though it was only two minutes down the road. Same with secondary school. And when I got my first job, she sat in the parking lot for the entire day. She's most comfortable at home: cooking, cleaning, looking after us. And she never understood why I felt so restless. I was never allowed to go out with friends. I wasn't allowed to go to shopping malls. So I became a timid person. At school I was always the student who was 'just there.' I'd sit in the back of the class. I wouldn't answer questions. One of my teachers asked me when I'd joined the class and I'd been there for two years. But I always loved learning. I wanted to be a teacher. I just never thought I had the courage. I didn't think I could stand in front of a class. I didn't think I could control the kids. So I kept giving up. I dropped the course two times. But my friends kept encouraging me, and I finally got my certificate in July. Since then I've been on nine interviews. I've had three placements already. Two were at Catholic schools, which especially worried me because I'm so visibly Muslim. But the students were great. The teachers were great. And I've grown so much. I can stand my ground. I still get nervous with every new placement, but I don't shake anymore. I'm hoping to get hired soon. And as soon as I get my first paycheck, I'm taking my mum to the shopping mall."

LONDON, ENGLAND

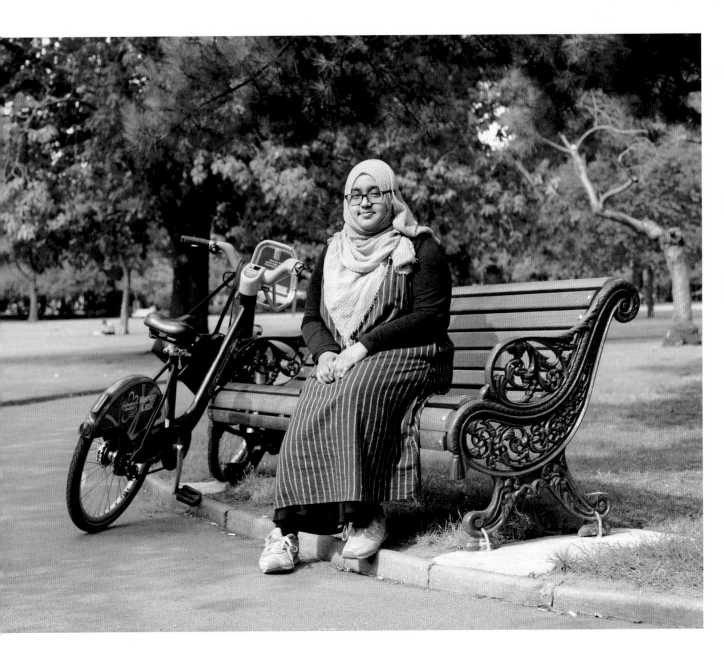

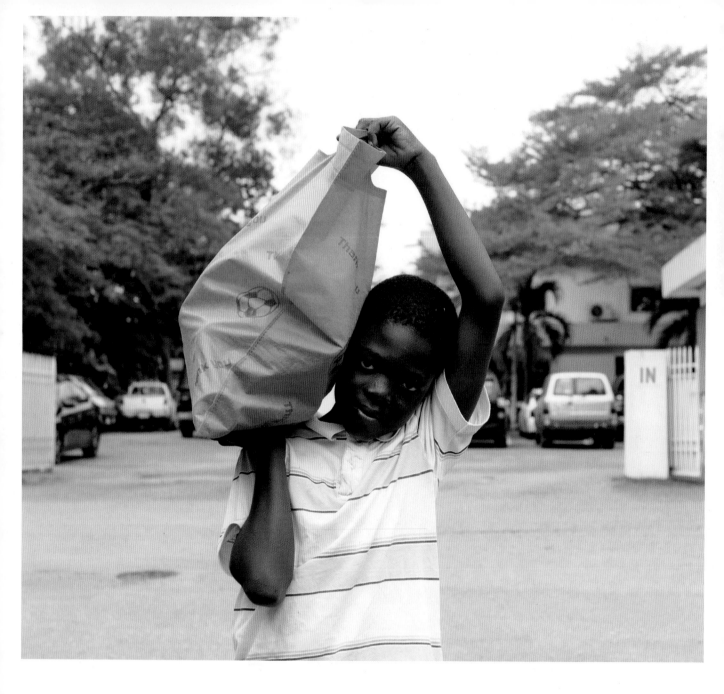

"I'm on the way to buy soft drinks for my mother. I also fetch water, and sweep, and help her wash clothes. She calls me 'boss' because I work so hard, but I love to help her because she cares for me so much. She buys me clothes. She reads me storybooks. She sings me gospel songs. She helps me with my homework. She gives me medicine when I'm sick. One time she baked my friend a cake because his parents couldn't afford any presents. I'm going to buy her a house one day. I really have a wonderful mother. She's very dark and beautiful."

ACCRA, GHANA

What do you want to do when you grow up?

"Swing on an adult swing."

"My mother died a few months ago. She was a wonderful mom until I was seven or eight. She was very involved. We went to libraries together. She had an answer to every question. She invented games for us to play. I was ahead of all the other kids in kindergarten, because she always encouraged me to learn. But when I was nine or ten, her behavior changed. She stopped being happy. She stopped making sense. And everything seemed to bother her. I was too young to understand what was going on, so I kept making excuses. I told myself that people just have different moods. And everything was normal. Then one day she came up to me while I was reading a book, and started insulting me. She called me an idiot, a moron, things like that. There was no reason for it. My grades were good. I had no problems at school. On that day I couldn't find any excuse for her. The alcoholism eventually pulled us completely apart. She became a shadow of herself. And her drinking really messed me up. The other kids could feel it. They could sense I had problems, and they pulled away. I became an introvert. Toward the end I only spoke to her every few months. She never completely stopped caring about me. Even when she was drunk, she'd ask me about my life. It was annoying. I hated it. But she tried. I ask myself now if I could have done more, but she'd already been to rehab so many times. I just try to tell myself that she's not suffering anymore. And I keep trying to remember her at her best. As the good mother I knew as a child."

WARSAW, POLAND

"He found me and my son on New Year's Eve, sleeping in a construction site. We'd been forced out on the street after my husband abandoned us. He said: 'You shouldn't live like this, come home with me.' He let us live with him for months, and he never asked me for a thing, and he was very good to my son. Sometimes I'd come home and find him carrying my son on his shoulders. After a few months, we developed romantic feelings for each other."

HO CHI MINH CITY/SAIGON, VIETNAM

"She always responds with empathy. She meets anger with empathy. She meets hate with empathy. She'll take the time to imagine what happened to a person when they were five or six years old. And she's made me a more empathetic person. I had a very fractured relationship with my father. Before he died, she made me remember things I didn't want to remember. She made me remember the good times."

NEW YORK, UNITED STATES

"The one I loved most was my last son. My other children were even jealous of our attachment. When he was very young, he would hang out the window and call to me as I left for the office. And when I arrived, I would find his toys in my briefcase. We remained close as he grew older. He was the one who always called me. He was always checking on me. He was always taking me to lunch. But then one day I went to the bank, and a lot of my money was missing. He had been stealing from me. He was falsifying my signature. When I confronted him, he begged on his knees for forgiveness. Then I started getting phone calls. He owed money to people who were threatening to kill him. I went into the slums to find the loan sharks and pay off his debts. I paid them all, with interest. I used to wear nice clothes. I used to have a nice apartment. Now I'm left with nothing but my pension. I sold all my belongings and I'm hiding from him. When I go to sleep at night, I wonder how he is doing. I wonder if he is safe. But I can't see him. Because if I see him, I will help him again."

RIO DE JANEIRO, BRAZIL

"I've been sitting here for three hours trying to figure out what to do. I need to make a sale. Rent is due in a week and I don't have the money. I'm already starting to miss payments on a loan I took out recently. I made two cold calls today and both of them went like shit. I'd never do anything bad to get money, but who knows. I'm beginning to dread going home. My kids are small and want to be with me all the time, but I'm so stressed that I have no patience. I've been losing my temper easily. We were at my brother-in-law's house this weekend, and he's doing much better than I am. His kids have a bunch of toys. My son kept begging me to buy the same stupid little toy truck that his cousin had. And I yelled at him to forget it. I only had enough money in my pocket to get us home."

LIMA, PERU

"My mom found out I was skipping school. When I came home, she told me that she'd bought something for me and put it in my room. When I went in my room, everything was gone. My TV was gone. My cable was gone. My systems were gone. My LeBrons were gone. My Jordans were gone. My Kobes were gone. All she left me was a pair of Reeboks."

NEW YORK, UNITED STATES

"My dad does anything I want."

PARIS, FRANCE

"Just trying to raise a girl in a sexist world."
RIO DE JANEIRO, BRAZIL

"We met while he was renovating a house for me and my ex-husband. My ex-husband wasn't interested in helping. He kept saying: 'Go with Howard to pick out the windows.' And: 'Go with Howard to pick out the doors.' Well, Howard and I were getting along so well, my ex-husband eventually said: 'Just go with Howard.'"

NEW YORK, UNITED STATES

"My boyfriend would do all sorts of crazy things when we first met. We'd talk until four in the morning. He said he'd die to be with me. But the moment he knew that I was falling for him, he suddenly grew cold. He'd call me names. He'd disappear for days every time we argued. And he started spending time with other girls. He said they were just friends, but it bothered me. Plus he would never commit. I asked him for a commitment because my parents are trying to fix my marriage, but he just listened to me cry. He wouldn't say a word. During that time, I reconnected with an old crush from my childhood. And this new guy treated me so well. He even came to meet my parents to show that he was serious. But my boyfriend logged onto my Facebook and discovered our messages. And he started crying and begged me not to leave. He said he'd marry me if I came back to him. So I did. But now he's saying that he hasn't decided if he can forgive me."

DHAKA, BANGLADESH

"We've been dating for a year and a half. It's been a wonderful relationship but recently it's changed a lot. I feel like I'm the one holding it together. I'm the one that calls. I'm the one that texts. We used to talk every day, but now she's not even trying. Maybe she just feels smothered. Maybe she's testing to see if I'll stick around. I just don't know. I can't decipher what she wants. When I ask her directly, her answers are never precise. She keeps saying: 'I'll think about it.' So I keep giving her one last try—over and over again. I just want to get things back to the way they used to be."

BOGOTÁ, COLOMBIA

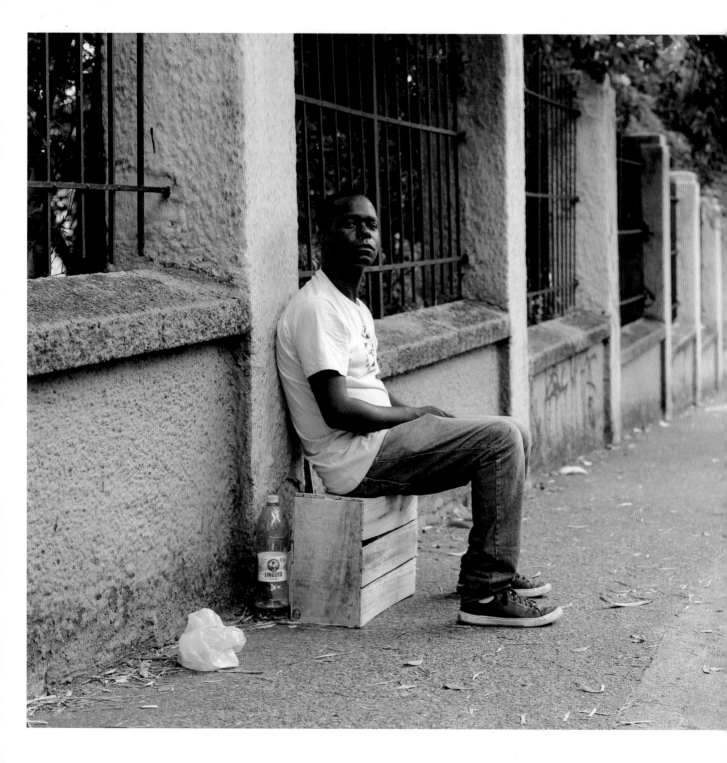

"When I was seventeen I had my first kid. The mother was addicted to drugs. I was in a tough situation. I was raising the child on my own. And I received an invitation to help rob a truck. I thought: 'I'll just do this today, and then it will be over.' I was the lookout. The police caught us while we were running away. Prison is a place that's impossible to explain. I was there for two and a half years before I even had a trial. I saw a guy being stabbed. I saw a guy slit his own throat with a razor. During the night I used to sit by the window, and look at the stars, and think: 'Not even an animal likes to stay in a cage.' All my friends forgot about me. Only my mother visited. I'll never go back there. Right now I'm in a tough situation again. I have no job. But people at the church help me with food. And I sit here and help people park their cars. It's only a few pennies, but I'd rather do this than steal from someone else who needs the money."

SÃO PAULO, BRAZIL

YOU CAN'T DO THIS HERE

OVER THE PAST SEVERAL YEARS, I've collected stories in more than forty countries. I've worked with well over one hundred interpreters. And almost everywhere I go, I hear a variation of the same thing: "You won't be able to do this here." I normally hear these words when I first arrive in a new country and I'm meeting with my interpreter in the hotel lobby. Often the interpreter is feeling pretty nervous. They're usually fans of the blog. Maybe they've spent a little time researching, and know how intimate and honest the interviews can be. It's hard for them to imagine *anyone* agreeing to be interviewed like that—not to mention complete strangers. So they want to temper my expectations a bit. Provide a little warning. "I don't think your process will work here," they'll say. Then they'll follow up with a reason: "*People in this country are . . . too private . . . too religious . . . too rude.*" And I'll always answer in the same way: "The process works everywhere."

But admittedly, there's always a moment when I worry that this time they're right. That I've finally arrived in a country where the people are closed off, unwilling to share, impenetrable. Of course, I felt this fear most acutely during my first overseas trip with *Humans of New York*. It was the winter of 2012, and for some reason I decided to dive straight into the deep end and begin with Iran. I'd never worked through an interpreter before. I had no experience approaching people outside of New York City. And relations were tense between our two countries. The nuclear deal was being negotiated. All American travelers had to be accompanied by a government-sanctioned "tour guide." I only knew that my guide was named Mohammed. He knew

nothing about my work. I planned on explaining everything once I got there. And not only would I need his permission, I'd need his help with interpretation. Even if Mohammed did allow me to approach people, would they be willing to speak to me? Or would they be too suspicious? Too distrustful of Americans? Too afraid of their own government?

Thankfully none of these fears materialized. Mohammed was young, liberal-minded, and excited to help introduce his country to the world. And approaching strangers proved to be easier in Tehran than in New York City. Most people were extremely curious about the work and eager to participate. Many women could not speak to me without the permission of their husbands, which was very frustrating at times. And this is one cultural norm that still bothers me immensely when I travel to the Middle East. But I discovered that most cultural differences actually worked in my favor. In the Muslim world, where hospitality is considered sacred, kindness toward guests is seen as a duty. So almost everyone was warm and inviting, and hardly anyone refused to be photographed.

There were a few uncomfortable moments. Some ultra-conservative Iranian blogs wrote critical articles about my work. They focused on the photographs I was taking of women. They called the work un-Islamic, which I remember made Mohammed very nervous. But overall the series was a huge success. Despite the government's ban on social media, it went viral in Iran. And toward the end of my trip, I was getting recognized on the streets. But most important for me, the work felt familiar. The interviews felt familiar—even though they were in Persian.

The laughter felt familiar. The tears felt familiar. And the stories felt familiar. My first overseas trip was a big confidence booster. Iran was a long way from New York City—both geographically and culturally. So if *Humans of New York* could be done there, it seemed like it could be done anywhere.

In the years since that first trip, I've traveled to many different countries. I've covered almost every major region and culture. But with each new country, the fear comes back a little. I worry that this time will be different. That this time the warnings will prove true, and "culture" will prove more powerful than my process. Despite all my experience, maybe this time I won't be able to feel my way through. My energy won't be reflected. My questions will fall flat. Some invisible web of traditions and customs will stand between me and the person on the street. It will muddy the waters. It will create an unbridgeable distance, and make it impossible to connect. This will be the time when I really "can't do this here."

But so far it hasn't happened. No matter how different the language is. Or the religion. Or the clothing. Or the buildings. The process always feels the same. Of course there are many different languages—so it never sounds the same. But it feels the same. I've approached more than ten thousand people now. All over the world. Usually I can tell if a person will say yes from the moment they look up. Before they even say a word. Because all the most important stuff is nonverbal. Every interaction on the street is ultimately just an exchange of energy. Does the person respond to your warmth? Or do they seem suspicious? Annoyed? Afraid? All of this stuff can be felt. It's universal. It

doesn't require interpretation. And it feels the same no matter what country I'm in.

The same logic applies to the interview. It's an energy exchange. Obviously it's more varied and complex than the initial approach. The interview involves hundreds of questions. But still, it's an exchange of energy. The interview can be felt. You can *feel* when it's going well. You can *feel* when a person is taking it seriously. You can *feel* when the person is being truthful, no matter what language they're speaking. Because truth is often spoken haltingly. With pauses. Like it's being dug up, one spoonful at a time, from somewhere deep. Truth feels heavy. It has gravity. It's usually not floating on the surface. Interviews rarely begin with truth. They begin with discomfort and uncertainty. People protect themselves with clichés or generalities, and punctuate their answers with nervous laughter. But most interviews will eventually get to truth. Once you've shown the person that you're patient. And serious. And that you care. That's when you feel things slow down. You see the person thinking through hard questions for the first time. And then the real moment comes. The authentic answer. And you can always feel it when it happens. No matter what language is being spoken. Even before my interpreter tells me the words that were spoken—I know the answer was real. I know that we've gotten there. I know that the process still works. And I know I *can* do it here. ◆

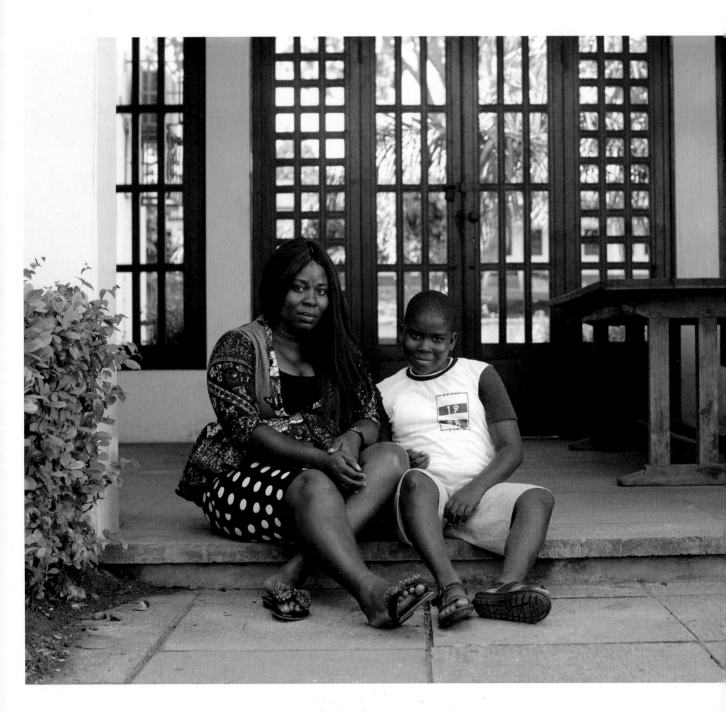

"There's no decorum in this country when it comes to childbirth. Our society expects you to have children. People start watching your stomach immediately after marriage. Soon the questions begin from family, friends, and eventually complete strangers. Thankfully I have a supportive partner, because we went through seven miscarriages and two stillbirths. The pressure from family was unbearable. I was made to drink potions. I bathed in holy water. At one point I was even stripped naked in front of people to be scanned in the spirit realm. It doesn't matter how much education you have. You get to the point where you'll try anything. You don't feel like a woman anymore. After years of trying, we finally visited a special doctor who said: 'There's nothing wrong with you. Go on holiday. Enjoy life.' We dismissed his opinion because we'd given up, but nine months later our son was born. Today I have three children. Because of my difficulties, I try to help women who are going through the same thing. I run a little community called My Sister's Keeper. We offer free therapy and fertility counseling for women who are having trouble. But mainly it's a place to cool off. To get a free spa treatment. To feel like a woman. And to think about anything but having a baby."

ACCRA, GHANA

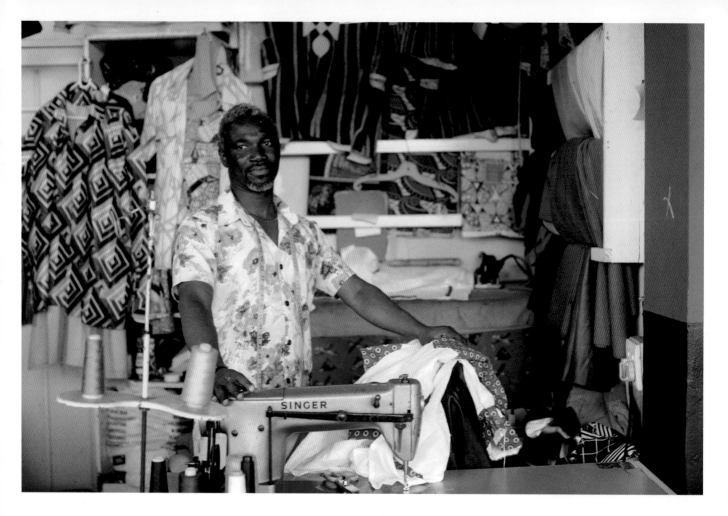

"I sold phone covers back in Ghana, but it wasn't going anywhere. So I came to South Africa to see if I could change my life. I tried to switch over to the clothing business. I knew how to sew, so I decided to give it a shot. But things are even worse than before. I can stand here all day and not get a single customer. I've been at it for three years, and I don't even know why I'm still making an effort. I should have a wife by now. And a house. And kids. But I have nothing. How can I meet someone when I can't even provide for myself? Recently I fell in love with a woman. She sells food around here. We used to talk every day and night. We bathed together, and slept together, and prayed together. She'd give me smiles and kisses. I didn't have much, but I gave her what little I had. For once I was finally happy. Then she came over to my house one evening, and saw that I didn't have anything. No radio. No television. Nothing. And she pretended like everything was OK. She acted like it didn't bother her. But two weeks later she broke off contact. She never said it was because I don't have money. But it's because I don't have money."

JOHANNESBURG, SOUTH AFRICA

"I've worked all my life as an office clerk. But when I was young I dreamed of being an important writer. I won some prizes in my town. But mainly I used writing as a weapon, because I was completely in love with a girl who liked reading. At the time she was dating another boy in class who played basketball. He was popular. Quite a bit taller than me. Eventually he went on to play for the national team. And I was so shy. I could barely speak to her. At the end of the year I wrote her a long letter declaring my love. She broke up with the basketball player over the summer, and when I returned to school the following year, she'd written 'Yes' on my desk. Everything changed. The world had light and color. There was no more rain. We'd go walking in the town center. We went dancing. But when Christmas came around, she told me we needed to talk. She was getting back together with the basketball player. So I played all my cards. I wrote a short story. It was about two soldiers competing for a woman's love. One of them was a powerful lieutenant. The other was a simple soldier, who loved her more and later died in battle. When I finished, I asked her to read it. She told me it was very nice, then married the basketball player."

MADRID, SPAIN

"When I was a child, it was up to me to feed our family because my father couldn't work. I had a job at a motorcycle repair shop. Everyone would sit at home and wait for me to make money. Once we almost ran out of food. We didn't have a single rupee and there was nothing to eat. I could handle it, but I couldn't bear the thought of my baby sister going to sleep hungry. I sat at my shop all day, praying for a customer. But nobody came. Then just as night was falling, a man drove up with a puncture in his tire. The price of the repair was three rupees. But when I was finished, the man handed me twenty rupees and drove away. I was able to buy two kilograms of rice. My entire life turned around that day. My shop became very busy. We were never hungry again. Even today I think about that man. I never saw his face. He changed not just my life, but the lives of my entire family. I wonder who he was. Sometimes I think it was God himself."

MUMBAI, INDIA

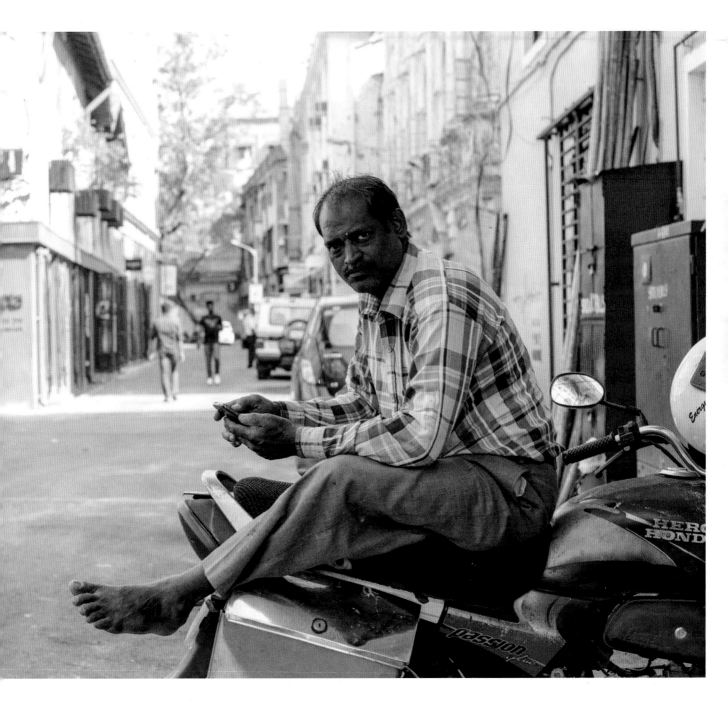

"I'm studying abroad right now. I have a bit of a 'boyfriend thing' going on back home. He's a nice guy. We met at a party and twenty minutes later he held my hair while I vomited. Even though I wasn't very attracted to him, he intrigued me. I'd never met a boy who didn't just care about sex. I'd only dated football players and gross teenage boys. He was different. He genuinely cares about people. He'd bring me all kinds of presents. One time I had a bad week at school and he brought me a gift package with all my favorite things. It was nice to have that much attention. I did just enough of the girlfriend thing to keep him around. Nothing he did affected me, and everything I did affected him. It was a weird sense of power to be the one with less feelings. I'd always been in the opposite position. Even after we broke up, I still hung out with him and let him give me gifts. He even gave me this journal for my trip."

MELBOURNE, AUSTRALIA

"I was nineteen. I was struggling with my identity. I wasn't good at making friends, so I decided to act like I was too cool for it. I pretended to be cold and difficult to approach. I viewed myself as spiky, but clever. In reality I was grating on everyone. I wasn't getting along with my roommates. I felt ganged up on. The atmosphere in our flat was tense. And at some point I just decided to run away. I opened my laptop, and bought the cheapest plane ticket I could find—to Liverpool, England. I didn't tell anyone. I skipped out on my rent. I left my cat behind. And I spent two months hitchhiking across England. I didn't have any money, so I'd go on couch-surfing websites to find places to stay. Afterwards I went to France. Then Belgium, and Holland, and Germany. I'd do anything to prolong the trip. I kept romanticizing the experience. I'd tell myself: 'This is eye-opening, life-changing.' I wanted so bad for it to be all those things I was so deep in my act. I wanted to be the kind of person who would do something like this. A confident person. Someone who didn't care what other people thought. But in reality I was just scared. Scared of going home and facing all my shit. I felt so grown-up. But I was just a little kid, covering up their eyes, and pretending they were hiding."

WARSAW, POLAND

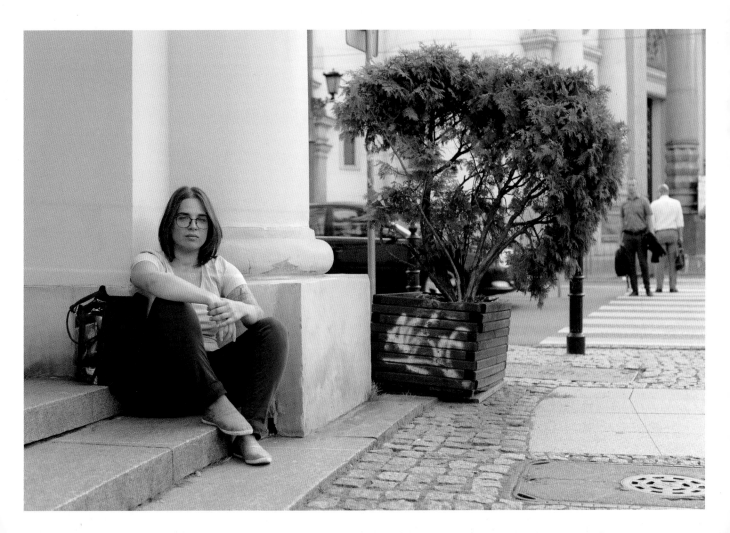

"The pauses are the worst. Whenever I'm talking to someone, and I don't know what to say next, and there's a pause—that's when I start looking at the floor. Then the nervous laughter comes in. And I can't recover. It's always been difficult for me. Even as a child. Whenever my mom asked me to say hello to adults, I'd just look at my feet and mumble under my breath. It comes so naturally to other people. They express themselves so easily. They're so happy—maybe not always happy—but light, and carefree. I try. But it feels like I'm trying to be another person. And I get uncomfortable. And the cycle repeats. I always imagine that people would prefer if I wasn't around. I never went to the disco when I was young. I've never had a romantic relationship. I haven't even kissed a girl. I do have parents that care about me, and they make sure I know. So I'm thankful for that. But I'd like something more. I want to be a dad one day. I'd like to have a career. I'd like to have a family. But if I can't learn how to talk with people, I'm afraid that none of those things will happen."

BARCELONA, SPAIN

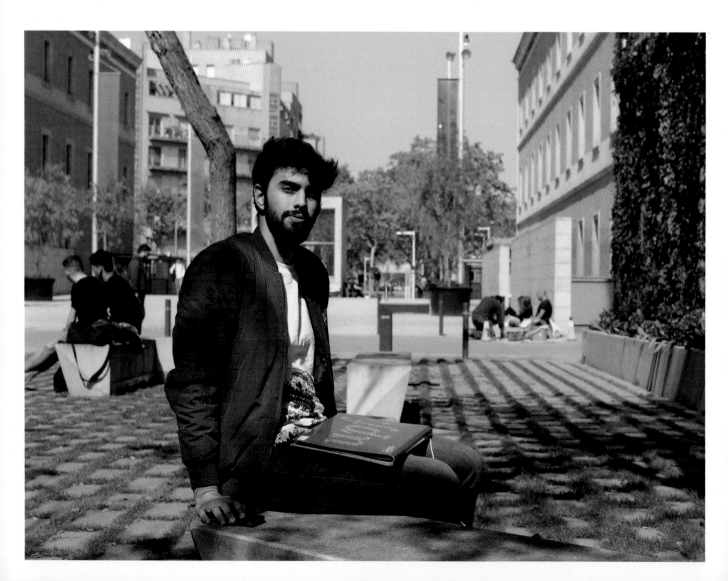

"I'm pretty sure I'm a sociopath. Or something close to it. My parents were pilots, so I spent most of my early childhood on a small island in Tunisia. The only other kids were the children of a local hotelkeeper. I was so isolated that I even invented my own words. By the time I got to high school, I was a monster. I only cared about being the best. I was a bully. I'd argue just for the sake of arguing. I would destroy any belief, just to be right. My behavior is different now. But I think I'm still a sociopath. I'm not sure I feel empathy. But I do always try to make the empathetic choice. It's an intellectual thing for me. I'm intellectually convinced of the need for empathy. I choose to help other people. I choose to be a reliable friend. I have a wonderful wife who judges me by my actions, and not my reasons for them. Sometimes I feel like Pinocchio. Was he a real boy? Yes, because that's what he always strived to be."

NEW YORK, UNITED STATES

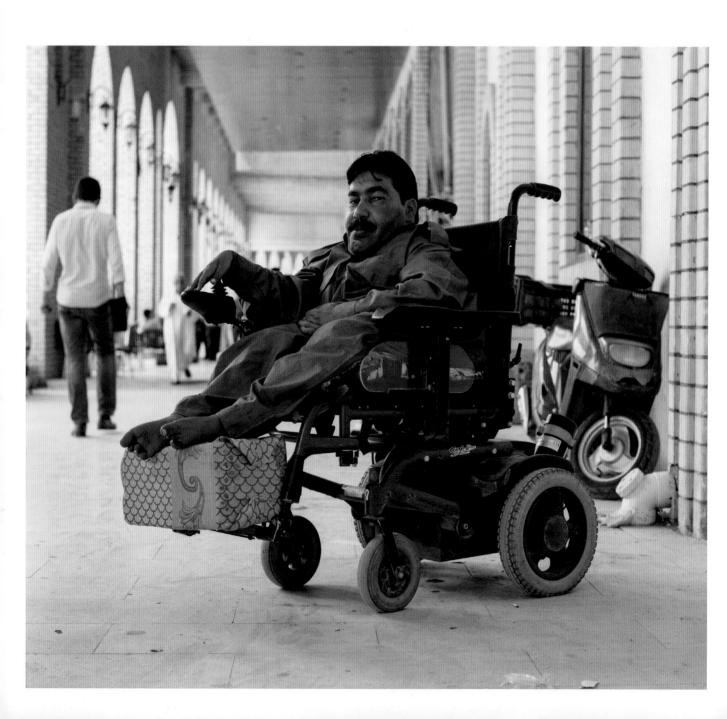

"I photoshopped my head onto a healthy body, to see what I would look like."

ERBIL, IRAQ

"I'm trying to start another company. The first one failed. I tried to get a regular job for a while but I just couldn't do it. There are a lot of downsides to being an entrepreneur. No boss to ask for help. No regular paycheck. My girlfriend and I have put a lot of our plans on hold. But at least I'm in control. I'm free. I own the value of my work. At my old job it was the same thing over and over. Same office. Same people. Even if you get a promotion, it's just a different set of responsibilities. A different brand next to your name on LinkedIn. Nothing meaningful has changed. The only thing that's changed is how people see you. And what is that worth? When I was in college, I met all these people with dreams of starting NGOs and changing the world. But then they had kids, and got a new condo, and a new car, and they got stuck. Everyone keeps saying: 'One day, one day.' But you ride the metro in the morning and you see all these people who've been working the same job for twenty years. They look empty almost. We all know that nothing takes eight hours to do every day. But that's the culture. We're stuck in that structure. We're stuck in meetings. Or killing time on our phones. Just waiting for the weekend. And what's the point of it all? To buy new things. To seem important. I just can't do it. I have to find a way out."

MONTREAL, CANADA

"I'm pretty sure life is going to start sucking around fifteen or sixteen because that's when I have to get my first job. After that everything looks pretty scary. Adults don't have an actual life. You can't go outside. You don't get to hang out with friends very much. Maybe text a little, but that's it. You just wake up, get ready for work, then work, then maybe watch a little TV, then go to bed. All of it seems depressing. But apparently everyone has to do it."

HONG KONG

"I thought I'd be a much more secure person at this stage in my life. I thought that if I played by the rules, I'd learn to be happy and becoming an adult would somehow reconcile all my issues. I'm realizing now that nobody grows up. Everyone just grows old."

"Yesterday we went on a treasure hunt with our metal detector. Gramble showed me how to dig very carefully and dust off your discoveries. We were hoping to find a pound or maybe an old Roman coin, but instead we found a tent peg. Then today we went to the bookstore and found an encyclopedia from the late Victorian era. We discovered a lot of facts that aren't facts anymore!"

LONDON, ENGLAND

"Adults guess and assume that I'm not going to understand things just because I'm a little kid. And it can be frustrating. 'Cause, like, I really want to know stuff. Or even when they do talk to me about things, they'll always try to 'tone it down to my level.' They especially avoid the heavy themes like sex and death and cannibalism and stuff. But that's stuff I want to talk about. I'm really fascinated by the Donner Party. The entire expedition, really. What did it feel like to eat people that you knew? I'm also fascinated by how the human mind deals with death. It's like people shut down the idea of death completely, and insist that heaven and hell are places after death. But death is death. And everyone after death is dead, because consciousness is just your brain. And even if there is evidence of life after death, it's difficult to assess. We're going to be incredibly biased toward any information that suggests there's something more. Because we are so desperate to believe it."

NEW YORK, UNITED STATES

"He fell down on his birthday. We'd just celebrated with a party. He was standing on a ladder, trying to fix a shelf, and he fell. It was all very sudden. He was in a coma for a week and then he was gone. After his death, I began to write in a journal. On the first pages, I wrote about his final days. I was so sad. I just needed to process what happened. But then I kept going back, back, writing everything I could remember: the walks we had together, the places we visited, museums, castles, holidays with the children. I carried a pen with me at all times. Every time I had a memory, I'd write it down. We'd known each other since we were fourteen years old. We'd take walks in this park back then—with our parents' permission, of course. It's been almost nine months since his death. I'm feeling a little better. I'm still writing, but it's not so much about memories anymore. It's more spiritual now. I think he's still evolving somewhere. One night I saw him in a dream. It was the young Claude. Twenty-five or thirty years old. It was so real. I don't even think it was a dream. I could feel him there. He was standing in a doorway, dressed completely in red. And Claude never wore red. But when I reached out to hug him, the door closed, and he disappeared. I believe he's still out there somewhere. And that I'll see him again on the other side of that door."

PARIS, FRANCE

"They're digital natives. If you watch adults with a computer, they are hesitant to click things. But children have no hesitancy. They don't need manuals. It's like breathing. It's like air. And they need to get used to it. I don't want them to fall behind the times. If you took away smartphones from every modern person, we'd be lost. Once we've tasted convenience, we can't return to the inconvenience of living."

TOKYO, JAPAN

"It feels like I know my grandson less now than when he was younger. He used to be an amusing kid. We'd go to museums and restaurants. We'd play games, and cards, and chess. We'd actually discuss things. He was very outgoing. But now he only wants to be on the computer. He's obsessed with this game called Fortnite. And what's the other one? Grand Theft Auto. He's losing his capacity to socialize face-to-face, especially with adults. He's either staring at a screen or desperate to get back to it. It frightens me. He's disassociating from the real world. He's becoming more aggressive and rude. It's all part of that culture. There's a complete acceptance of violence. I can hear him screaming in his room: 'Great body shot!' 'Great head shot!' He spends his mother's money on abstract things like new weapons and armor, then gets angry if she says no. We've tried setting a screen-time schedule with the school psychologist, but he's angry about that. He's always demanding more time. I feel like we're losing him. He probably thinks that I'm just an old fart, and I'm not supporting his interests. But I have no interest in entering that world. Just as he appears to have no interest in entering ours."

MONTREAL, CANADA

"I'm from a small city in the south of Spain. It's
known for skydiving. In 1991 there was a huge
event with delegations from all over Europe. I was a
twenty-four-year-old interpreter at the time, and they
assigned me to the president of the skydiving union.
His name was Michel. He was a retired soldier
from France. He'd been part of the Resistance, and
still had a number tattooed on his arm from his
time in a concentration camp. We spent four days
together. Nothing romantic happened, but there
was something forbidden about it. He was forty
years older than me. We'd walk arm-in-arm. He was
dignified. He was fascinating. He was charming. And
after he went home, we began exchanging letters. It
became a beautiful friendship. It lasted for years. But
my husband didn't like it, so eventually I stopped
responding. Michel wrote a few more times but
eventually gave up. I never gave him an explanation.
Recently I discovered the letters while cleaning my
room. I decided to look him up on the internet, but
all I found was his obituary. He died four years ago.
He was eighty-eight. Right now I'm on a journey
through France, collecting information on his life.
I found some military records already. Today I'm
going to call his wife and ask for an interview. I want
to put everything into a book—a tribute of sorts. I
don't know what I'm looking for. It's just something
I feel like I have to do. I want to end the story."

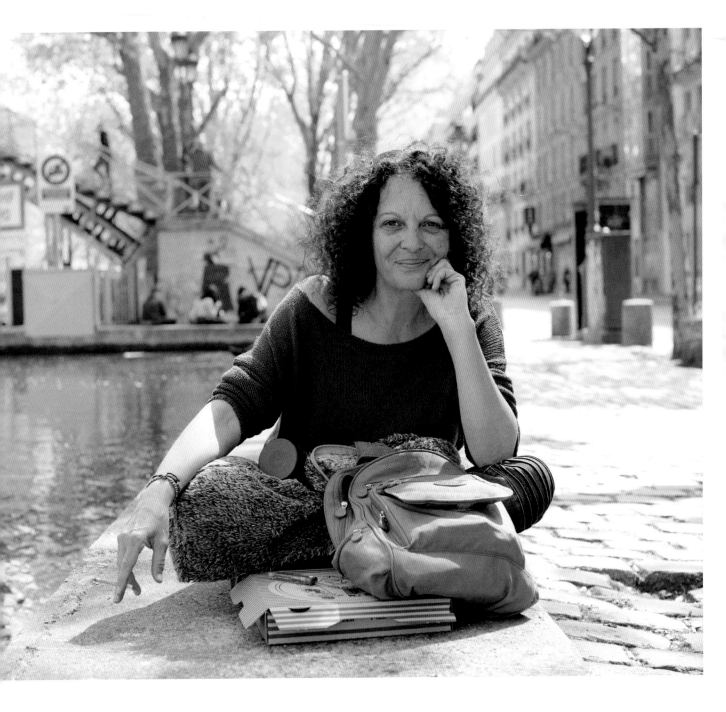

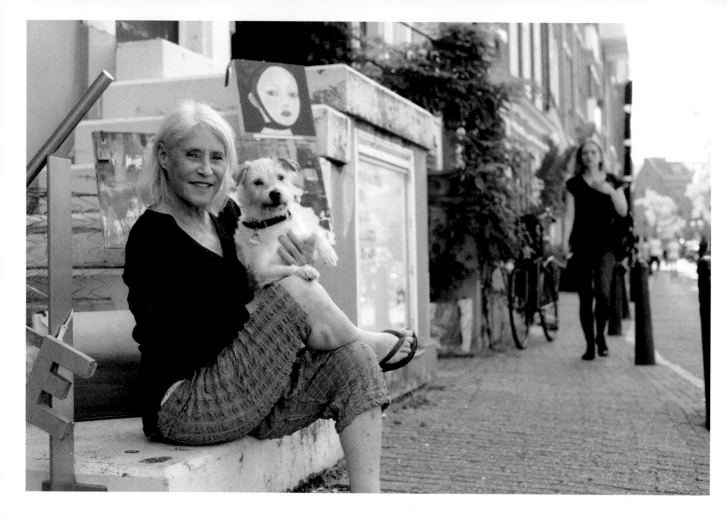

"My husband got involved with a younger woman at work. I was relaxed about it at first. He's thirteen years younger than me, so I thought: 'Shit happens.' But then she got pregnant. Luckily through the divorce process I had the opportunity to take over this shithole place with no heating, which I turned into an art studio. And now I'm living my best life. Everything is for sale except the pink chandelier and the dog. Anyone is free to stop by at any time. You can eat or drink whatever you want. All the young people in the neighborhood love me. I'm the oldest person in our friend group. Everyone else is in their twenties or thirties. They call me Queen Mama. I call them my adopted kids. I always help them with their school projects and resumes and interviews. I only ask one thing in return. Each of them has to teach me one new thing every week: a piece of music, a trend, an idea. Just so I can stay up to date. Before you take the photograph, let me go inside and put on some makeup. We were out until two last night."

AMSTERDAM, THE NETHERLANDS

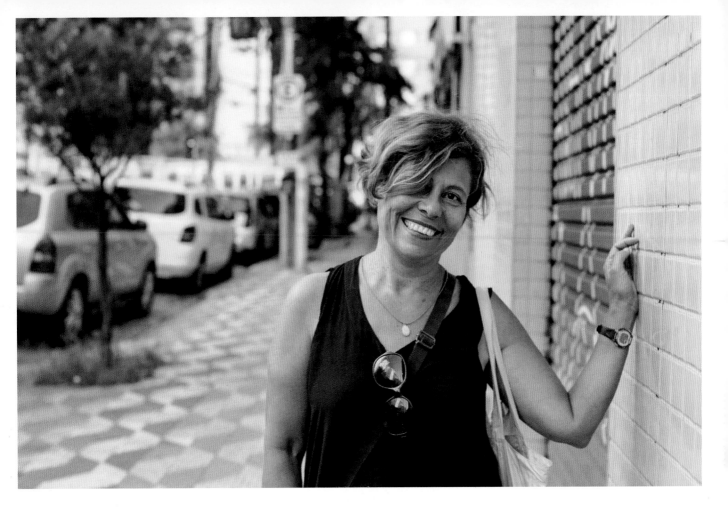

"After twenty years of marriage, I caught my husband cheating and had to leave him. But honestly, I wish I'd gotten my divorce much sooner. For so long I'd been denying my right to be an individual. The family had become so much more important than my dreams. I had small joys back then: getting a brand-new car, having our twentieth anniversary, when my son got into college. But now the intensity is so much greater. I'm doing all the things I love to do. I studied nutrition and got a job at the hospital. I buy whatever I want. I watch cartoons. I never miss a Shrek movie. I go to the orchestra at least once a month. And right now I'm coming back from a class on finance. I'm going to invest in the stock market and get a house by the beach."

SÃO PAULO, BRAZIL

"I've wanted to be a mother since I was eight years old. I always dreamed of starting a family. But we've been trying for three years now, and we can't get pregnant. We keep going to checkups, and the tests are fine, and everyone says that there's nothing wrong— but still nothing happens. It'd be easier if we had a reason. Right now I feel powerless. I'm already thirty-five. I can feel the clock ticking. And it gets harder and harder as time goes by. It's especially difficult during that time of the month. I usually isolate myself on that day. I don't want to talk to anyone. I don't want to do anything. He usually orders us a pizza. We watch movies and cuddle. And he reminds me that the most lucky thing has already happened. We were born in the same city, and we went to the same school, and we were able to find each other. What are the odds of that? We are already so lucky. And no matter what happens, we'll always be here."

ROME, ITALY

"Today's his tenth birthday. He's a very emotional young man. He likes to solve other people's problems. One time when he was five years old, he came with me to the store and we bought two pounds of fresh apricots. I let him carry the bag home. He walked a little bit behind me the entire way. After a while, I asked him to hand me an apricot. 'I can't,' he said. 'I've given them all away.' I knew then that I was raising a humanitarian."

TABRIZ, IRAN

"I gave my three-year-old daughter some worthless coins, and jokingly told her that she was rich. She went and hid the coins away, and I forgot all about them. A few months later, we needed money for food, and I asked my oldest daughter if we could use some of her birthday money. She refused. I almost started crying, because I thought then that I had completely failed as a parent. But suddenly, my youngest daughter appeared, and gave me back the handful of coins that I had given her."

MEXICO CITY, MEXICO

"My only obstacles are my thoughts."

"I'm trying to live my life without conflict, so I don't say much."

MUMBAI, INDIA

"I've got it all figured out. Just let time go by and try not to think about
very much."

SÃO PAULO, BRAZIL

"I'm a psychotherapist to some of the most successful people in Holland. My clients tend to come to me around the age of forty. They've accomplished so much, but they're still driven by this fear that they're not going to make it. And they start to ask themselves: 'Is this going to be the rest of my life?'"

"I came to the city when I was twenty and became a fruit seller. It's allowed me to build a house in my village. I feel healthy. I get to eat. A lot of people don't get to eat on time. So I've gotten everything I wanted. The minute you think: 'I have a lot'—that's the moment your spirit is at rest. My spirit is at rest."

JAIPUR, INDIA

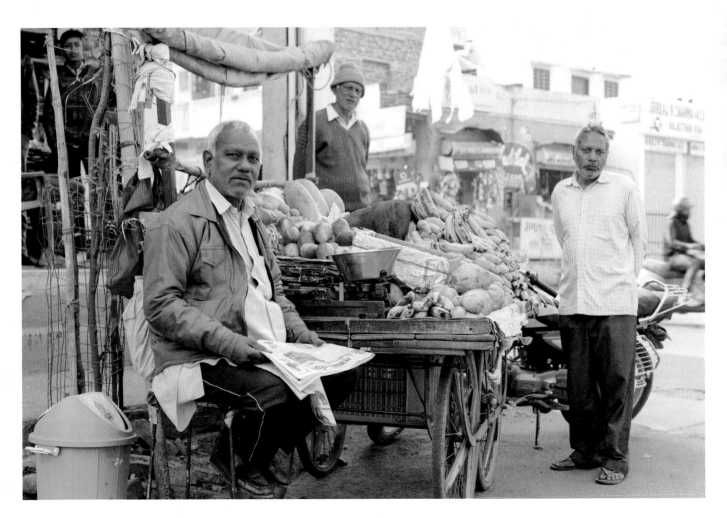

"I don't want to grow the business. Just maintain it. I've got a little money under my pillow. But that's not what it's about. It's a lifestyle. It's paradise, man. I work here all summer and travel the world during the off-season. If I need some extra cash, I'll work crew on a yacht. I'll never push people to buy more. Some of my customers ask me: 'Why don't you expand your shop? Why don't you turn it into a café, and start selling Coca-Cola?' Because that means more staff. More wages. More taxes. More responsibility. I don't want to weigh myself down. I want to be free. It's a long time in the ground, my friend."

BAY OF ISLANDS, NEW ZEALAND

"My younger sister passed away last year from an unexpected stroke. So I'm raising both my daughter and my niece. In our culture, it's an automatic. It just kicks in. She belongs to me now. I'm a single mother so it's not easy. There are definitely months when I add up income and expenses and the numbers don't work. And both of them are thirteen so their moods are all over the place. Today is like this, and tomorrow is like that. But God has given us favor as well. We can afford to share an ice cream. We have shelter. We have food. And after four months of no work, I just found a new management position. So we've come a long way. My niece is beginning to heal. Her grades are improving at school. She still speaks of her mother in the present tense, but there's no more crying at night. And I've grown a lot as well. Because more than I want to acknowledge—the struggle has given me meaning. This is my purpose. I have a little family. And we share what little we have."

JOHANNESBURG, SOUTH AFRICA

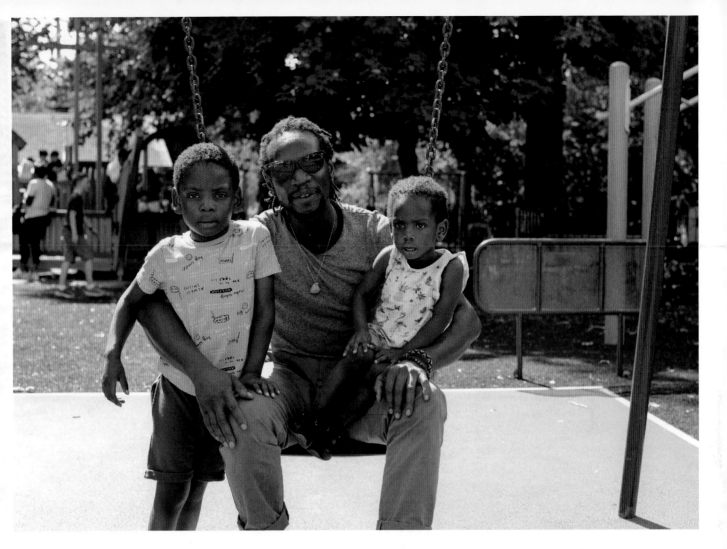

"I'm the best uncle. I think it's because I have a little more energy in the reserve tank, since I'm the only one of my siblings without kids. I'd love to have children but just haven't had the chance yet. But I do have twelve nieces and nephews, and I try to see them as much as I can. This morning, I called my sister and offered to take these two for the day. I know how much she needs the free time. Just a chance to get stuff done. Maybe get out of the house for a few hours. And no matter how crazy it gets with these two, it's always stress-free for me. It's just golden. I always want them to have someone they can come to that's not their mum. They have a great relationship with their mum. But mum is always mum. And you don't want to disappoint her. So if you ever have a problem, or you get in a little trouble, and you're afraid to tell someone—but you still need some guidance—that's when you come to Uncle Marcus."

LONDON, ENGLAND

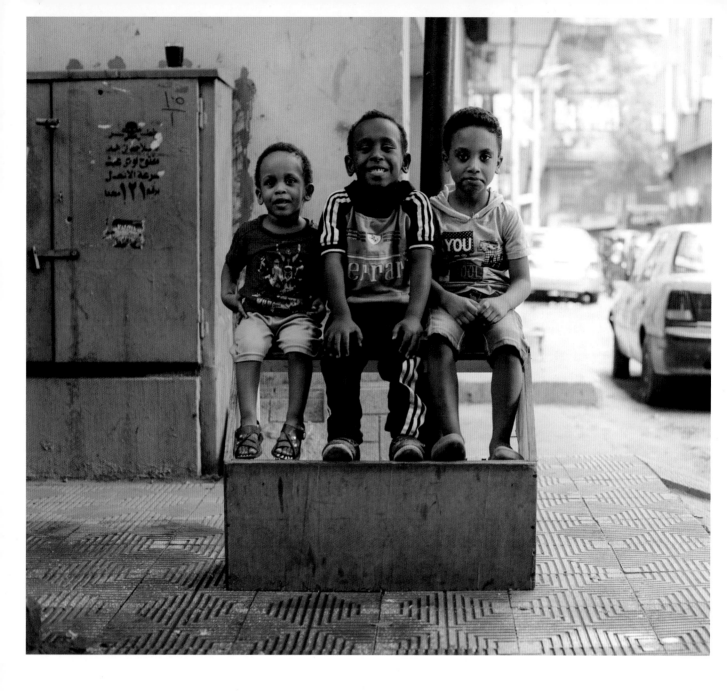

"People scream from their balconies, 'Don't play here!' But where else are we supposed to play? And they tell us: 'Don't play so loud!' But how do you play not loud?"

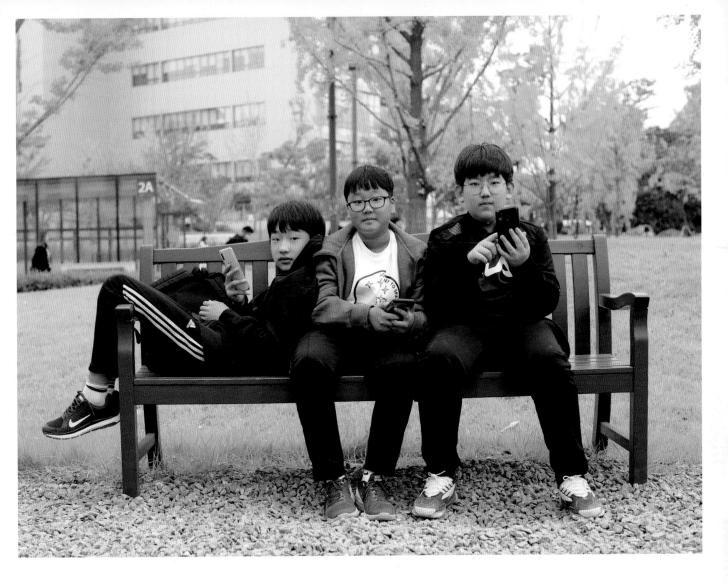

"The girls at our school are really good at hitting."

SEOUL, SOUTH KOREA

"She speaks more languages than anyone in the family. Because she plays with all the children in the street."

ERBIL, IRAQ

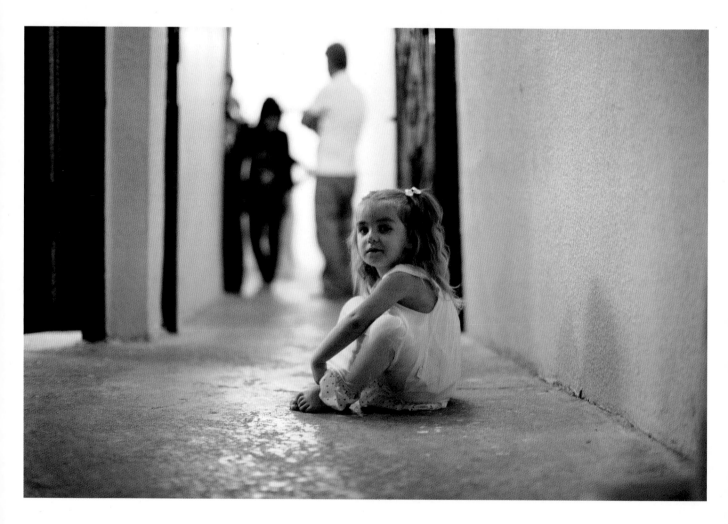

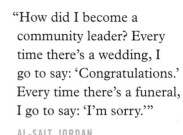

"How did I become a
community leader? Every
time there's a wedding, I
go to say: 'Congratulations.'
Every time there's a funeral,
I go to say: 'I'm sorry.'"

AL-SALT, JORDAN

"One of our neighbors discovered my brother's body. There wasn't a note, but he did leave a message on his phone. All it said was: 'I'm so tired.' Everyone in my family changed after that day. My mom blamed herself for not recognizing the signs. She became very short-tempered, and authoritarian. She began to put more pressure on me. To succeed. To do better. To be presentable. But I became very dark. I gave up on everything. I didn't want to go to school. I didn't even want to answer texts. I stayed that way until the third year of middle school, when I met a really good friend. She kept trying to talk to me in class. Even though I was a dark person, and I wasn't really responding, she kept trying to talk to me. I'm not even sure why. It's just her personality. She's nice to everyone. She never says bad things about people. You can tell her anything, and she'll listen without giving her opinion. One day we were riding the train home from school. And I told her the reason I was so dark. I'd known her for two years at that point, and I'd never even told her. I hadn't told anyone. She just listened to me silently. And when I finished, she gave me a hug, and said: 'You should have told me earlier.'"

TOKYO, JAPAN

"We'd just spent the entire day driving back from my parents' house in Winnipeg. He held my hand the entire way. It was such a beautiful time of life. We had an eight-month-old daughter. He loved that little girl so much. You could tell by the way he looked at her. Absolute adoration. We always used to argue over who'd get to bathe her. He was the one who put her to sleep that night. I remember he came downstairs and told me that he'd said 'goodbye' to the baby. I said: 'You mean goodnight, not goodbye.' Then he told me that he loved me. And we both went to bed—I thought. The next morning I found him in the garage. It looked like he was just standing there. My neighbor said I screamed like a wounded animal. My God I was traumatized. I never slept another night in that house. It was two years before I could sleep at all. I dropped from a size twelve to a size six. At the time I fucking hated his guts. I mean c'mon, this baby wasn't an accident. We committed to this. Our daughter needed him. And it was all so humiliating. Everyone knew that my husband had hung himself in my garage. Apparently I was so insignificant as a human being—so abhorrent, that my own husband felt the need to take his own life. My privacy was gone. There was no front stage and back stage anymore. Everyone knew the worst thing about me. And I figured that if I could handle that, I could handle anything. I transformed myself. I became more courageous. More extroverted. I went back to university and got my master's. Now I work as an expert witness in custody cases. I think that two people died on that day. Blair, and the woman who was terrified to live without him."

TORONTO, CANADA

"My brother shot himself last November. He always viewed himself as my superior. He'd never come to my door when he visited. He'd always wait in the car for me to come out. He had more money, more lovers, more everything. But he was always searching for more. He was never satisfied. My brother was a character. He was a successful character, but he was a character. And that character ended up eating him."

CÓRDOBA, ARGENTINA

"Something happened the second year of college. I grew very hard on myself.
I became sad, and disappointed, and angry. But then I met a girl—the
first I'd ever been with. And everything was postponed for a while. I felt
energized. I was even doing my homework. But now we've broken up, and
I'm having to face all the stuff that the relationship allowed me to ignore.
I'm overthinking everything: 'What should I do? What shouldn't I do?' But
the actual doing never happens because I have no motivation. I'm sad
all the time. It's worst when I go to bed, and I realize that I haven't done
anything, and that I won't do it tomorrow either. A lot of people believe in
me, but they're getting tired because I'm not there yet. And it's not their
responsibility anyway—it's mine. I'm just afraid I'll never get back to the
way I used to feel. The feeling of being awake. And loving myself. And
getting out of the house. And exercising. And going to the beach. And
hanging out with friends on Sunday evenings. And thinking just the right
amount of thoughts. No suspicions. Or criticisms. Or fears of the future.
Only the thoughts that are useful. The thoughts I need in this moment."

MADRID, SPAIN

PASSU, PAKISTAN

SAN FRANCISCO, UNITED STATES

"Mom raised me on her own since I was young. My dad didn't care about our family. He was there physically, but he wasn't there. He kept all his income for himself. He gambled away our possessions. We couldn't buy anything for ourselves because he would sell it. He sold all our electronics. He even sold our furniture. But my mother still did everything for him: cooked his food, did his laundry . . . everything. Then one day she came home from work and the house was empty. There was nothing left but our clothes. I told her it was time to go. For the last two years we've been living in a rented house together. Mom seems so much lighter now. We can own our own things. We can actually make progress and move forward in life. I've started working at a pharmacy and I'm paying my way through college. I'm still in touch with my father. I even give him money for rent and food. I have no interest in taking revenge. I'm showing him how he should have treated us."

JAKARTA, INDONESIA

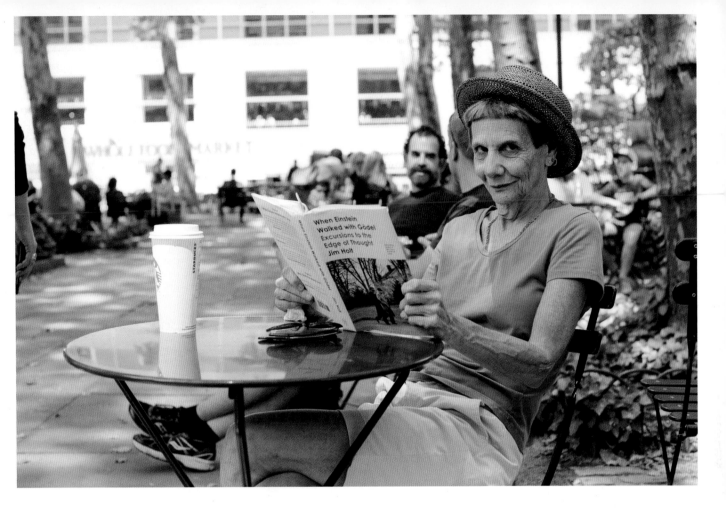

"My father called me 'stupid' a lot. Even when I'd bring home good grades, he'd say things like: 'You're smart, but you don't know anything.' I just wasn't a big reader like him. He always had a book in his hand. Math was my thing. During lunch I'd go to the junior high library and sit on the floor with puzzle books. Now I'm a teacher, and I've taught every math class in the high school curriculum. A few years ago I was teaching my precalculus class, and I stumbled upon a set of numbers that generated ellipses with identical positioning in both the rectangular and polar coordinate systems. So I turned them into variables, wrote a two-page proof, and had my work published in a journal called the *Mathematics Teacher*. Take that, Dad."

NEW YORK, UNITED STATES

"The situation was horrible. The Soviet Union had just collapsed. Nobody was able to adapt except for the criminals. You'd see people you loved begging on the streets for food. Everyone around me had one dream: to leave Moldova. But not me. It seemed like a foolish idea. I thought: 'Why go someplace where there's nobody waiting for you?' It seemed too risky. So I stayed. I got a degree. I worked as an economist in the Ministry of Statistics and Prices. I bought my own apartment. And I felt safe. I knew how to manage my life and solve any problem. But suddenly I had this very strong feeling that my life was finished. I'd reached the limits of my world. I'd never experience anything new. I'd never be surprised again. But I was still young at the time. I was thirty-five. I was strong and not afraid of anything. I told myself: 'I can do this. I have just enough energy to live one more life.' So I decided to change my life completely. But that isn't the reason I finally left Moldova. I'm embarrassed to even tell you. Because I'm better than this—but I left because I met a man. He was visiting from Paris. He seemed very nice. He was handsome. He looked like a university professor. He looked like someone I could trust."

"I moved to Paris to be with the man. I brought along my teenage son. The city was so beautiful compared to where we'd come from. The man paid for everything. He told me: 'Anything you need, I'll give you.' And for a few moments I felt protected from the troubles of life. His home was like a prison, but I cannot say that the prison was uncomfortable. He told me not to worry about residency papers. He said that he'd talk to his lawyers and everything would be arranged. But time went on and the papers never arrived. Whenever I questioned him, he'd change the subject. Then he started to say: 'I won't do it. Because if you have papers, you'll leave me.' I was trapped. I couldn't work. I didn't have a bank account. I didn't speak the language. Over the years I became like a child. All I ever said was 'thank you' and 'I'm sorry.' He convinced me not to trust anyone. I could see on TV that French people had friends, and went to the office, and took vacations. But it was like a different world. There were years of my life when my only human contact was with my dentist. I lost hope. You can't live in pain all the time. You have to give up. So I just focused on survival. I couldn't leave because my son would have no life back in Moldova. He was the only thing I loved. Eventually he turned eighteen and got his official papers. Then he wrote a letter explaining my situation. He sent it to some ministry—I don't know. He didn't even tell me about it. One morning he asked me to sit down, and he said: 'Mama, don't get too excited. But I just got a phone call. They told me your papers are ready.'"

"I never tell the story to anyone. I find it shameful. I find it pitiful. When I finally escaped, the man said to me: 'I hope you'll forgive me for what I've done to your life.' But honestly his soul is not my problem. I've done everything I can to forget those years. I think you have only one duty in life. You stand up and you go. No matter what happens: I will buy a dress, I will color my hair, I'll put on my lipstick, and I'll go out and meet people. After I got my papers, the first thing I did was enroll in French school. I began to make friends. I learned that people liked me. I could make them laugh. Can you imagine? For ten years I hadn't made anyone laugh. I began to see that I wasn't handicapped. I wasn't deformed. I wasn't broken. I became a salesperson at a makeup store. I was so good at it. Number one in Europe for my company. And I met a man who cares about me. His name is Mark. He's super beautiful. He's bald. I love bald. I typed 'bald' into the dating site. And he sincerely cares about me. He's given me home and family. Twenty times a day he surprises me with something kind. It took me three years to tell him about my past. I didn't want him to know that I'd lived through dramatic things. I didn't want to be a survivor. I wanted to be delicate and feminine. It's my pleasure to be weak. It's my joy. I cried for three days after I told him. But he didn't care at all. My past didn't bother him. It only bothered him that I was crying."

PARIS, FRANCE

"I grew up in Hungary. Back then we were cut off from the world. We could only visit other socialist countries. We were always told: 'The country you live in is enough. You don't need more. Everything coming from the outside is not good.' So we were always ten years behind in music. But if you stayed up late, you could listen to an underground radio station from Germany. The frequency barely came through. But I would listen in the kitchen when my parents were asleep. And if Pink Floyd came on, and you managed to record it—it was like gold. You could trade the tape with your friends. My older sister left Hungary when I was nine. She didn't tell anyone. The police came and questioned our entire family. They called her a dissident. But she'd send me packages from the other side of the Iron Curtain: chocolate, dolls, cool T-shirts. She sent me so many different kinds of things. In our shops at home we only had two choices: this or that. But my sister seemed to live in a place where she could choose anything. And I also wanted to choose. So when I turned twenty-two I hitchhiked to London. And when I arrived—I found choices everywhere. You could buy anything. Study anything. Wear anything. It's not that I wanted something specific. It had nothing to do with greed. It's about choice. It's about knowing that if you want something badly enough, you can get it. It's an energy. The energy of knowing that the option is there."

LONDON, ENGLAND

"I'm OK now, because we're speaking in generalities, but if you were to ask me about anything specific, like names or dates, I wouldn't be able to remember them. My mother had it too. It was ten years of her not knowing who anybody was. And I don't want to be remembered like that. That's why I'm sitting here alone. I used to have a lot of friends, but I've withdrawn from all of them. Group situations are especially hard because I can't steer the conversation toward something I can remember. And when I do get stuck, it's more embarrassing. So I've missed weddings. I've stopped returning calls. I do have one friend who won't give up on me. He calls me from Florida. And if I'm trying to tell him about a bridge, he'll list off every bridge in New York City until I remember the one that I'm trying to talk about."

NEW YORK, UNITED STATES

"Sometimes I'd start crying in class for no reason. Then when I got home from school, I'd just go straight to my room. I couldn't even talk to my mom about it because I'd just start crying. People would tell me: 'Just get up, exercise, and take a walk.' But none of that helped. Things got so bad that even the school was watching me. I started bawling during a chemistry exam and I ended up in the school psychologist's office. I remember thinking: 'I don't care if I ever see another chemistry exam again. Or my friends. Or my mom.' And I started to get this feeling that I was definitely going to do it. I was going to lock myself in my room that night and take a bunch of pills. The only thing that stopped me was imagining my mom finding my body. That was three years ago. That time seems so far away now. I found a great therapist. I learned so much about myself. There's so much that I want to do now. I want to travel. I want to get married. I want to have kids. There are so many poems that I haven't written and songs I haven't heard. So it's terrifying for me to think that I came so close. My problems were small back then. They were teenage problems. But I came one step away from not being. And I had made the decision to take that step. I'm afraid that I can go back to that place again. And next time, my problems will probably not be so small."

BOGOTÁ, COLOMBIA

"I got kicked out of school because I got in a fight. I didn't even start it. Another kid challenged me because I took their pen. He threw a small table at me, and it made me so angry. I wasn't even thinking. So I started punching him. Then the teacher ran over and started to hit us. We got sent to the principal's office, and he told us we were being expelled. My parents were so angry when I got home. My mom was crying. Then my dad beat me with bamboo sticks."

BANGKOK, THAILAND

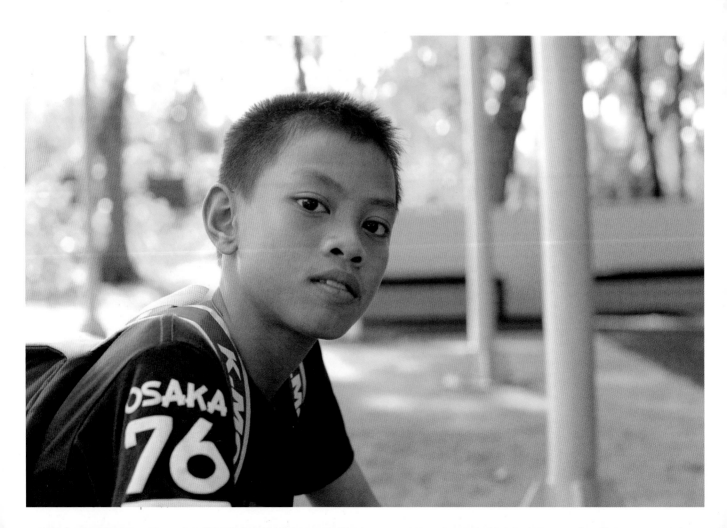

"I'm a fund manager. One of my employees stole millions from my clients. He hid it from me for almost two years. He was working with a broker to create fake transactions. He disappeared when I discovered the scheme. I could call the police but it would be all over the press, and I'd never get another client. I could declare bankruptcy but I'm not a coward. So I'm trying to pay my clients back the initial amount they invested. I sold my other business. I sold two houses and a car. That's why I'm taking trains and online taxis. Some of my clients feel sorry for me. Most of them are angry. A few hate me. All of them keep calling. I tell them to give me time, but they keep calling. I'm smoking four packs of cigarettes a day because of the stress. I've got to find fresh money. If I can get new clients, then I can slowly repay the old ones with the profits that I make. But all of them want their money now."

JAKARTA, INDONESIA

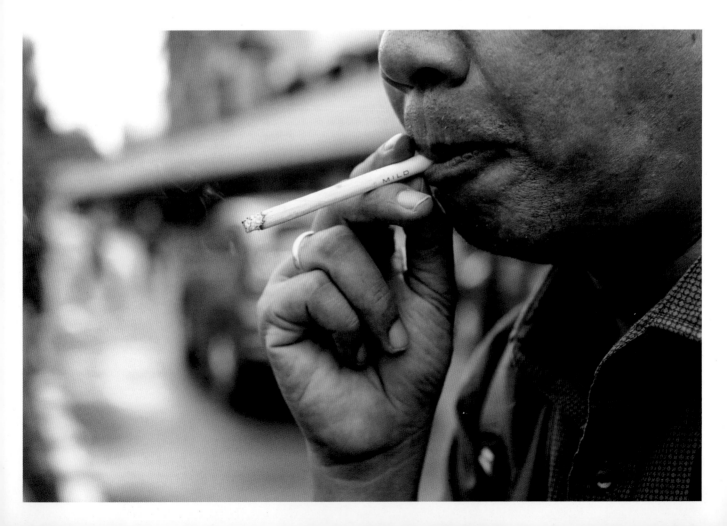

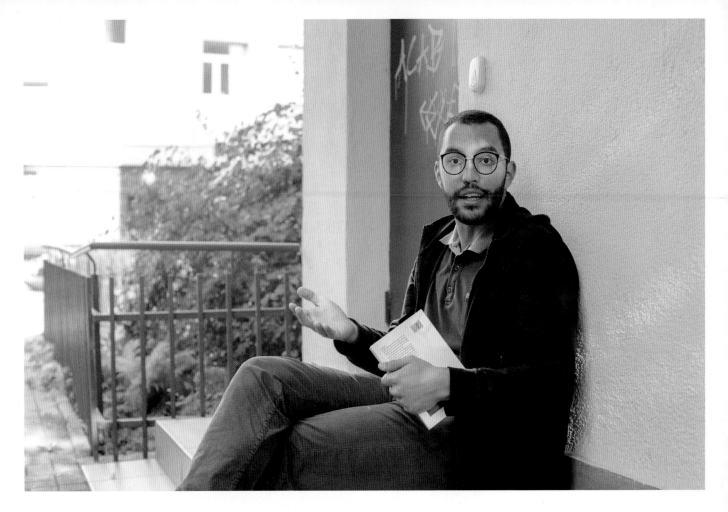

"We had a revolution in 2011. It was the first in North Africa. Imagine living your entire life, and all your teachers are saying that we have a wonderful president. Then suddenly everything flips. The streets are filled with people, and they're saying the president is a horrible person. Some of them have weapons. Everyone is choosing sides. Some going left. Some going right. There are feuds within families. The country was like two magnets, with the same charge, each going different ways. Everyone was fighting. And afterward there was no improvement. Our new leaders ganged up against their own country, and sold us out in a very bad way. It's very hard to enjoy life in Tunisia. I both love and hate my country at the same moment. The people are amazing. My family is there, and I want to be with them. But here there is peace. I can read my book in a quiet space and not be bothered. And that's the frustration. You want to see this peace in the place where you most love. Not only for yourself, but for your neighbors, your friends, your parents, and your children."

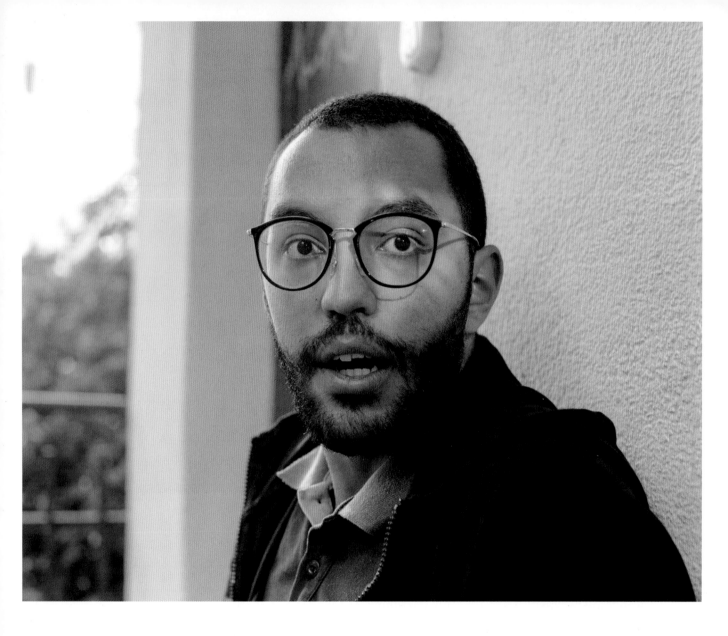

"I feel like I'm mistaken just because of where I'm from. The glimpses. The looks. It messes with your head on some level. I'm studying to be an architect. I'm supposed to be a dignified person. But the moment that green Tunisian passport comes out, I go from one hundred percent to ten percent. The security officers need to know everything. They treat you like a prisoner. Maybe it's just a policy. Maybe it's nothing personal. Maybe it's not racism. But you take so many hits, so many blows, and you start to think that's how the entire world sees you."

WARSAW, POLAND

"I hated Japan at first. My family moved here from the Philippines when I was seven years old. I didn't speak any Japanese. Every day, I was bullied at school—both for being a foreigner and being larger than everyone else. Kids kept telling me that I didn't belong in Japan. I just wanted to go home. But in third grade I saw a sumo tournament on television, and one of the wrestlers was of Filipino descent. I thought: 'This is something I can do.' So I joined a sumo club, and over the years I developed a reputation for being strong. Other kids at school began treating me with respect. I even became a bit famous, because I was the only sumo wrestler from our hometown. I'm training professionally now. Sumo has taught me so much about this country: the environment, the customs, and the rules. And I don't feel like an outsider anymore. I'm only eighteen, so I still have a long way to go. But I'd like to reach the top rank. That way I can earn enough money to bring my entire family to Japan."

TOKYO, JAPAN

"We worked together at McDonald's. I was in a deep depression at the time. It felt like my mind was dying. Hours passed. Days passed. I just tried to keep to myself and make the fries. But she was different. She was friends with everybody. Always smiling. Always blushing. Always talking. One morning it was snowing outside, and she walked in the front door, covered in snow, and she started dancing and twisting on the floor mat, and the snow was falling off her, and the light was behind her, and she looked like an angel to me. But we never spoke. Her friends kept telling me that she had a crush on me, but I was too shy. Sometimes we'd be at the same post together, and both of us would just stare at the computer screen. If we accidentally looked at each other, we'd look away really fast. Then one night we both finished around ten p.m. and we sat alone in the break room. We started talking a little bit. She couldn't sit still. She kept getting up and walking around the room. I told her that people were saying she liked me. She didn't respond. She just stared at the wall. Then after a long time she finally looked at me. I put my arm around her shoulder, and we kissed."

LONDON, ENGLAND

"I was shooting a lot of tequila. I'd already thrown up before even going out that night. Then at the bar I saw an ex-girlfriend of mine, and she was with a guy, so I walked up to him and said I'd put a brick through his window if he took advantage of her. That was really humiliating—so I drank even more. Everything after that is pretty hazy. I remember it in vague blips. I remember walking up to Kylie, and kissing her, then running away. Then all my mates were leaving. So I walked back up to her and said: 'I'm going home. Are you coming with me?' She said yes, and the rest is history. But we tell family that we met at a university lecture."

LONDON, ENGLAND

"He's a new kid. It was my job to show him around the school. I wasn't wearing my glasses when I met him, so all I could see was blond hair and a red face. He didn't say a word. He just had a blank expression the entire time. And he's pretty far from my type. But we both play percussion in the band, and I'm the section leader, so it was my job to help him learn. I didn't have much patience with him. He's not good on the mallet. He can't play his scales. He doesn't even know his notes. Plus he could barely make eye contact. But one day after school we were with a group of friends in the park, and I started making fun of him. I told him: 'You're so shy you can't even do anything.' He started to pout, then he said: 'I'm game to do anything at all.' So I said: 'Well, I dare you to kiss me.' And he did."

MONTREAL, CANADA

"We were married in the traditional way. Our two families knew each other, so a meeting was arranged. We'd never met. He came to my house with his mother, and we went to a room for two hours and talked. We talked about our expectations, our idea of love, and our plans for the future. I thought about it for two days, then I sent him a text message, saying: 'Let's do it.' And he wrote back: 'All right, my dear.'"

"I had to break up with my girlfriend last week. We'd been trying to hide our relationship because our parents think we're too young to date. I'd been telling my mom we were just friends. And we told her dad I was gay. But last week a neighbor took a picture of us kissing in the park, and my mom surprised me with the pictures when I got home. I had to promise that I'd end the relationship and focus on my studies. I'm actually on my way to her house right now. But it's only because I need help with a school project."

"It wasn't a shotgun wedding. He proposed before Dad got diagnosed. We'd already scheduled the ceremony. We'd rented a large room at the museum. And Dad promised me that he'd make it. He said he'd still be healthy enough. But as the date got closer, he got sicker. And we didn't want to risk it. So we changed our plans. We moved up the date. We held a tiny ceremony at the registry office. Maybe twenty people came. Dad stayed in bed until it was time to go. But he made it the entire day. He drove me to the wedding in the same car that he'd driven my mum—a green MG Midget. He walked me down the aisle. He gave a speech at the reception. There was no focus on being ill. Or why we moved the wedding. It was just a nice speech. I have a film of it, but I haven't watched it yet. I think it might be too sad. Dad passed away five months later. My husband and I had a vow renewal recently. It was exactly one year from the planned date of our original wedding. We held it at the same museum. It was the original guest list. There was a lot of soul-searching involved. We weren't sure if it was the right thing to do. We weren't sure if people would understand—especially because it happened to fall on my dad's birthday. But it turned out lovely. Really lovely. There was so much Dad in the room—his photos were everywhere. But this day was about us. About our relationship. About showing the world how much we loved each other. About our future. And about moving forward."

LONDON, ENGLAND

"My ex-wife got the real estate.
And I got my peace."

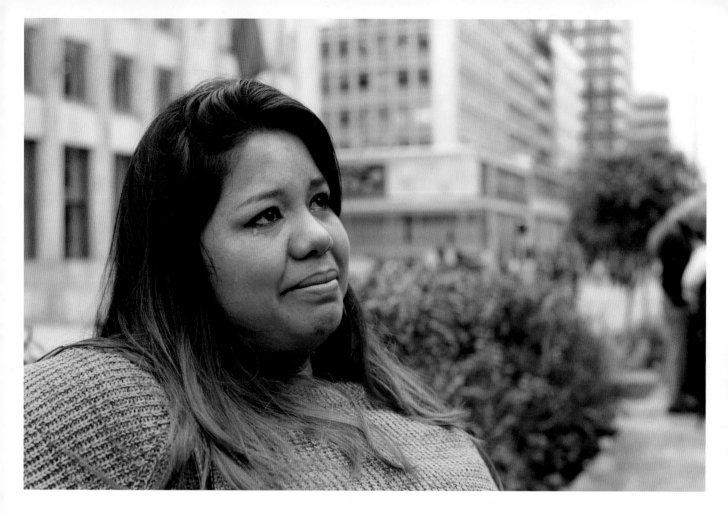

"I'm starting from nothing. I lost everything back in Venezuela. I had my own natural soap factory but the crisis made it impossible to get ingredients. Then the government began to take seventy percent of my earnings. I had to close it down. Things got so bad that I couldn't even find food for my baby. I had a little money, but there was nowhere to buy food. I'd wait in line all day for one bag of flour. We could go days without eating. When I tried to breastfeed my daughter, I'd almost faint. Leaving the country was my only chance. I'd never said 'goodbye' to my daughter before. She was screaming my name when I left. It hurt worse than giving birth. But I didn't have a choice. I told her that I was going to Colombia. I told her that I was going to make a diamond, and I'd bring it back to her. Now I sell key chains in the street. When I make some money, I send packets of food back home. I'm trying to keep a good spirit. I'm doing OK. I grew up very poor. I came from nothing. So I've been here before."

BOGOTÁ, COLOMBIA

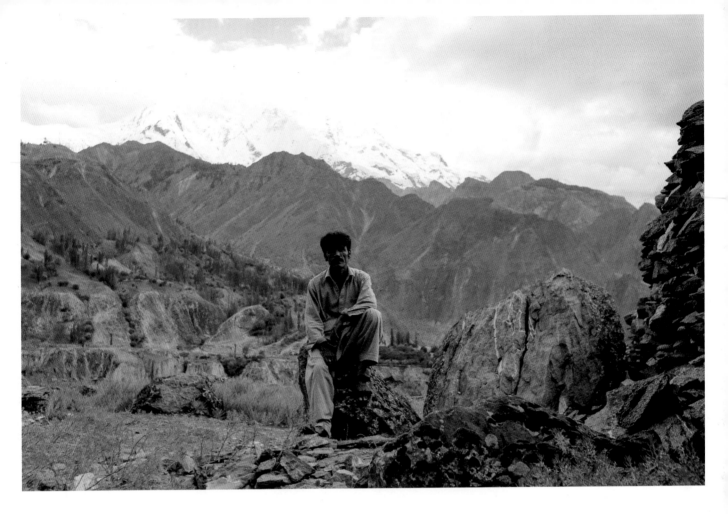

"There were no paved roads here when I was a boy. We had to walk for three days to get to places that only take two hours now. There was never any money for school. We had no wealth or property. Beginning at six years old, I cleaned dishes at a restaurant until nine p.m. Then I would go to sleep and start again. All my money went to my parents. I'd hear stories about cities and airplanes, but they seemed like fairy tales. I'd dream of visiting these places, but before I could get too far, I'd be hungry again. So I grew up thinking that the entire world was like our valley. I thought all children lived like me. Then one day when I turned sixteen, I had the opportunity to visit the city of Gilgit. I couldn't believe it. I saw a boy eating at a restaurant with his father. He was my age. He was wearing a school uniform. I broke down in tears."

HUNZA VALLEY, PAKISTAN

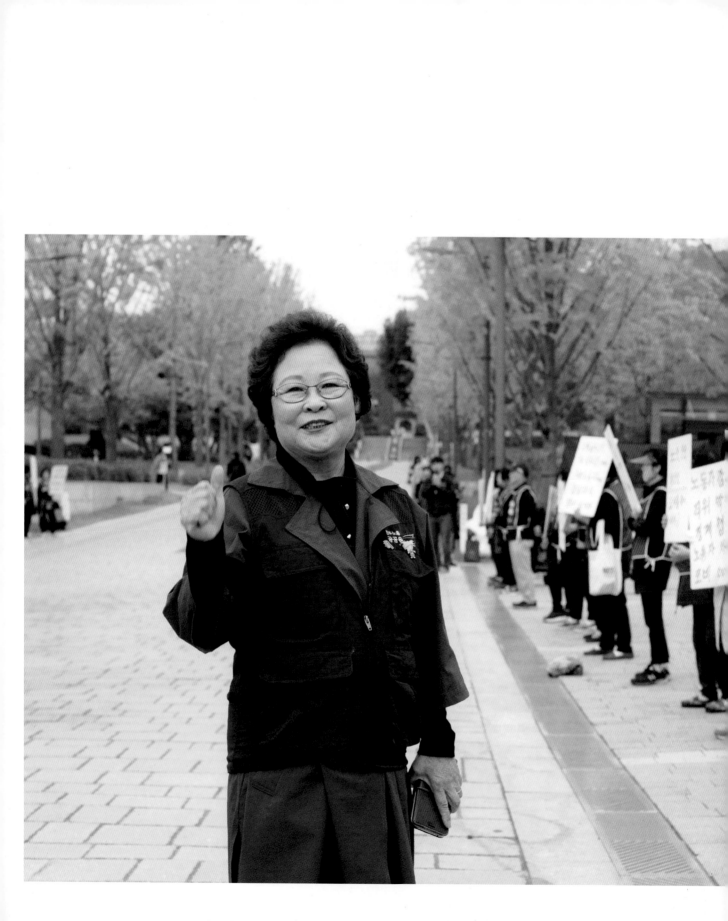

"For most of my life I helped my husband run his architecture business. But when he used our house as collateral for a bad loan, I was forced to get an extra job as a cleaning lady. At first I was humiliated. I didn't tell anyone. I viewed cleaning ladies as the bottom of the chain. We weren't treated with dignity. We were paid less than the minimum wage. And the boss could speak to us in any way he liked. But ever since we formed a union, we've found our power as workers. We can't be fired anymore without cause. We've raised our minimum pay. And we even have benefits now. In the beginning I'd wear a mask to these protests. But I'm not ashamed anymore. Last year my colleagues voted me the head of organizing. If anyone has a problem with the boss, they come to me."

SEOUL, SOUTH KOREA

"I was born in New York, but I've lived here for six and a half years. I look Japanese. I sound Japanese. I have a Japanese name. So I'm expected to 'be Japanese.' To follow the rules. To not stand out. To never express my opinions, or ideas, or feelings. But at heart I'm a New Yorker who is very open and eager to express my thoughts, because I was brought up to believe that those matter. But I've had to learn to keep them to myself. To kill them, almost. To ignore them to the point where I pretend they don't exist. Otherwise it's too hard to feel one way, and act another."

TOKYO, JAPAN

"My whole life was denial until the divorce. I always had a script that I followed, probably handed down from my mother. Always be cheerful. Always have a smile or a joke. Insist that everything is great, or will be better soon. Be likable, which is different than lovable. And parties, parties, parties. I was always the hostess. Because the hostess never has to expose herself. Always bringing other people together: 'Let's sit Margaret next to Susan because they both went through this or that.' Never mind what I might have been through. Or who I am. Not that I'd know who I am. Because that takes time. And the hostess is too busy keeping things bubbly and effervescent. When the party's over, there's only time to sleep. And I don't remember my dreams. Now if you'll excuse me, I have a dinner for eight this evening."

NEW YORK, UNITED STATES

"Mario and I had been friends since the age of six. We were from the same small town in the countryside. We always kept in touch. We'd occasionally get coffee together. I knew he was gay but we never talked about it. It just didn't come up. He never volunteered the information and I never asked. I felt that I was being respectful. At one point, I began to notice that his face was changing. He started to get very thin. But I never asked about it. Maybe I thought that he'd feel I was invading his privacy. Mario could get offended very easily. He was like a volcano. Maybe, subconsciously, I just didn't want to get involved. When I finally knew for sure, it was too late. I visited him at the hospital the day before he died. I could only look at him through a glass window. He was covered in blankets. I felt like such an idiot. I could have asked him at any time. I could have said: 'What are you hiding from me? Are you sick? Are you afraid I will reject you?' Then we could have hugged each other and cried together. We could have maybe even laughed at the situation. But we never got to do that. Because I never had the balls to ask."

BUENOS AIRES, ARGENTINA

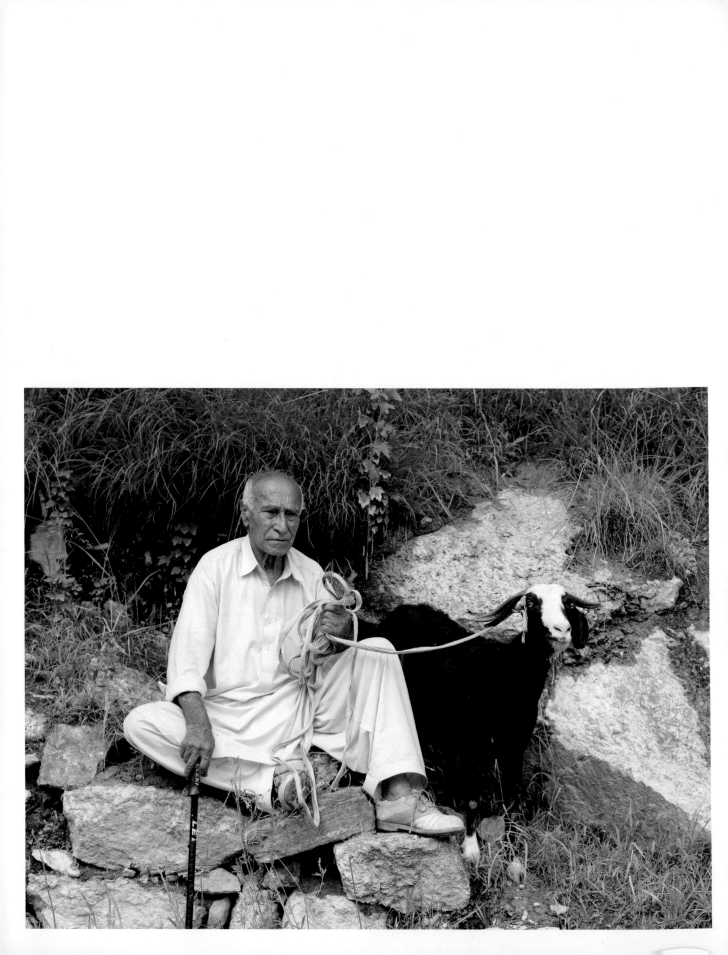